HISTORIC PHOTOS OF
OLD CALIFORNIA

TEXT AND CAPTIONS BY NANCY HENDRICKSON

TURNER
PUBLISHING COMPANY

This 1877 panoramic view of San Francisco was taken from California Street Hill. Among the recognizable landmarks are Alcatraz Island and Telegraph Hill, Mission Street, California Street, Saint Mary's Church, Grace Episcopal Church, as well as many of the homes, hotels, and buildings destroyed in the fire that followed the 1906 earthquake.

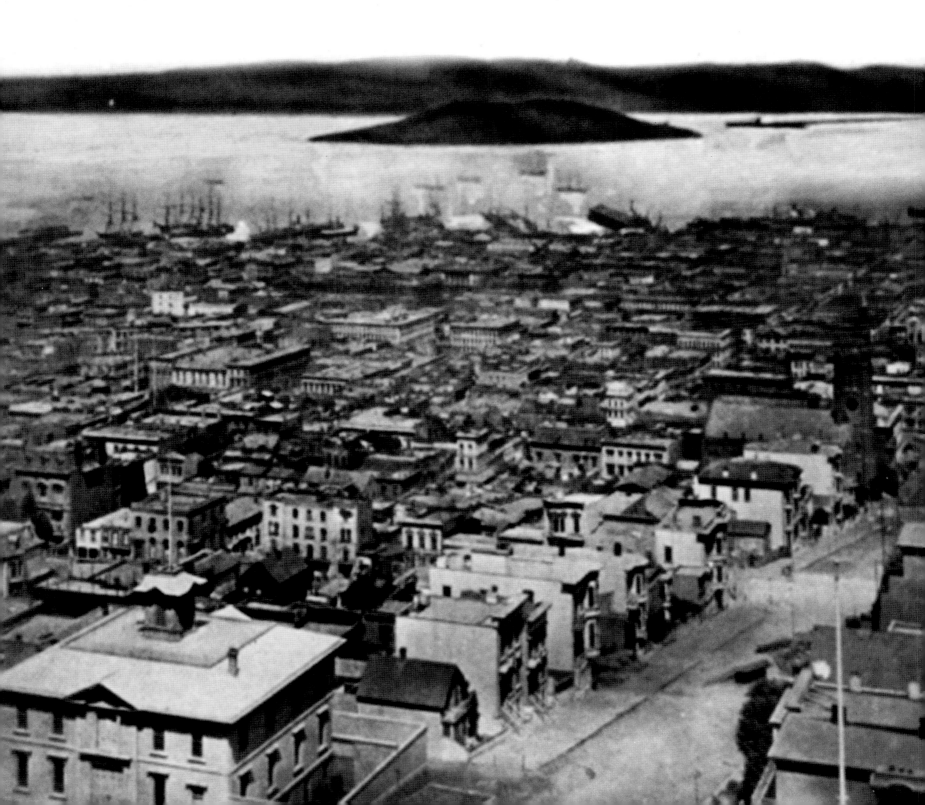

HISTORIC PHOTOS OF
OLD CALIFORNIA

Turner Publishing Company
200 4th Avenue North • Suite 950
Nashville, Tennessee 37219
(615) 255-2665

www.turnerpublishing.com

Historic Photos of Old California

Copyright © 2009 Turner Publishing Company

Library of Congress Control Number: 2008910976

ISBN-13: 978-1-59652-524-5

Printed in China

09 10 11 12 13 14 15 16—0 9 8 7 6 5 4 3 2 1

CONTENTS

During a Spanish expedition to northern California in 1776, Padre Pedro Font named the massive mountain range they encountered the Sierra Nevada, meaning "snowy range." The Sierras remained almost untouched by American explorers up to an 1863 geological survey headed by Josiah Whitney. Because of the unusually light shade of the granite, naturalist John Muir nicknamed the mountains the "Range of Light."

Acknowledgments

This volume, *Historic Photos of Old California,* is the result of the cooperation and efforts of many individuals, organizations, and corporations. It is with great thanks that we acknowledge the valuable contribution of the following for their generous support:

Library of Congress
The California State Library

This book is dedicated to all those who are willing to brave the unknown.

PREFACE

California's early days are documented in thousands of historic photographs that reside in archives, both locally and nationally. This book began with the observation that, while those photographs are of great interest to many, they are not easily accessible. During a time when California is looking ahead and evaluating its future course, many people are asking, "How do we treat the past?" These decisions affect every aspect of the western state—architecture, public spaces, commerce, infrastructure—and these, in turn, affect the way that people live their lives. This book seeks to provide easy access to a valuable, objective look into the history of old California.

The power of photographs is that they are less subjective than words in their treatment of history. Although the photographer can make decisions regarding subject matter and how to capture and present it, photographs do not provide the breadth of interpretation that text does. For this reason, they offer an original, untainted perspective that allows the viewer to interpret and observe.

This project represents countless hours of review and research. The researchers and writer have reviewed thousands of photographs in numerous archives. We greatly appreciate the generous assistance of the individuals and organizations listed in the acknowledgments of this work, without whom this project could not have been completed.

The goal in publishing this work is to provide broader access to this set of extraordinary photographs that seek to inspire, provide perspective, and evoke insight that might assist people who are responsible for determining California's future. In addition, the book seeks to preserve the past with adequate respect and reverence.

With the exception of touching up imperfections caused by the damage of time and cropping where necessary, no other changes have been made. The focus and clarity of many images is limited to the technology and the ability of the photographer at the time they were taken.

The work is divided into eras. Beginning with some of the earliest known photographs of California, the first section records photographs through the end of the 1860s, focusing on the peak of the gold rush. The second section spans the decades of the 1870s and 1880s, a time of tremendous expansion and economic growth. Section Three proceeds through the 1890s, when California moved away from an era of gold rush fever to one focusing on industry and tourism. The last section covers the first two decades of the twentieth century as Californians overcame earthquake devastation and reemerged as a land of tourism, agriculture, and industry.

In each of these sections we have made an effort to capture various aspects of life through our selection of photographs. People, commerce, transportation, infrastructure, religious institutions, and educational institutions have been included to provide a broad perspective.

We encourage readers to reflect as they go walking in old California, strolling through its cities, its parks and neighborhoods, and its natural scenery. It is the publisher's hope that in utilizing this work, longtime residents will learn something new and that new residents will gain a perspective on where California has been, so that each can contribute to its future.

—Todd Bottorff, Publisher

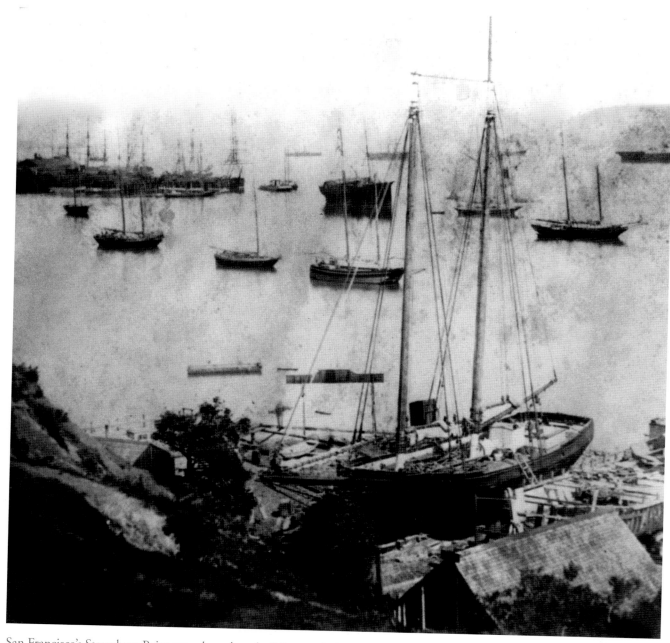

San Francisco's Steamboat Point served as a boat building yard. *Overland Monthly* reported the *Sophie McLean* was built there in 1858 to run on the Bay. "As her keel struck the water, she steamed away up the Bay, five or six miles, then turned back to the city, landed her guests at Broadway wharf, and next day went down to San Jose's shipping point."

Exploration and Exultation!

(1850–1869)

California is a child of many mothers. Although native peoples inhabited the land for 10,000 years, her European history began when both Spanish and English explorers claimed the land as their own. To ensure Spanish supremacy, an expedition led by Father Junipero Serra established 21 missions stretching from San Diego to Sonoma, built by Native American labor. For a short time, Russian trappers and traders established a foothold on the coast but eventually vacated their base at Fort Ross, north of present-day San Francisco.

In 1821, following Mexico's independence from Spain, California became a Mexican province, and in 1848, following the Treaty of Guadalupe Hidalgo, became part of the United States. That same year, gold was discovered by James Marshall at Sutter's Mill, and from that moment on, California changed forever: gold-seekers poured in from the corners of the globe, all hoping to strike it rich in El Dorado.

The first lighthouse, built on Alcatraz Island, beamed the way into San Francisco Bay. San Francisco was transformed from a shanty town of tents and shacks to a city of 30,000. By 1850, California was admitted to the Union as a non-slave state. Business boomed, Sacramento grew into a central shipping port, and by 1860, the first Pony Express riders arrived after a wild ten-day ride from St. Joseph, Missouri.

While the Civil War devastated the East, California remained virtually untouched; her largest contributions to the war effort were the men who left to fight, and the millions of dollars in gold shipped back east to help pay for the war. San Francisco continued to boom; buildings sprang up, ships were built, hotels were erected, and plans for a transcontinental railroad were in the works. At the same time, the city's waterfront attracted the world's reprobates. Liquor, robbery, murder, and prostitution were commonplace. Seamen were shanghaied and business owners threatened with arson by extortionists. Life in this quarter was so barbaric that it was named the Barbary Coast after an equally dangerous area of Africa.

After the war ended and the rest of the country settled into the era of Reconstruction, California was poised for explosive growth.

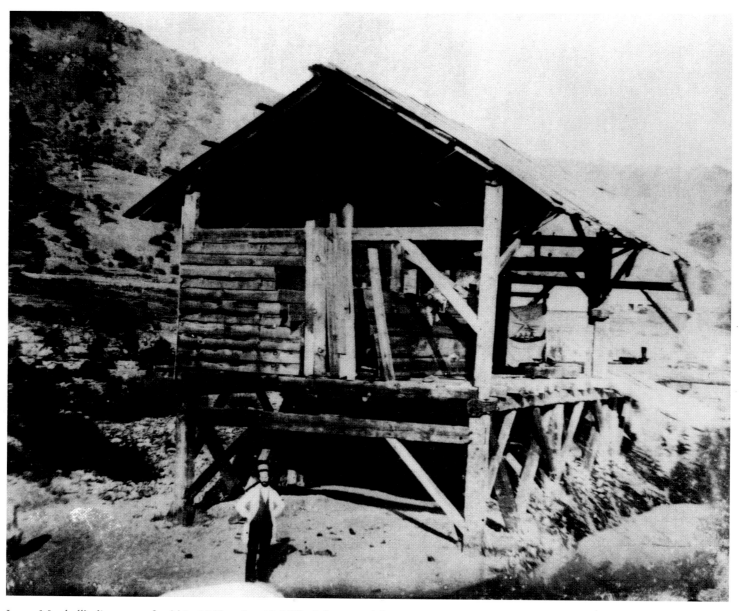

James Marshall's discovery of gold in 1848 at Sutter's Mill, Coloma, California, triggered one of the largest migrations in American history. More than 90,000 people poured into California in the two years following Marshall's discovery—and 300,000 in the next four. Marshall himself never profited from his discovery and in 1885 died penniless.

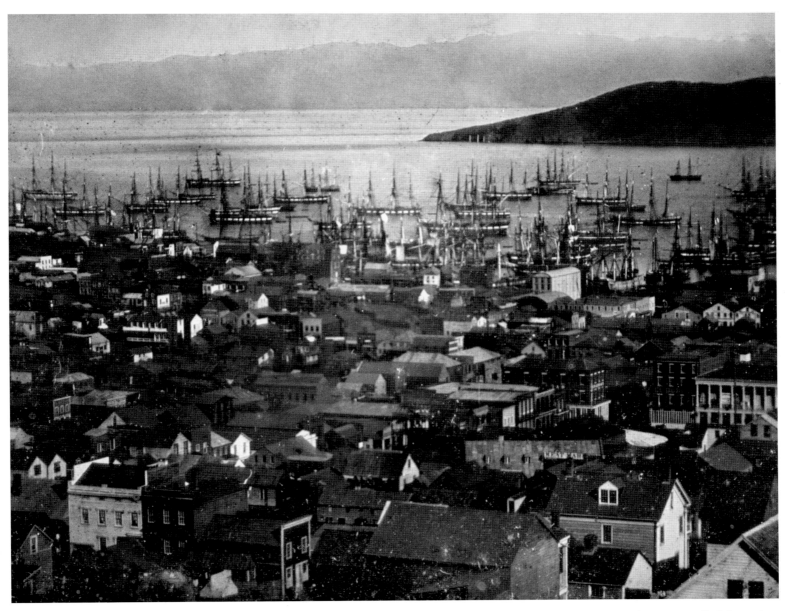

The effects of the gold rush were far-reaching: San Francisco grew from a shanty village to a boomtown. The miners called themselves Argonauts after the mythical men who accompanied Jason in search of the Golden Fleece. While a few of the early miners did strike it rich, the majority did not. It's estimated that one in every five miners who came to California in 1849 died within six months.

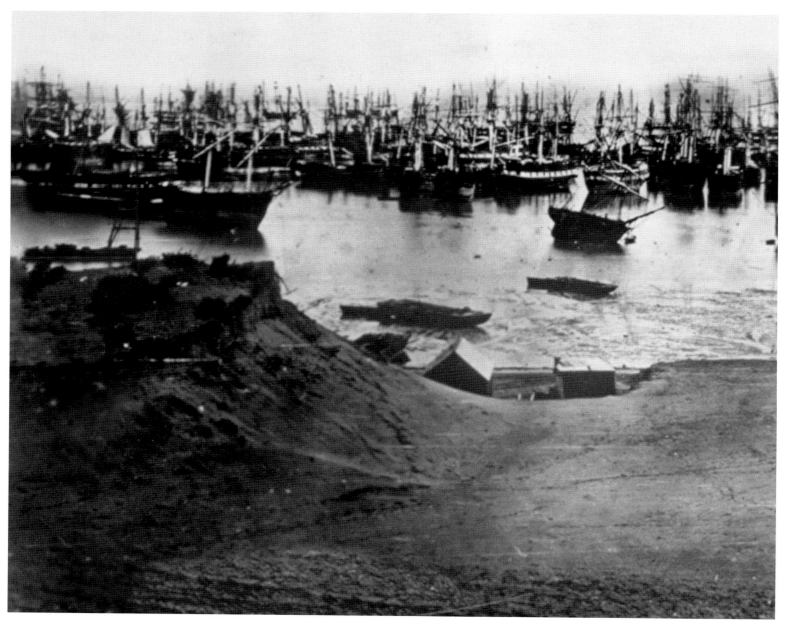

This view of San Francisco Harbor from Rincon Hill shows a forest of masts—vessels left derelict by crews who jumped ship in search of gold. Argonauts from the East Coast sailed around the tip of South America, a journey that took five to eight months, covering 18,000 nautical miles. Others sailed to the Isthmus of Panama then trekked overland through the jungles, hoping to find a ship on the Pacific side that could take them to San Francisco.

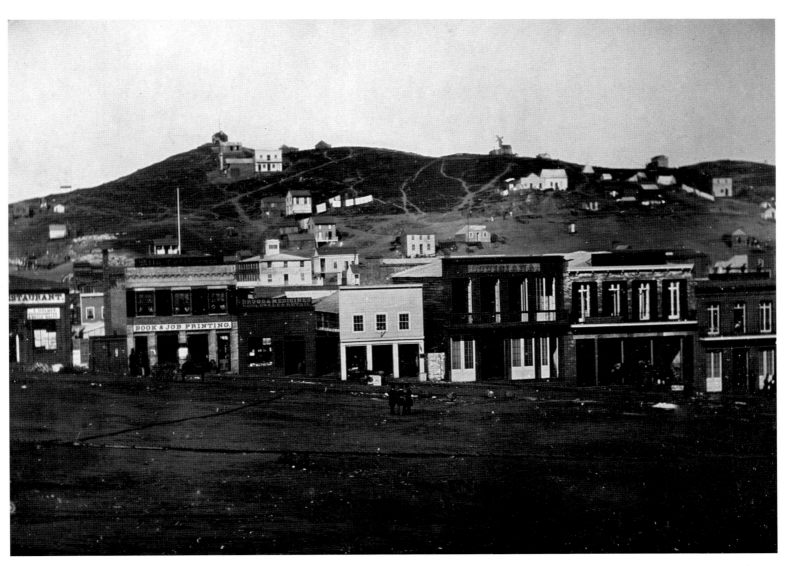

Portsmouth Square, pictured in this photograph from around 1850, is located on the site of the first public square established by the Mexican community of Yerba Buena, which was renamed San Francisco in 1847. During the Mexican-American War, the first American flag was raised in this plaza, and on October 9, 1850, the first Admission Day celebration took place. Today, the square is known as the Heart of Chinatown.

Sacramento, named the state capital in 1854, rapidly grew as a distribution center during the gold rush. Later, it became the western terminus for the telegraph, the Pony Express, and the Transcontinental Railroad. Freeman & Co. Express, pictured here in 1852, was one of the largest and most flourishing express companies, continuing in operation until mid-1860.

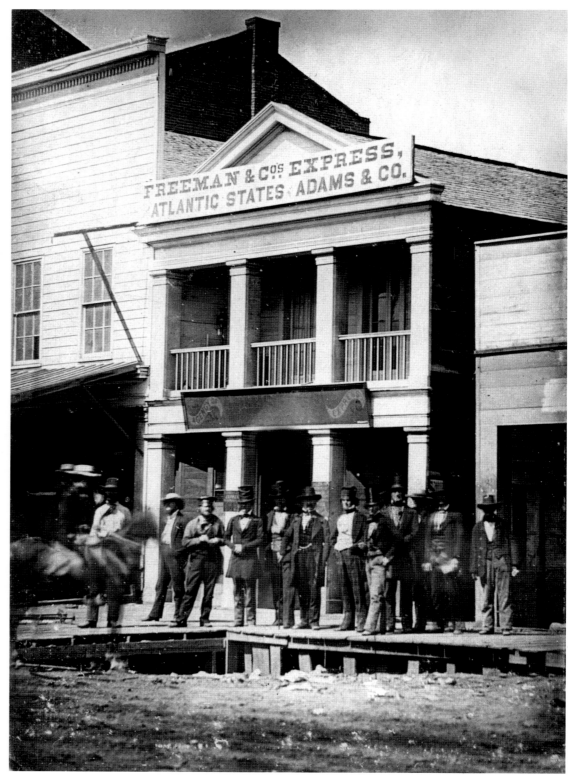

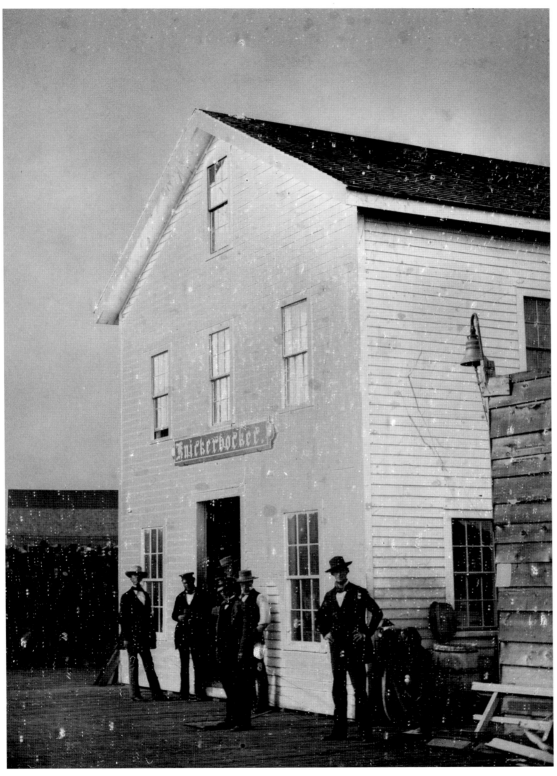

When the Gulick brothers came to California from New York in 1850, they realized that the road to wealth came not through searching for gold, but by setting up a business. Choosing to establish their business in Benicia rather than San Francisco, the brothers built Gulick's Wharf and the Knickerbocker Emporium. John, pictured in this 1852 image with brother James, became a Wells Fargo agent; in 1857 James left the Bay Area for Hawaii.

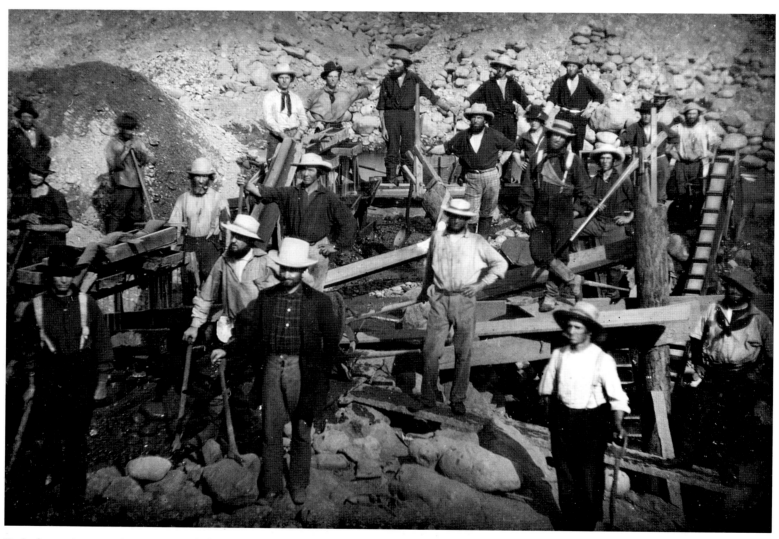

Early forty-niners used pans to search for gold in the rivers and streams. Over time, other technologies were developed so mining could take place on a larger scale. Rockers and cradles were first used; later, prospectors used a sluice like the one shown here, which allowed the water flowing through it to separate lighter materials from gold. U.S. Geological Survey estimates that 370 tons of gold were removed in the first five years of the gold rush.

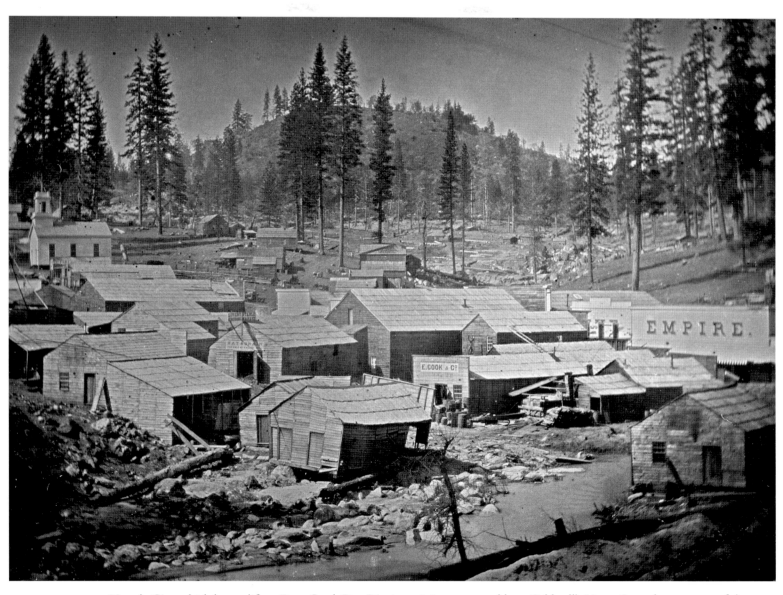

Nevada City, which began life as Deer Creek Dry Diggins mining camp and later Caldwell's Upper Store, became one of the most important mining towns in California. With California's statehood in 1850, this gold mining center became the seat of Nevada County. In 1859, when silver was discovered in Utah Territory, many of the town's citizens joined what would become known as the Comstock Silver Rush.

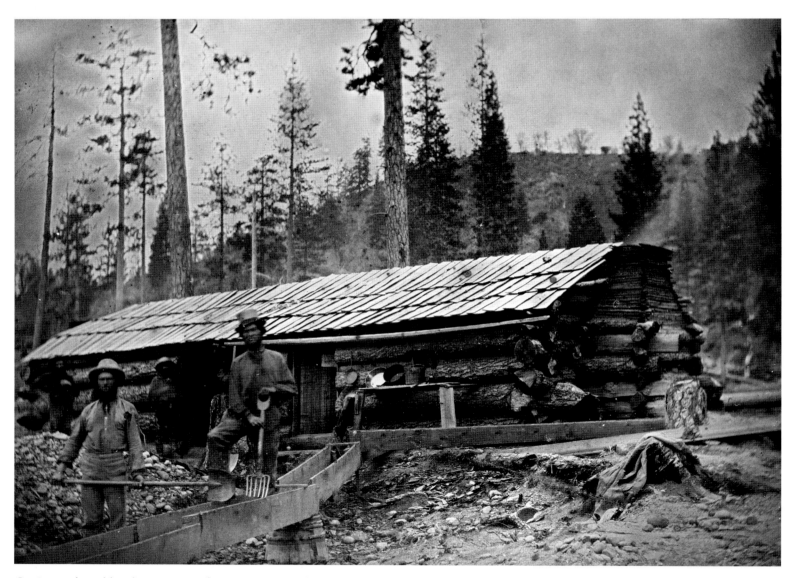

Getting to the gold rush was no easy feat. Some miners chose the six-month, 15,000-mile ship voyage around Cape Horn. Even at $300 (about $8,500 in today's dollars), the ships were quickly filled. The cheapest route to California was overland, following the ruts of the Oregon Trail, while the shortest route was through the Isthmus of Panama. If all went well, the voyage and land trek across the isthmus took about four months.

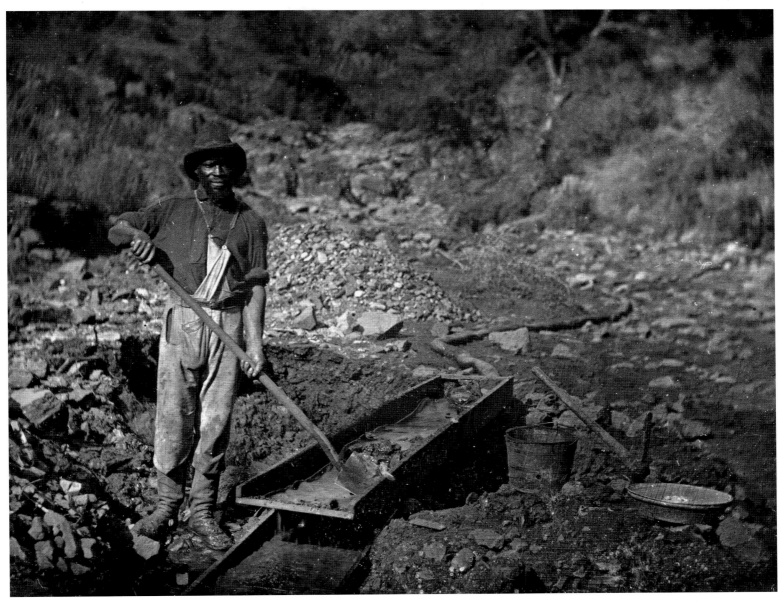

Of the 300,000 gold miners who arrived by 1855, the largest number were Americans, followed by tens of thousands of Mexicans, Chinese, Europeans, and South Americans. It's estimated that fewer than 4,000 miners were of African descent, most coming from Southern states or the Caribbean. By 1850, the Solano County (located between San Francisco and Sacramento) census showed only 21 African-Americans living there.

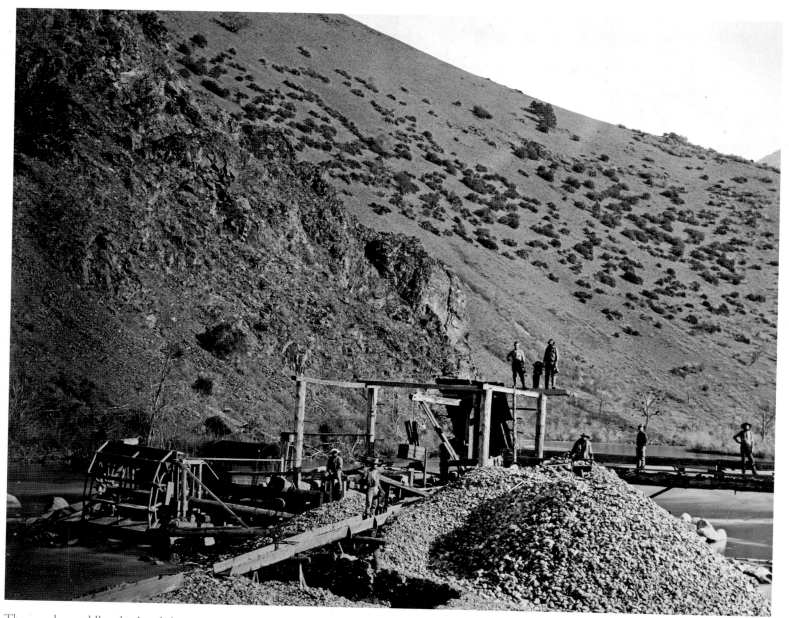

The wooden paddle-wheel and sluice were used to retrieve gold from Bogus Creek in northern California's Siskiyou County, near today's city of Yreka. Thousands of forty-niners who poured into the county in 1851, following the discovery of gold, expanded the Siskiyou Trail, which was originally a Native American path. This setting was described in Joaquin Miller's novel *Life Amongst the Modocs*.

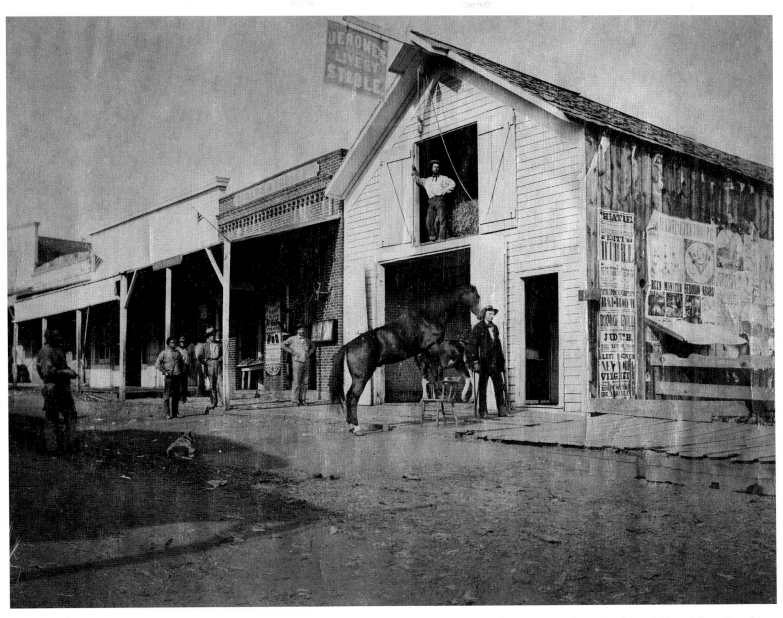

Volcano, located in the "Heart of the Mother Lode," was home to thousands of Argonauts who arrived in 1855 and functioned as a large-scale hydraulic mining operation. At the time of this photo (ca. 1855), Volcano sported 17 hotels, a theater, and a library. Jerome's Livery Stable burned to the ground in 1862, along with the butcher shop, the doctor's office, and the St. George Hotel. Today, Volcano is registered as a California Historical Landmark.

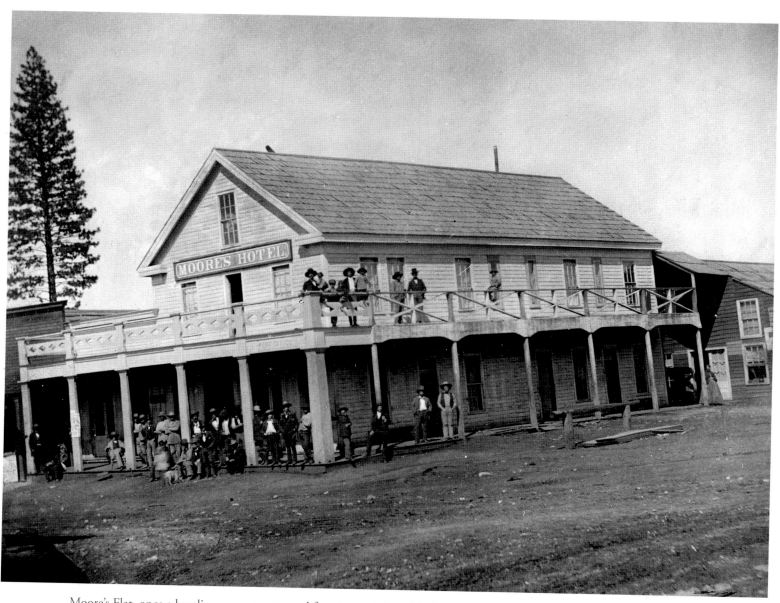

Moore's Flat, once a bustling town, was named for pioneer Hiram Mark Moore, who arrived in the area in 1850. Later, Moore opened a store and Moore's Hotel, a two-story wooden building that was destroyed by an 1865 fire. In 1878, the world's first long-distance telephone line was built extending from French Corral through Moore's Flat and on to Bowman Lake.

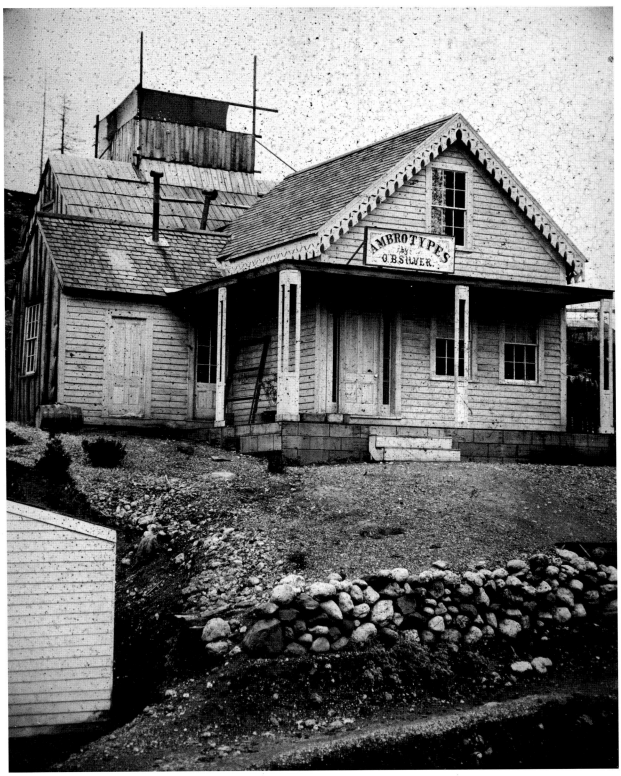

The Dutch Flat settlement was founded by German (Dutch) immigrants in 1851, and during the gold rush days was considered one of the richest gold mining locales in the state, outputting approximately $5 million. The O. B. Silver Ambrotype studio made photographs by creating positive images on sheets of glass, a technique that was less expensive than the earlier daguerreotypes.

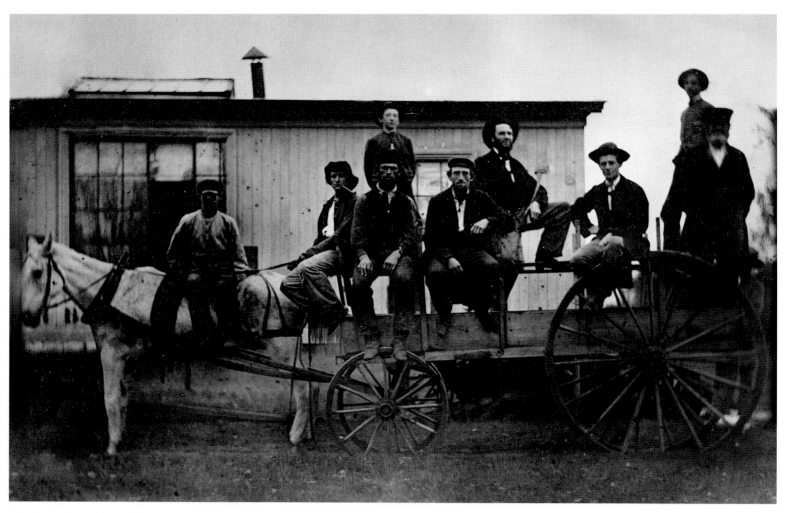

Josiah Wright, early California photographer, used a horse-drawn wagon to transport his traveling studio. Some of Wright's contemporaries worked with large glass-plate negatives measuring up to 18 x 22 inches, and required mules to haul 2,000 pounds of equipment to set up darkrooms on site.

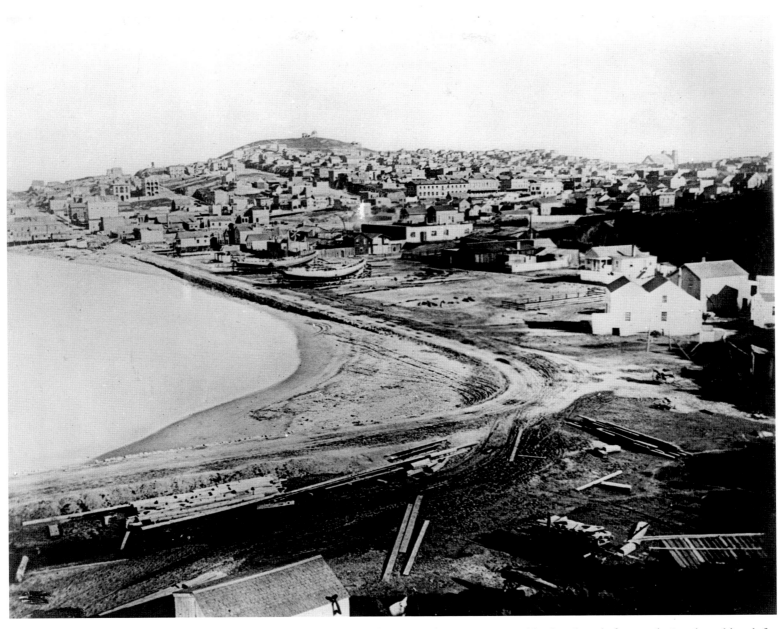

San Francisco's historic North Beach was the locale of the infamous Barbary Coast, a neighborhood made famous during the gold rush for gambling, prostitution, and crime. By late 1849, the population included 300 women, most of whom were prostitutes, and 20,000 men. Later North Beach residents included Joe DiMaggio, Janis Joplin, and beat novelist Jack Kerouac.

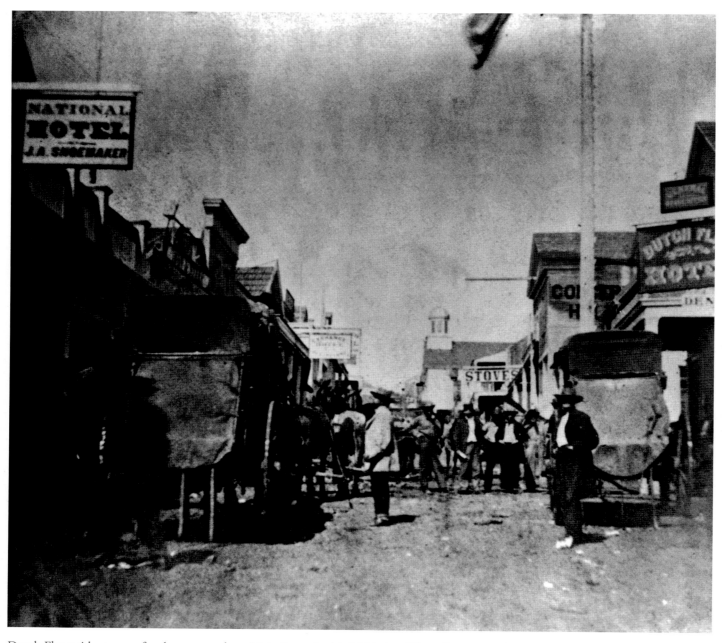

Dutch Flat residents pose for the camera along Main Street in this 1866 view. The village, set in the pines of the Sierra Nevada, thought of itself as "the Athens of the foothills." Among its buildings was an opera house where Mark Twain lectured, an amateur dramatic society, and a debating society. By the late 1860s, it had one of the largest Chinese settlements outside of San Francisco.

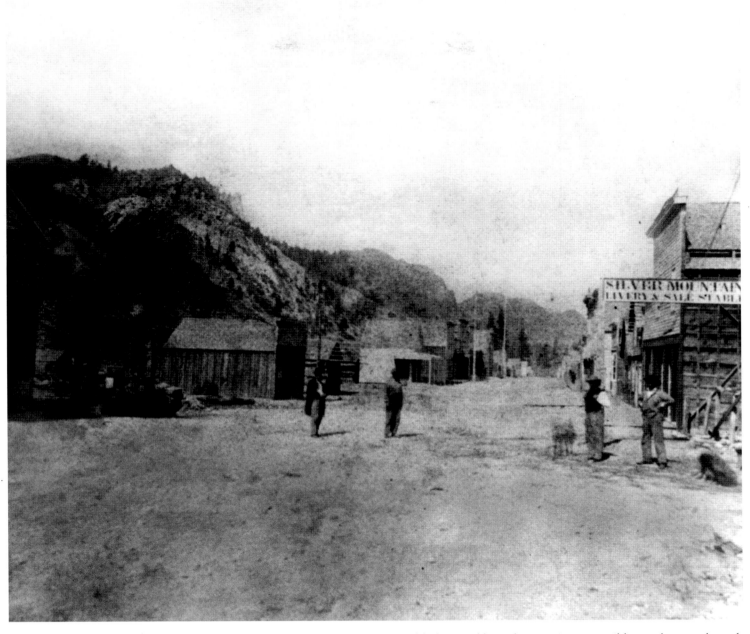

When John Fremont and Kit Carson crossed Alpine County in 1844, their trail brought attention to possible travel routes through the Sierra. Although the area was crossed by Mormon Battalion members and the forty-niners, the Comstock Lode silver discovery in 1859 lured miners here. Silver Mountain, whose Main Street is pictured here, was established by Scandinavians who discovered an outcrop of silver.

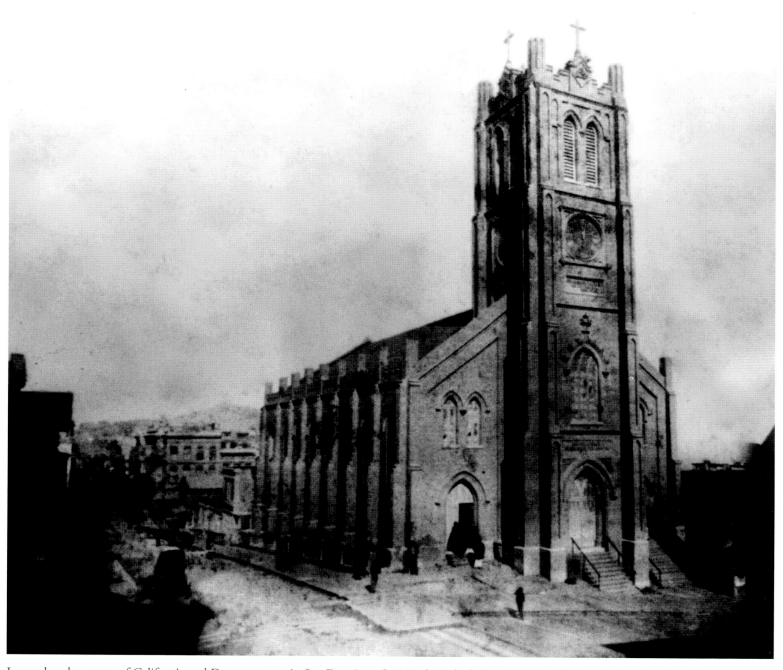

Located at the corner of California and Dupont streets in San Francisco, St. Mary's Cathedral was built in 1853 under the direction of Joseph Sadoc Alemany, the First Archbishop of San Francisco. Architects William Craine and Thomas England designed the cathedral to resemble a Gothic church in Alemany's hometown in Spain. The original plan called for a steeple, but because of the threat from earthquakes, the top was left as a bell tower.

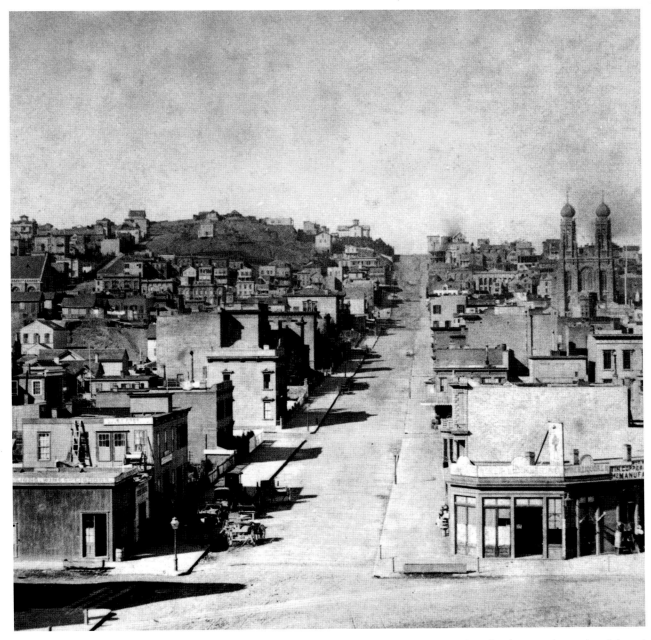

This view of Powell Street in San Francisco was taken from the Lincoln School House located at 5th and Market around 1866. The school was opened in 1856 under the tutelage of Miss Kate Sullivan. A San Francisco Municipal Fiscal Report of 1865 questioned the costliness of a new Lincoln School House, noting that the city could not invest $90,000 to construct a public building.

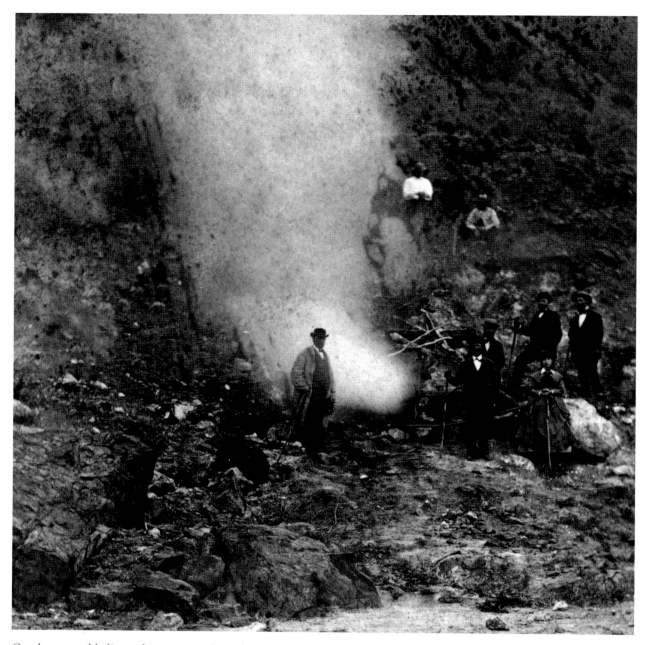

Gentlemen and ladies gather to enjoy the Indian sweat bath and geysers around the mid-1860s. An early Sonoma County history noted that the healing properties of the springs were well-known to local Indians, including a steam jet known as an Indian sweat bath. It was here that rheumatic patients were brought and laid on a scaffold over the spring, then steamed and cured or "relieved by death from [their] sufferings."

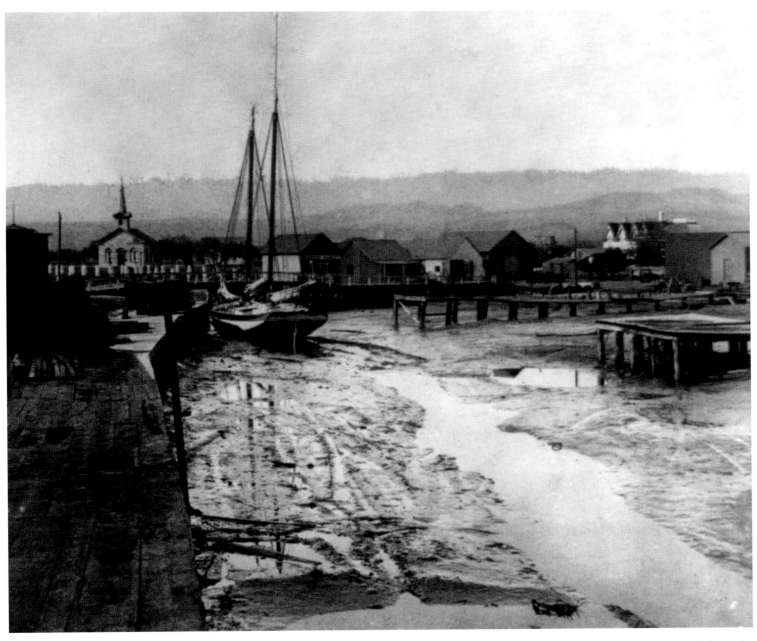

The shores of Redwood City were first occupied by the Ohlone Indians, whose main food supply was shellfish gathered from the bay. By 1776, a Spanish force had explored the coast, with land grants given to high-ranking officers. Officer Arguello and his family were granted 69,000 acres including what is now Redwood City. After the Mexican-American War, parcels of land were sold to white settlers and a town grew up around waterfront industries.

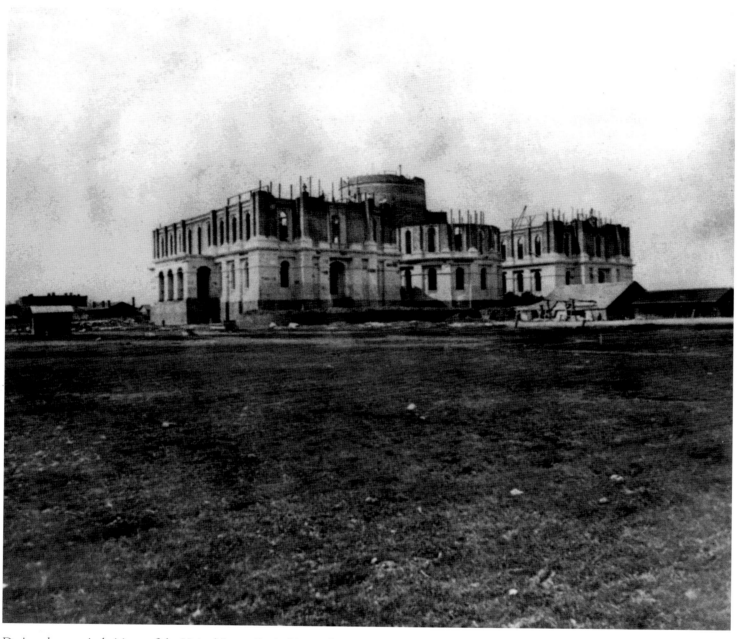

Designed to remind visitors of the United States Capitol in Washington, D.C., the new capitol building in Sacramento was begun in 1860. Built in the Classical Revival style, the building was completed in 1874. The dome is accented with neoclassic design elements, with pilasters, columns, colonnade windows, and a cupola.

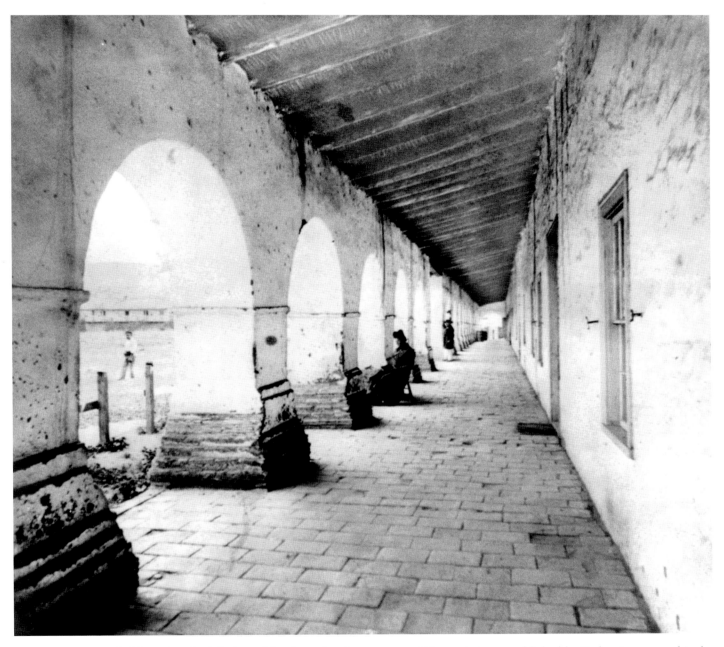

Founded in 1797, the Mission of San Juan Bautista was one of four missions established by Father Lasuen and is the fifteenth of the 21 missions in California. The present church, dedicated in 1812, sports animal footprints in the tiles because the tiles were left outside to dry in the sun. The church also has a cat door carved into a side door in the Guadalupe Chapel, allowing cats inside to catch grain-eating mice.

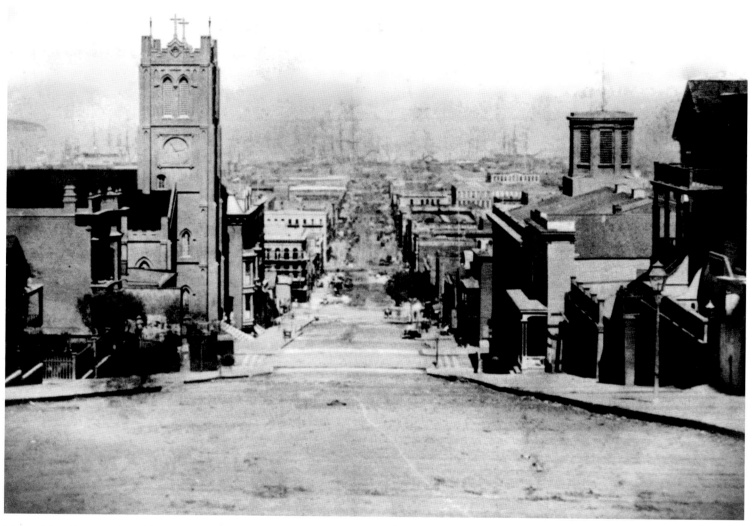

View of San Francisco's California Street from the corner of Stockton around 1866. Although the gold rush brought the first influx of citizens to this town, those who stayed capitalized on the potential for commerce. Among early businesses were Wells Fargo (1852), the Transcontinental Railroad (1869), Ghirardelli chocolate, the first cable cars, and Chinatown, populated by Chinese immigrant railroad workers.

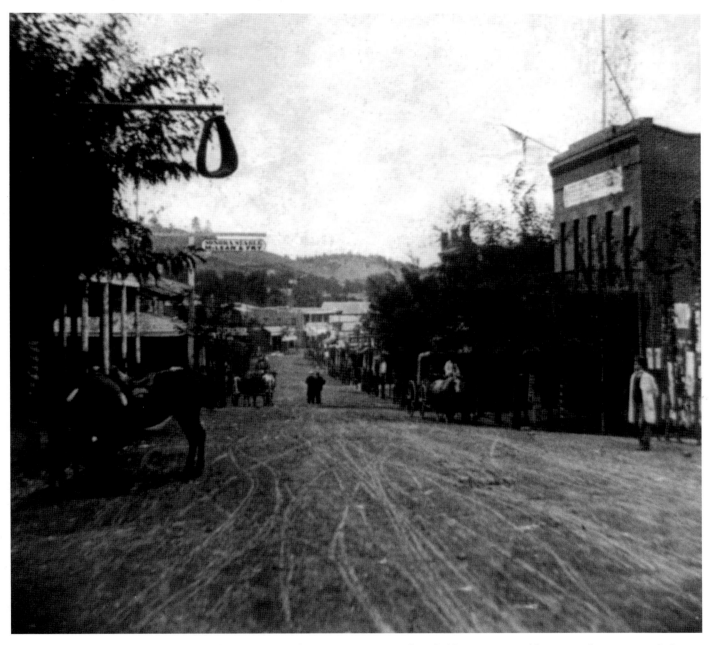

Named to remind them of their Mexican heritage, Sonora was founded by Mexican gold miners who came north during the 1849 gold rush. Washington Street, viewed in this image from around 1866, ran in front of the courthouse, St. James Episcopal Church, and the Opera House. Both Mark Twain and Bret Harte lived in a cabin located just outside Sonora, on Jackass Hill. It was here that Twain wrote his famous story "The Celebrated Jumping Frog of Calaveras County."

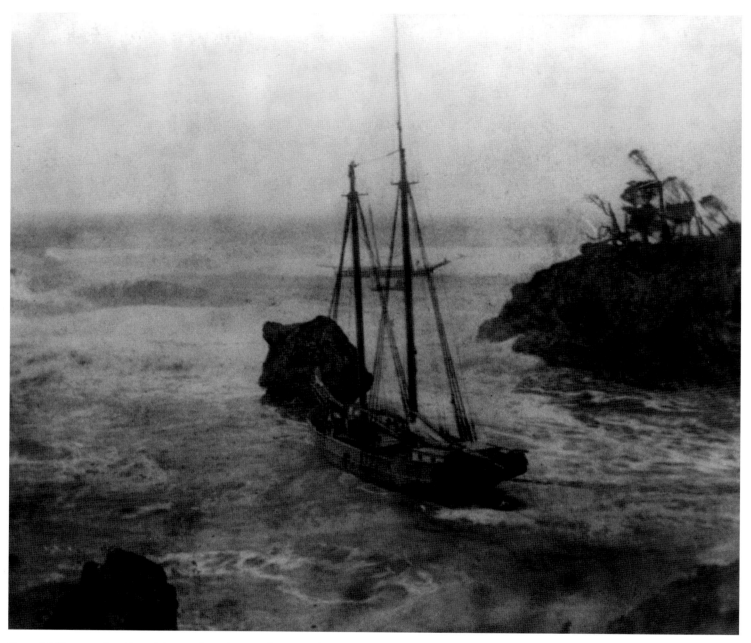

From 1542 onward, sailing ships, such as the one shown in this 1866 image, have plied the waters off the California coast. European explorer Juan Rodriguez Cabrillo sailed into what is now San Diego Harbor, while Sir Francis Drake landed near the northern end of San Francisco Bay. As sailing traffic grew, so did the need for lighthouses; in 1853 the first seven were built along the coast.

The California missions represented an attempt by Spain to colonize the Pacific Coast and convert the locals to Christianity. Mission Santa Cruz was one of 21 missions built along El Camino Real ("The Royal Highway"). Consecrated in 1791, Mission Santa Cruz served the local Ohlone and Yokut native populations.

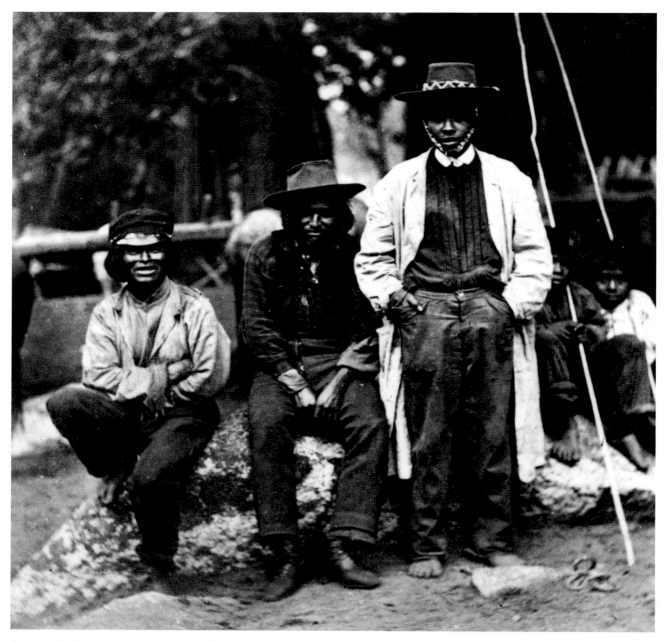

Among the first people in the present-day Lake Tahoe area were the Paiute Indians. They lived as hunter-gatherers, hunting the lands and fishing the lakes of northern California. Theirs was a peaceful culture that excelled at the craft of basket weaving. Explorer Jedediah Smith was an early friend of the tribe. In 1889, Wovoka, a Paiute shaman, introduced the Ghost Dance, a ritual he believed would return the buffalo and rid the land of whites.

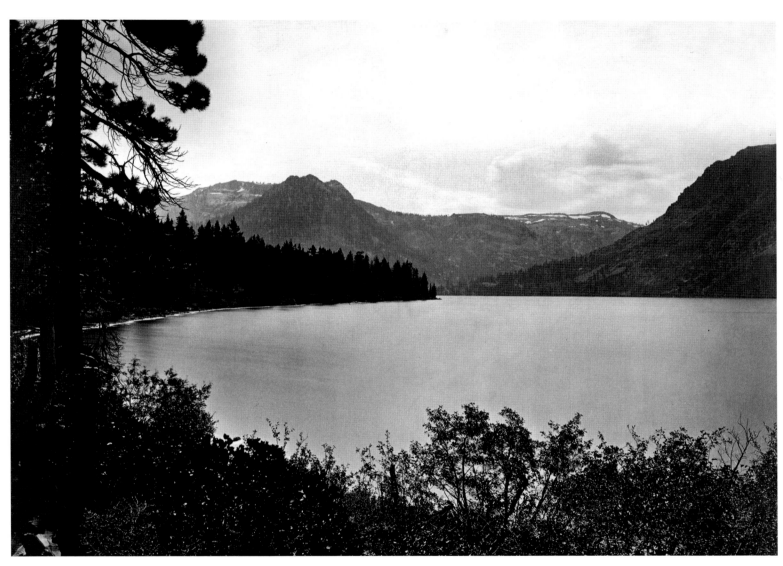

Close to Lake Tahoe and the California-Nevada border, Fallen Leaf Lake was created by glaciers traveling down the Glen Alpine Valley. The lake's water quality is so excellent that at the northern shore, the lake's bottom can be seen from the surface one-quarter mile offshore.

Yosemite's famous Half Dome is reflected in the surface of aptly named Mirror Lake. Although the lake has little water most of the year, it grows to lake status in spring and early summer, returning to more of a meadow for the remaining seasons. When deepest, its calm surface offers beautiful reflections of the surrounding granite cliffs.

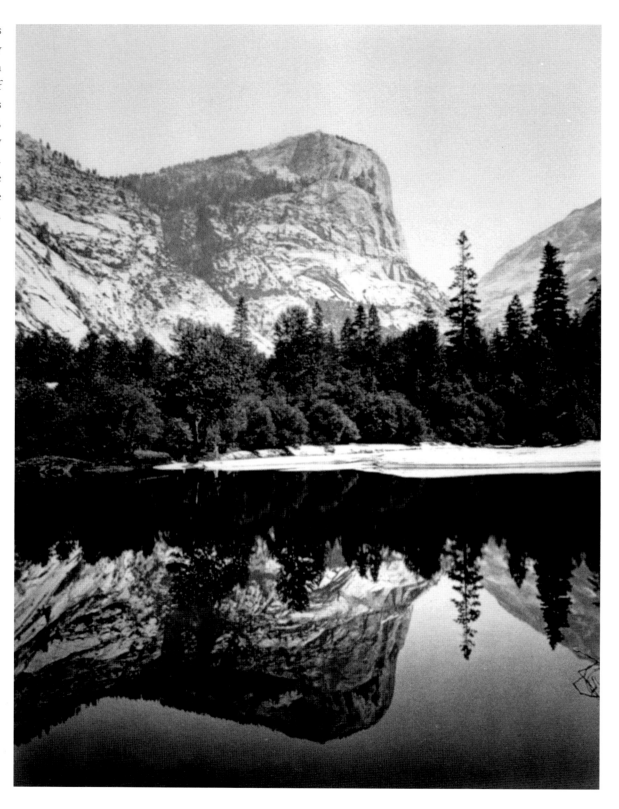

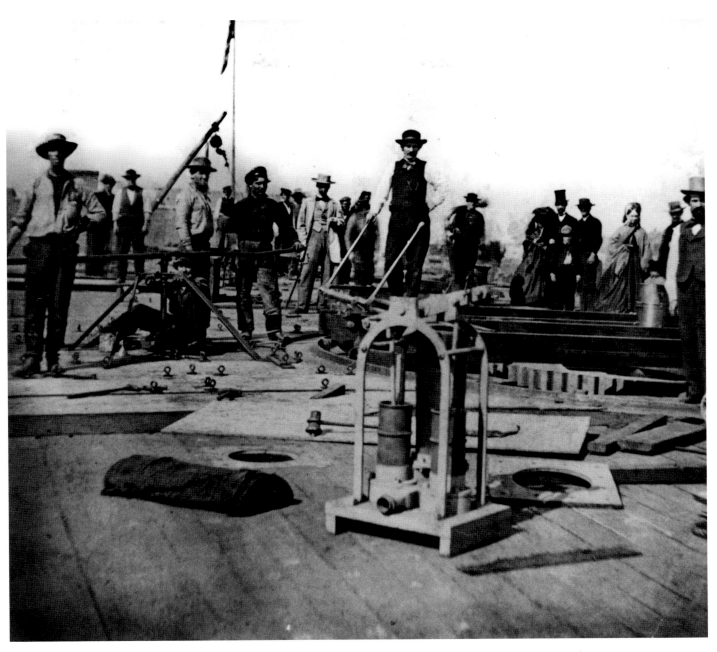

The single-turreted Passaic Class Monitor battleship USS *Camanche* was built in 1863 in New Jersey. Later that same year, she was dismantled and shipped to California on board the *Aquila,* which sank in San Francisco Harbor. Salvaged from the *Aquila,* the *Camanche* was rebuilt and finally commissioned in 1865. For most of her career, she served as a training ship for the California Naval Militia.

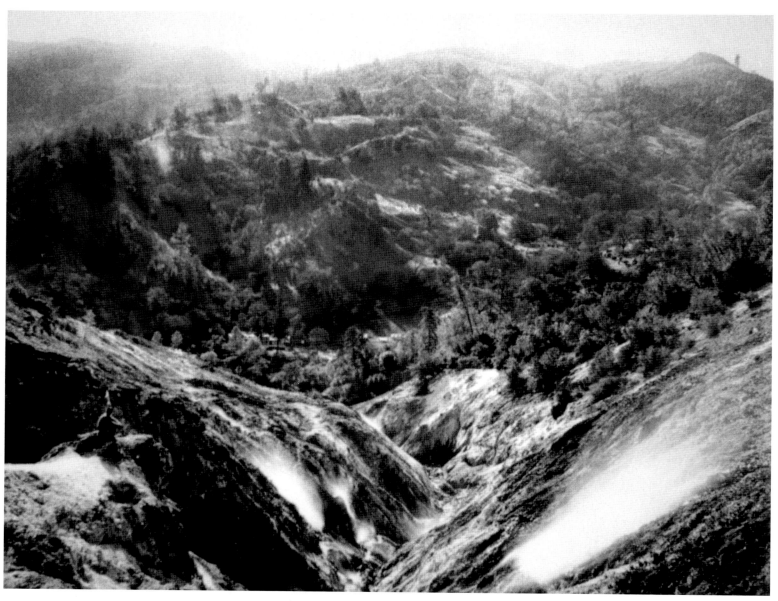

During the mid–nineteenth century, tourists visited the steaming geysers and hot springs of Devil's Canyon on Geyser Peak, located near what is now the town of Calistoga. Helen Hunt Jackson, author of *Ramona,* wrote of her trip to the Geysers, commenting on the "hissing and fizzing of the steam and boiling and bubbling of the water."

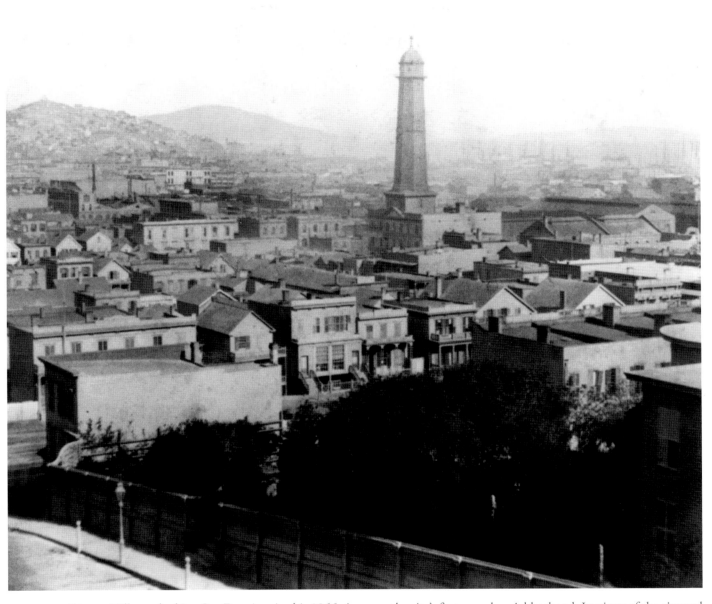

Rincon Hill, overlooking San Francisco in this 1866 view, was the city's first upscale neighborhood. Its views of the city and bay were unparalleled, and its fashionable homes far removed from the brothels and saloons of the city. Although most of the homes survived the great earthquake of 1906, they did not escape the resulting fire, which left only the brick chimneys.

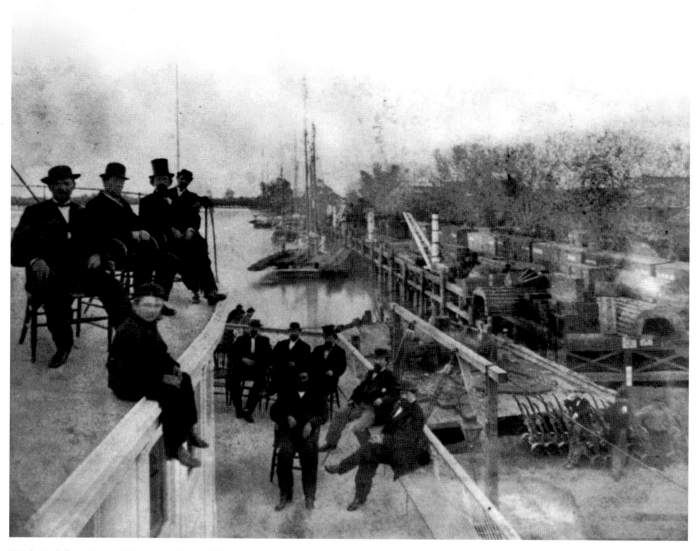

With California's rapid post–gold rush boom, Sacramento became a major shipping center for northern and central California. In the mid-1860s, supplies were sent to Central Pacific Railroad crews who were building the Transcontinental Railroad's eastward tracks. When the CPRR first began operation, its biggest building was a tool house on the levee, used as the first ticket office.

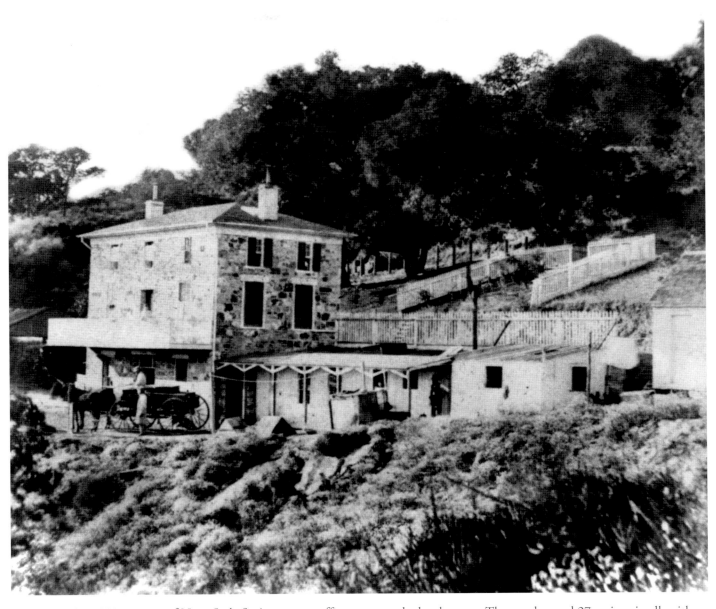

An 1899 account of Napa Soda Springs was as effervescent as the local waters. The area boasted 27 springs in all, with an average daily flow of 4,000 gallons. The main spring, named the Pagoda, was the source of the commercially bottled Napa soda. The bottling house is shown in this 1866 view. Napa soda water was sold in "every city and town on the coast" and was considered an effective aid to digestion.

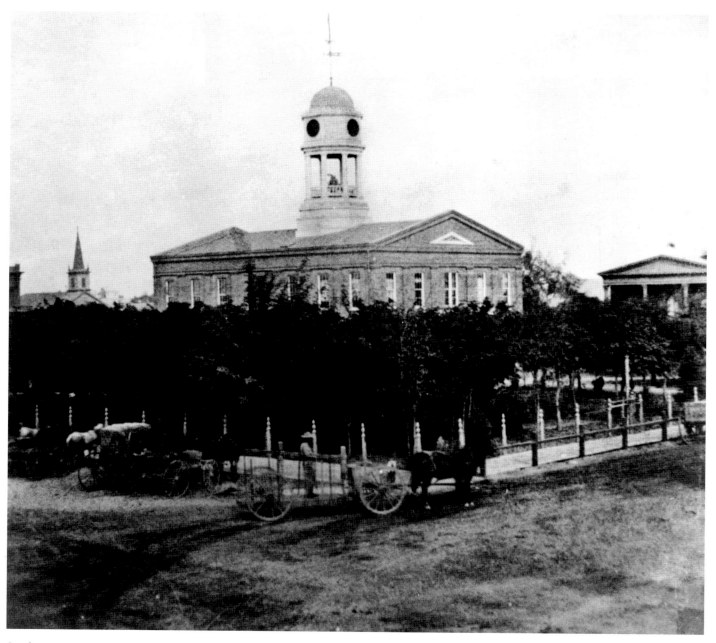

Stockton can trace its origins to Charles Weber, a German immigrant who purchased 49,000 acres through a Spanish land grant after discovering he could profit more from meeting the needs of gold miners than being a gold miner. The city takes its name from Commodore Robert F. Stockton, who participated in the Mexican-American War for domination of California. Stockton went on to become a gold rush supply center.

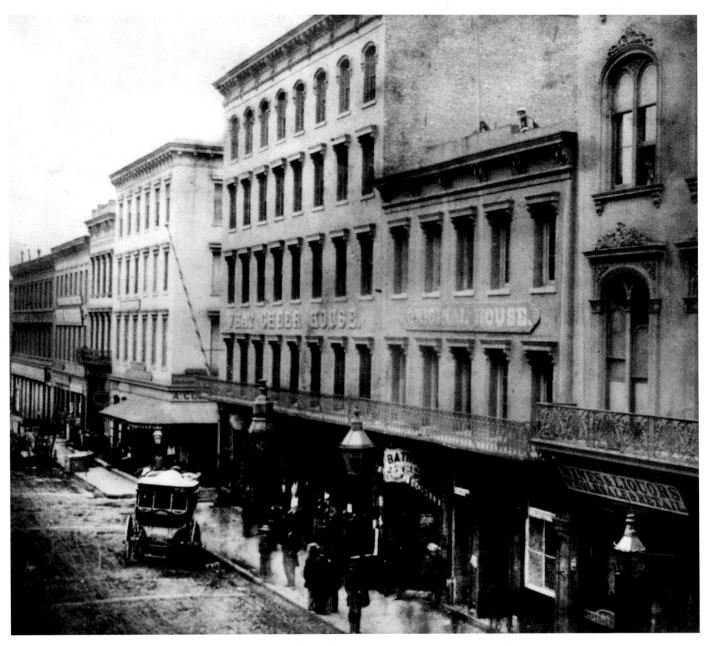

Constructed as a hotel in 1853, Sacramento's What Cheer House was the brainchild of Robert Woodward, a forty-niner who struck it rich in the gold fields. Understanding the needs of the growing city, he opened a hotel and club for men. The What Cheer House provided clean, safe rooms, good food, and non-alcoholic beverages to permanent residents as well as travelers. Woodward went on to become a leader in San Francisco's museum and gallery society.

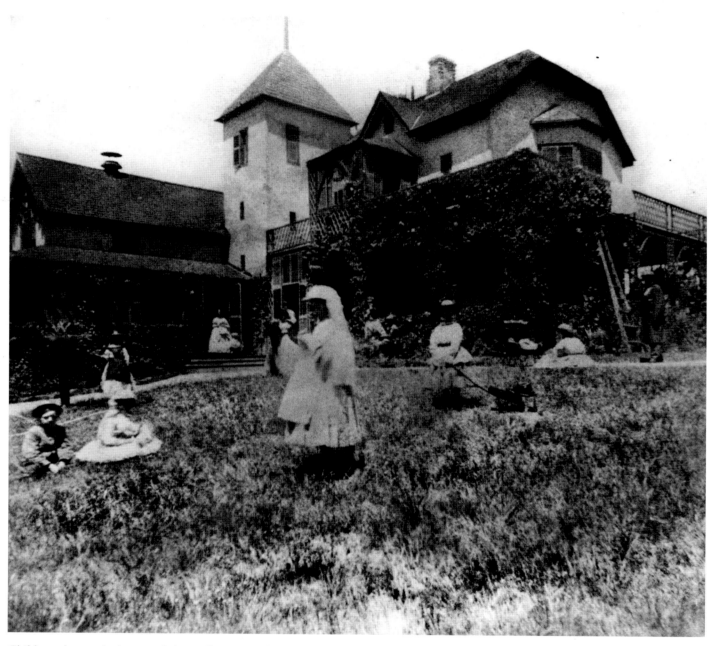

Children play on the lawn at Oak Knoll, an agricultural estate formed by New England native Joseph Osborne. Osborne established Oak Knoll on a 1,100-acre tract he acquired in the Napa Valley in 1851, where he planted over 6,000 grapevines. Five years later at the State Fair in San Jose, he was awarded the medal for the best-cultivated farm in California. Osborne is credited with bringing the Zinfandel to the Sonoma Valley.

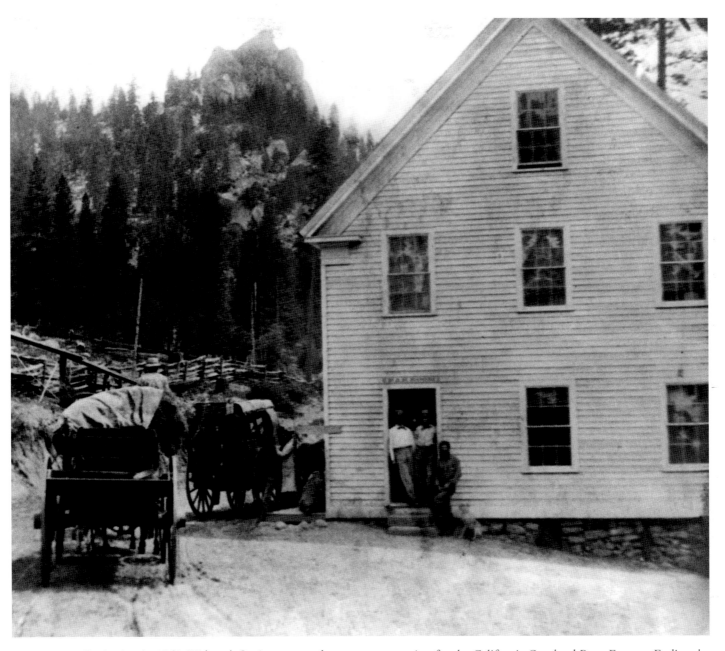

Beginning in 1860, Webster's Station was used as a remount station for the California Overland Pony Express. Earlier, the station was a popular stopping place during the Comstock Silver Rush. Located on the Placerville Carson Road, the station was also called Webster's Sugar Loaf House, a name attributed to a nearby mountain of the same name. The station operated as a stop on the stage line until the late 1860s.

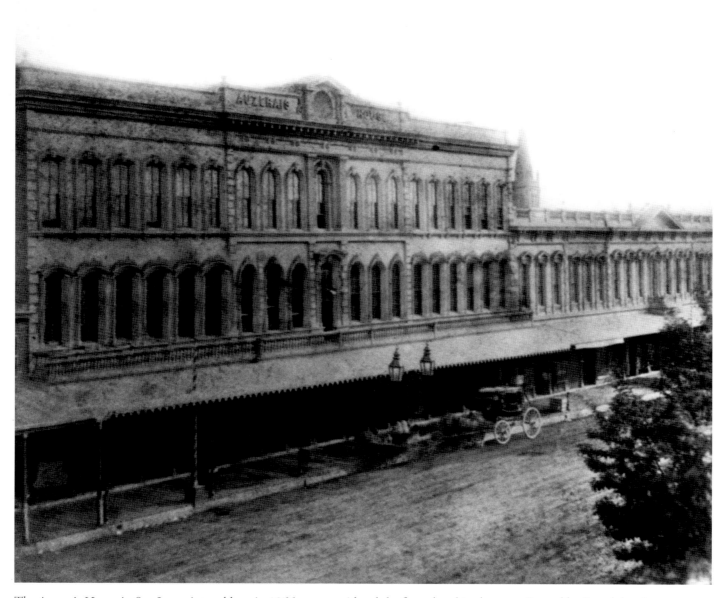

The Auzerais House in San Jose, pictured here in 1866, was considered the finest hotel in the state. Owned by French brothers John and Edward Auzerais, the hotel was designed by architect Jacob Lenzen and constructed of marble and brick. The hotel cost $100,000 to build and $50,000 to furnish, with its black walnut marble-top furniture imported from Paris. Presidents Grant and Hayes stopped at Auzerais House as did General William Sherman.

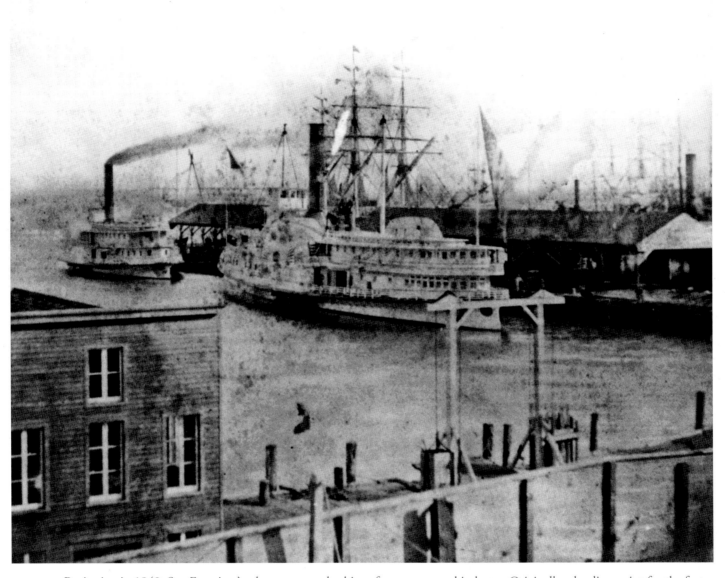

Beginning in 1849, San Francisco's wharves were a beehive of commerce and industry. Originally a landing point for the forty-niners, the wharves quickly developed into small cities lining the waterfront. The owners of each wharf charged huge tolls on passengers and cargo, including up to $200 a day for anchorage. Shown in this 1866 view is the Broadway Wharf, located between Front and Davis streets and completed in 1851.

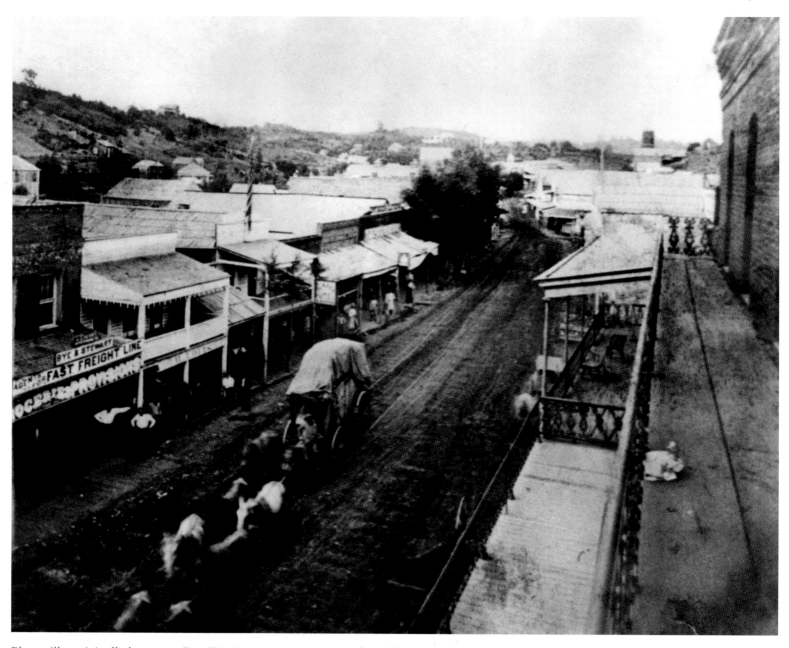

Placerville, originally known as Dry Diggins, was a nerve center for gold mining operations in the Mother Lode. At one time, Placerville was the third largest city in California, home to banks, dry goods stores, and the Cary House Hotel, from which this 1866 image was captured. The hotel, built in 1857 and considered the most magnificent in gold country, sported 77 rooms and a bathroom on each floor with hot and cold running water.

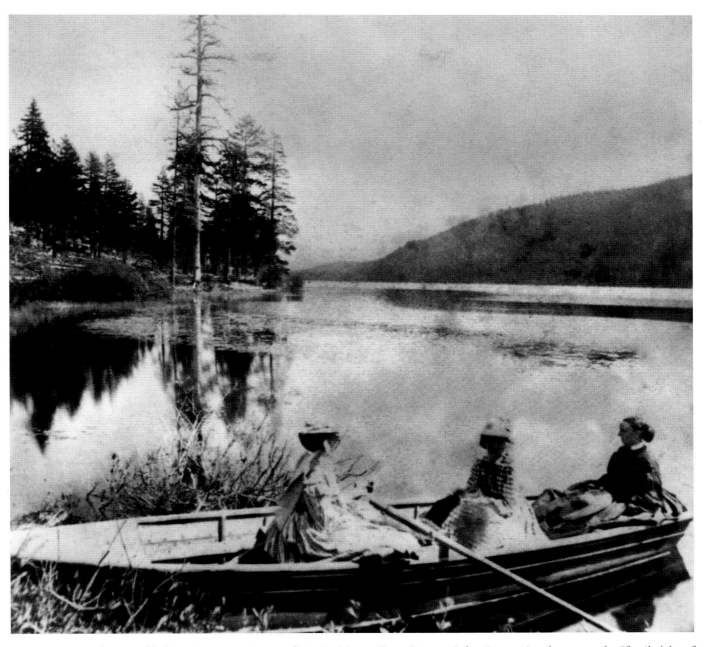

A gathering of ladies enjoys a rowing expedition in Mirror Cove, Donner Lake. At one time known as the "family lake of the mountains" due to its safe rowing and sailing, Donner was bordered at each end by meadowland, pine, willow, and quaking aspen. A favorite destination for artists, Donner Lake was the subject of renowned landscape artist Albert Bierstadt in 1872.

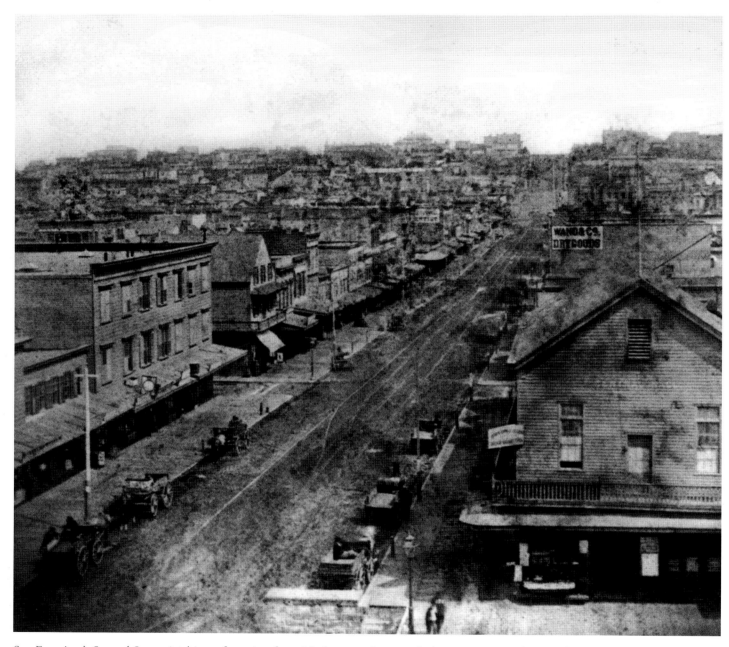

San Francisco's Second Street, in this rooftop view from Market, was the central player in a street scheme called the Second Street Cut. The plan was to cut down Second Street through fashionable Rincon Hill to a grade that heavy teams could pass over, allowing a business district to spring up at the southern end of the street. The scheme was a disaster and ruined the beauty of Rincon Hill, with the Second Street Cut becoming a hang-out for thieves and muggers.

This gold miner's cabin, located in the Sierra Nevada, was far better lodging than the majority of those in the mining camps. Most of the miners lived in tents or decrepit shacks, where disease ran rampant and death came often. Some would-be miners such as Henry Crandall soon realized that the "ounce-a-day" that once seemed like a fortune would barely cover the cost of provisions in gold-crazy California.

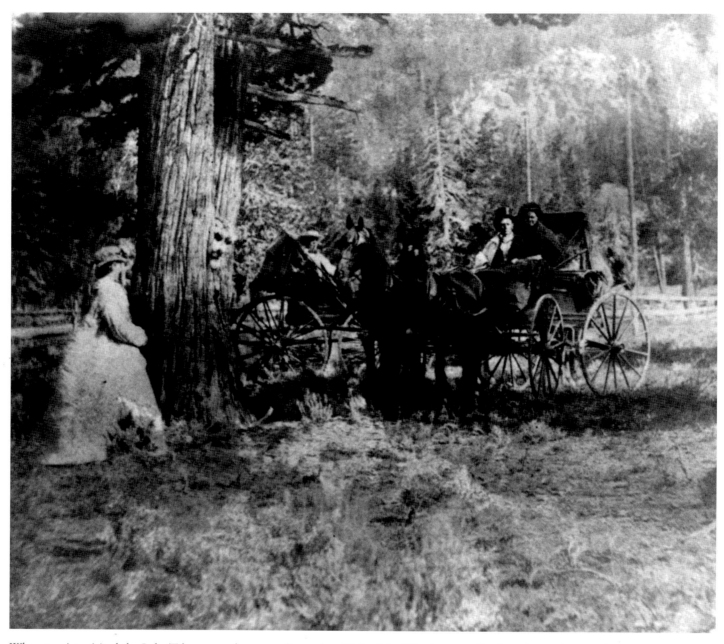

When tourists visited the Lake Tahoe area, they were directed to Nick of the Woods, a peculiar knot in a cedar tree that resembled a goblin's face. The parties pictured here around 1866 probably drove their horse and buggy from nearby Yank's Station, the present-day town of Meyers.

CIVILIZATION COMES WEST

(1870–1889)

By 1870, San Francisco was the tenth-largest city in the United States. In the following two decades, the population, previously centered in gold country, began to grow in the south. San Diego, home of the first of Father Serra's missions, grew from a population of 2,300 to 40,000. Flying legend John Montgomery piloted a heavier-than-air craft, a glider dropped from a balloon 600 feet over the city, and novelist Helen Hunt Jackson introduced the world to Southern California via her love story, *Ramona*. By the mid-1880s, the Transcontinental Railroad had reached San Diego, electric lights were installed, a ferry system established, and a transit system put into operation in the city.

During the same time period, the Central Pacific completed its line between San Francisco and Los Angeles, contributing to tremendous expansion and economic growth in the City of Angels. In just two decades, Los Angeles grew from 5,000 to 50,000.

Meanwhile, coastal towns such as Santa Barbara and Santa Monica attracted visitors seeking a respite from the cold weather in the east. Grand hotels were built along the length of the state, while California ports grew in prominence as shipping centers for both goods and passengers.

In Palo Alto, Leland Stanford, one-time governor of California, broke ground for Stanford University on the land he had purchased for his horse farm. In the mountains outside San Jose, construction was completed on Lick Observatory, the world's first permanently occupied mountaintop observatory.

In 1880, Senator George Hearst acquired the *San Francisco Examiner* in payment for a gambling debt and then turned it over to his son, William, who used the *Examiner* to build a publishing empire.

California's growth wasn't always so sunny; the 1870s and 1880s saw a wave of anti-Chinese sentiment, even though Chinese immigrant labor had built the railroads and worked the mines. In 1871, a mob attacked Los Angeles Chinatown, lynching 18 men and boys. Then, in 1882, Congress passed the Chinese Exclusion Act, barring all Chinese immigration. This law would remain in the books for 60 years.

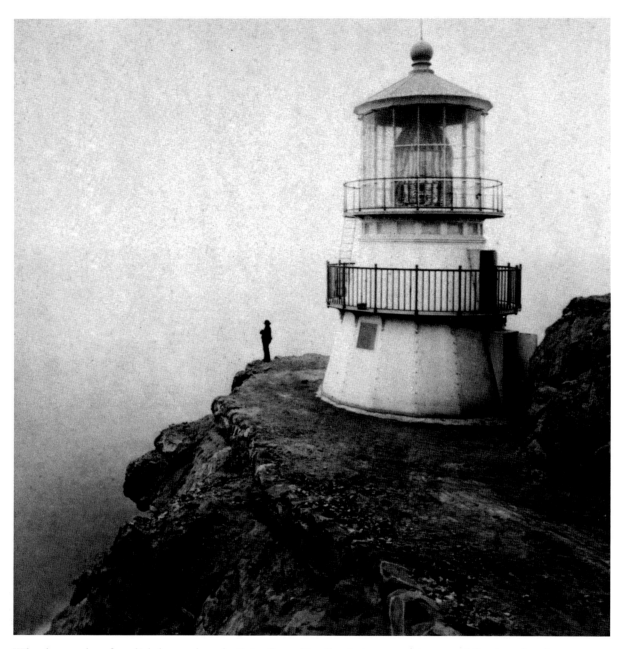

What better place for a lighthouse than the Point Reyes Headlands, known as the second-foggiest place in North America. Built in 1870, about the time this photograph was taken, the lighthouse was in service for more than 100 years before retiring in 1975. Its 6,000-pound French Fresnel lens has 24 vertical panels and a counterweight and gears much like those found in a grandfather clock.

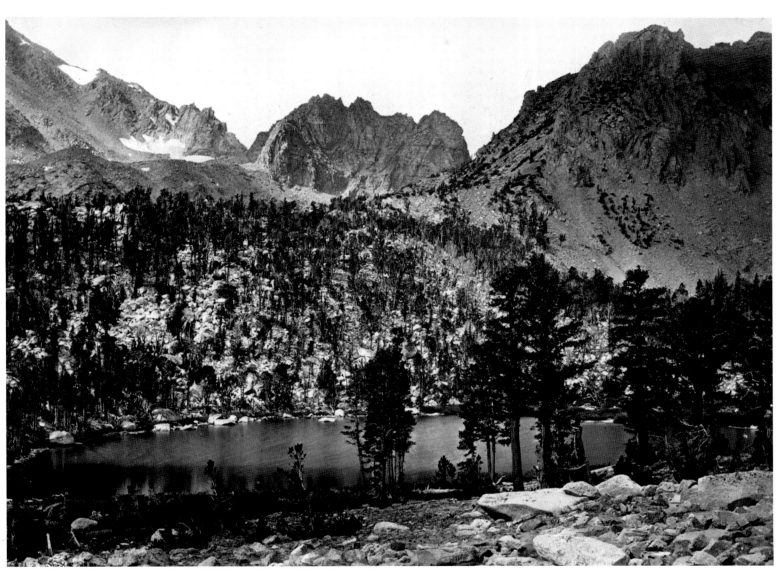

Alpine lakes, such as the one pictured in this 1871 photograph, abound in the High Sierras at altitudes above 8,000 feet or at the tree line. After the mountains were formed, glaciers shaped the landscape, creating the lakes. According to geologists, there were many glacial periods in the Sierra Nevada during the Pleistocene era.

Death Valley was aptly named by the prospectors who crossed this stretch of desolate landscape on their way to the gold rush. Despite extreme temperatures, ranging from a high of 134 degrees Fahrenheit to below freezing, gold, silver, and borax were all successfully mined here. Death Valley, at the lowest elevation in America, was part of an 1871 survey west of the 100th meridian led by Lieutenant George Wheeler.

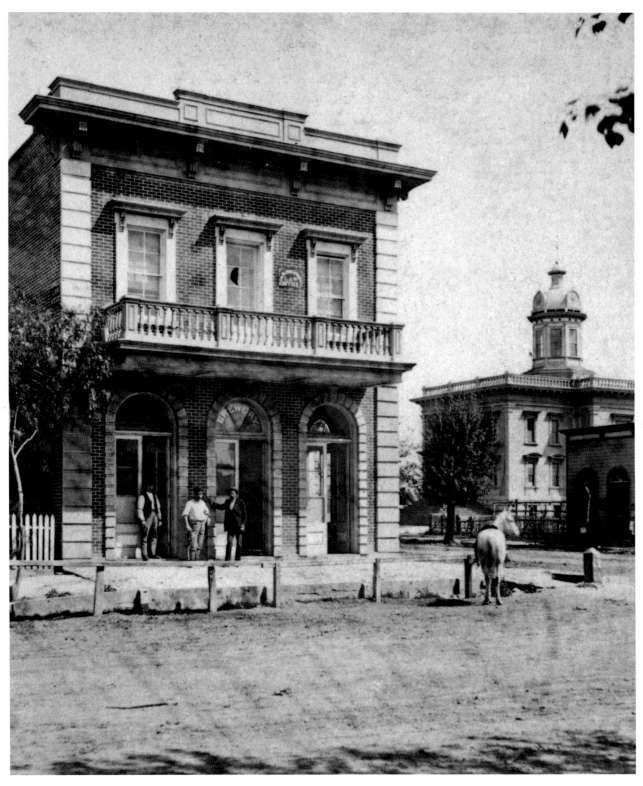

This early San Bernardino brewery was probably the one built by John Andreson, a Danish immigrant who spent much of his early days as a seafarer exploring the wilds of South America. Andreson later ran boats up the Sacramento River, then opened a grocery store in San Francisco. Not content to live a sedentary life, Andreson moved to San Bernardino, where he opened a small brewery that eventually produced up to 30 barrels of beer a day.

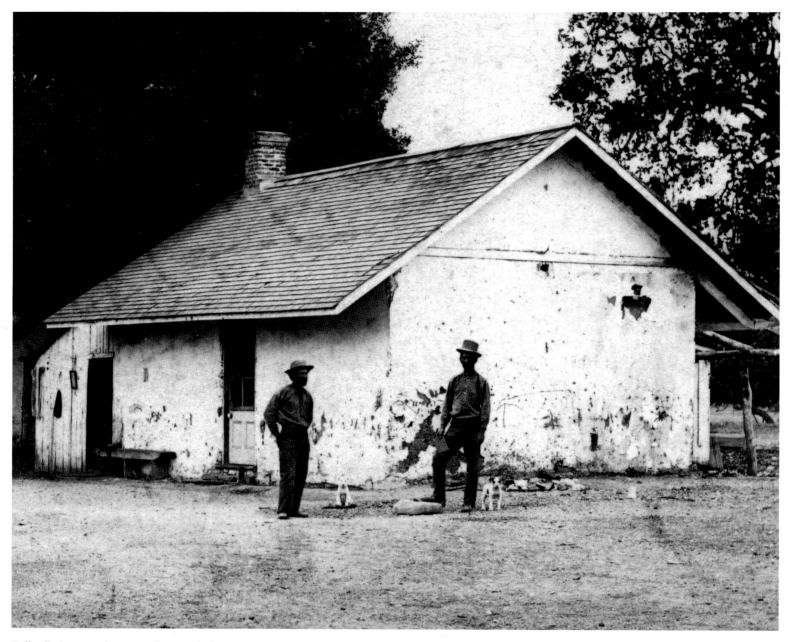

Ballard's Station, shown in this 1874 photograph, was established as a stagecoach stop on the route between Santa Barbara and San Luis Obispo. The adobe structure, which still stands, was built by William Ballard, a longtime agent for the Los Angeles Stage Line. During his tenure, Ballard reportedly made the acquaintance of Wyatt Earp, a hard-working 17-year-old stage driver for the line.

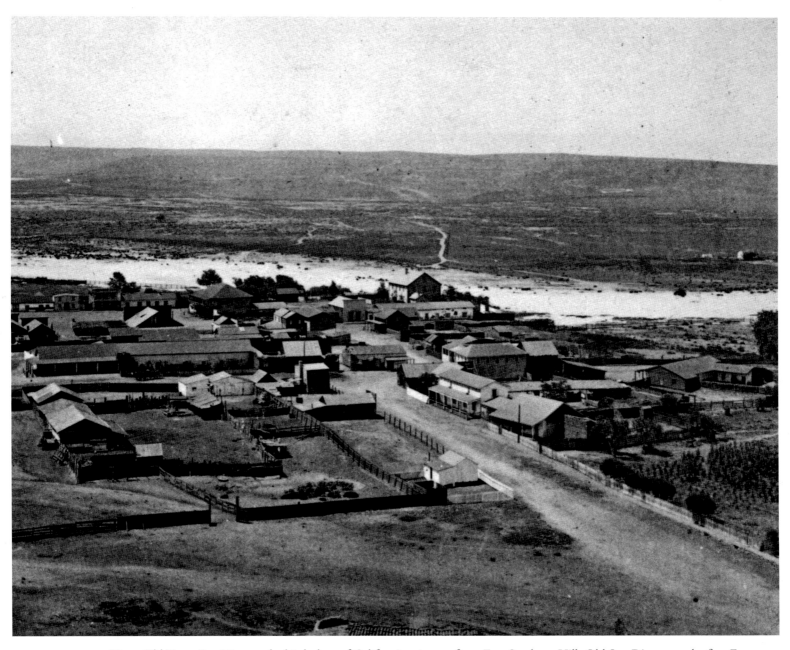

Here, Old Town San Diego—the birthplace of California—is seen from Fort Stockton Hill. Old San Diego was the first European settlement on the West Coast. After the first mission was built on the hill from which this photograph was taken, a small Mexican community was formed with adobe buildings at its base. In 1846, San Diego was captured from the Mexicans, and the first United States flag was raised over the town.

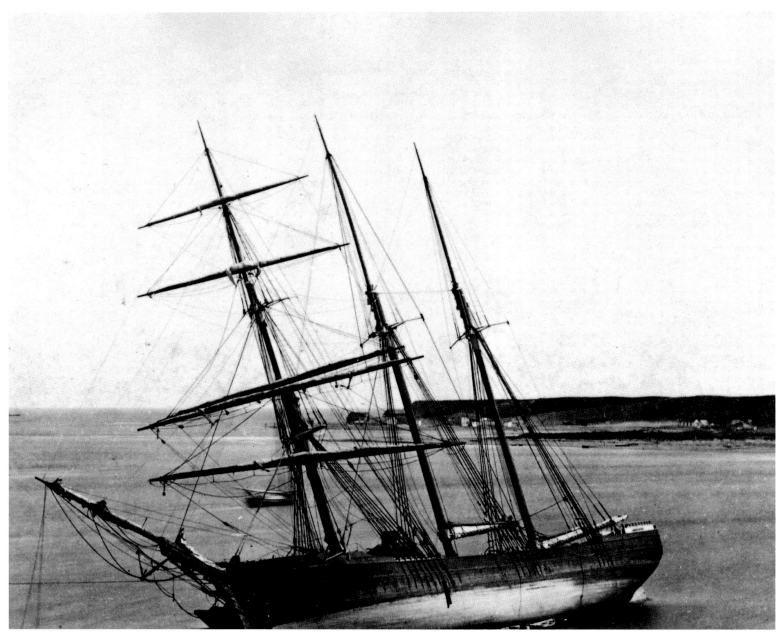

This stereographic image pictures a ship that has run aground in Wilmington Harbor, near Los Angeles. Wilmington, which was part of a 1784 Spanish land grant, was originally known as Banning's Landing. Southern California's first railroad ran from Banning's Landing to Los Angeles. As the oceanside city continued to grow, it was eventually annexed by Los Angeles in 1909.

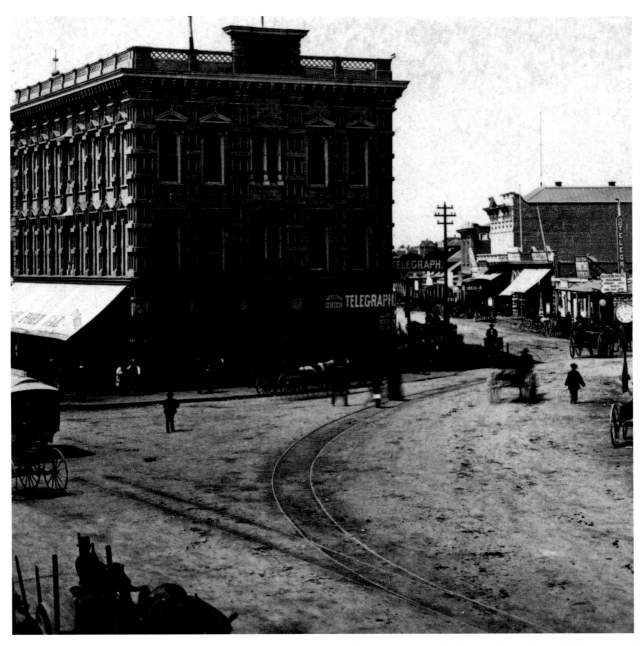

This 1877 photo of the Los Angeles County Bank building, in Temple Block, also shows the Adolph Portugal dry goods store and the Western Union telegraph office. Opposite the county bank stood the Farmers and Merchants Bank. Temple Block was the business center of Los Angeles, with almost all important transactions taking place within a short distance of the area. It seems that Portugal, who is listed on the 1870 census as a 38-year-old Jewish resident from Poland, made an excellent choice in locating his dry goods store here.

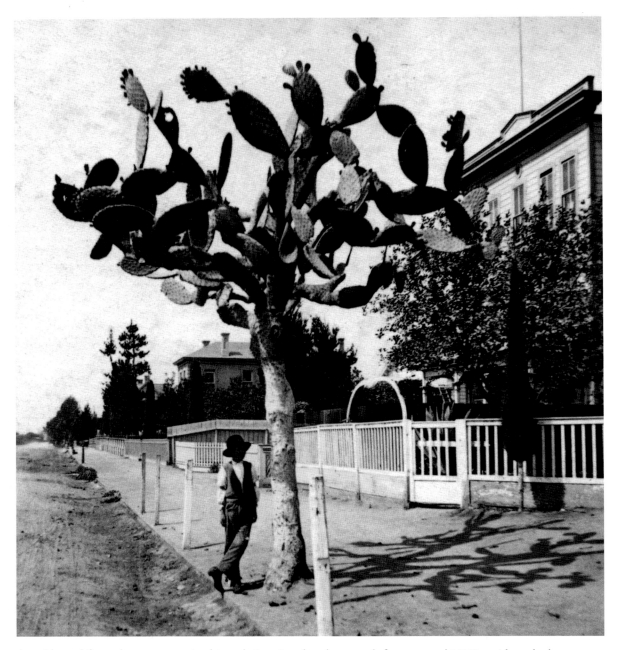

As evidenced from the cactus tree in this early Los Angeles photograph from around 1877, residents had not yet begun the wholesale use of non-native plants in landscaping. Later, trees, shrubbery, and flowers from temperate zones around the world, such as the Mediterranean and Australia, turned the desert of California's southern regions into a year-round blooming paradise.

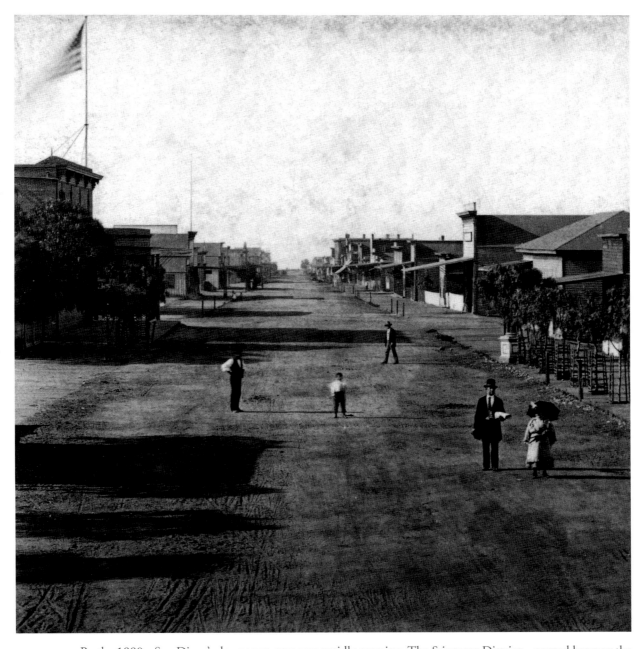

By the 1880s, San Diego's downtown area was rapidly growing. The Stingaree District—named because the sting of the district could be as bad as the sting of the stingrays in Mission Bay—was filled with opium dens, bawdy houses, and gambling halls. One of the area's best-known residents was Wyatt Earp, who came to San Diego after his Tombstone days and invested heavily in local real estate.

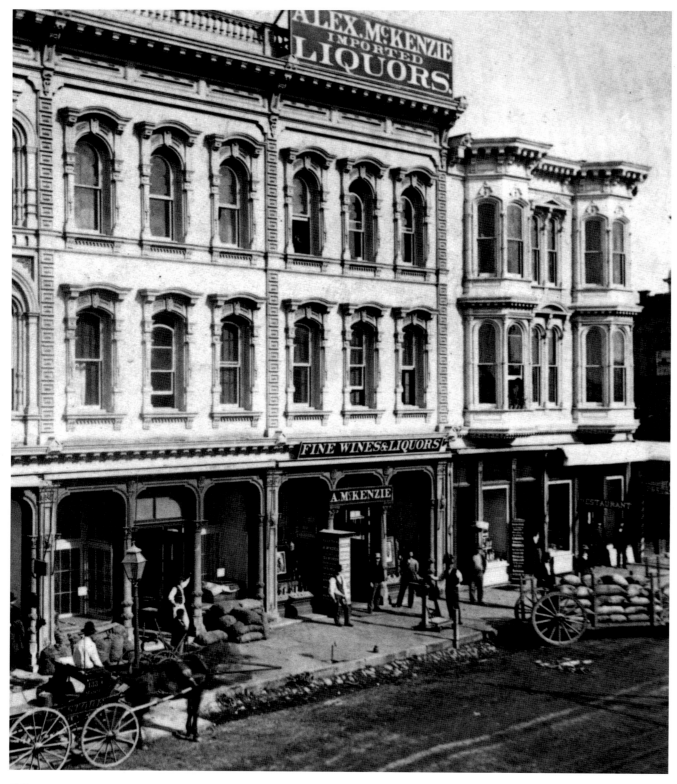

Despite the threat of earthquakes, three-story buildings such as these were built in 1880s Los Angeles. The law offices of Judson, Gillette, and Gibson, located on the second floor of the McDonald Block on Main Street, shown in this photograph, were home to the first organizational meeting of the Los Angeles Athletic Club. The LAAC was the first private club in Los Angeles, with its members drawn from the "best young men" of the Angelenos.

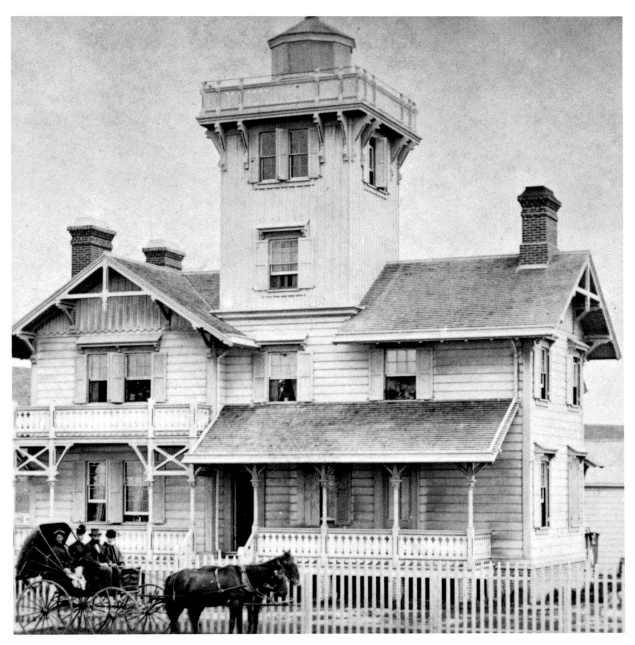

The Point Fermin Lighthouse was the first beacon lighting the way into San Pedro Bay. Local businessmen petitioned the government for a light as early as 1854; however, disputes over land rights and funding delayed construction for 20 years. The lighthouse was designed in the "Stick Style" by Paul J. Pelz, a draftsman for the U.S. Lighthouse Board. Elements of this style included diagonal and crisscrossing brackets, shown here adorning the gabled roof, porch, and balcony.

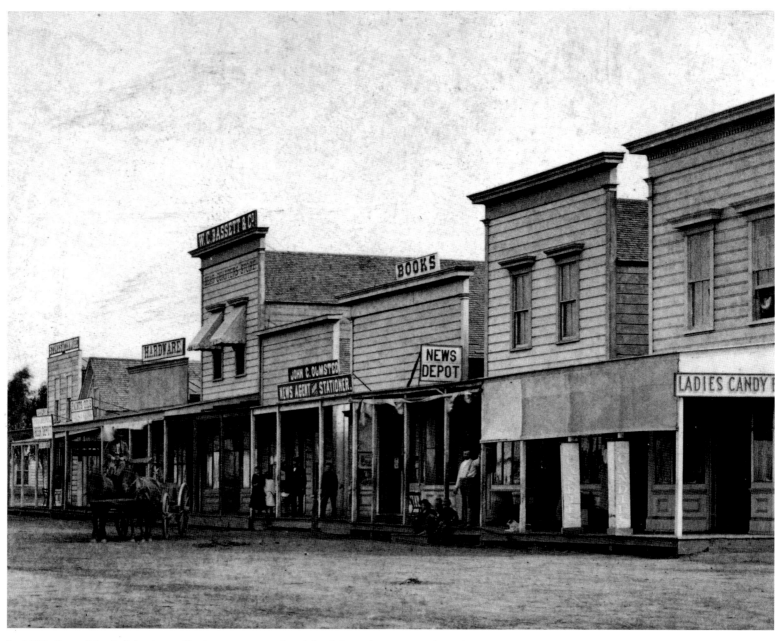

In 1880, Santa Monica's business district was centered on Third Street between Utah and Oregon (now Santa Monica Boulevard). Visible here are S. Wilson Stoves and Tinware, the Ladies Candy Factory, W. C. Bassett and Company, and John C. Olmstead Books. Seven years later, the Arcadia Hotel was built here, and at the time was considered one of the great hotels of the Pacific coast.

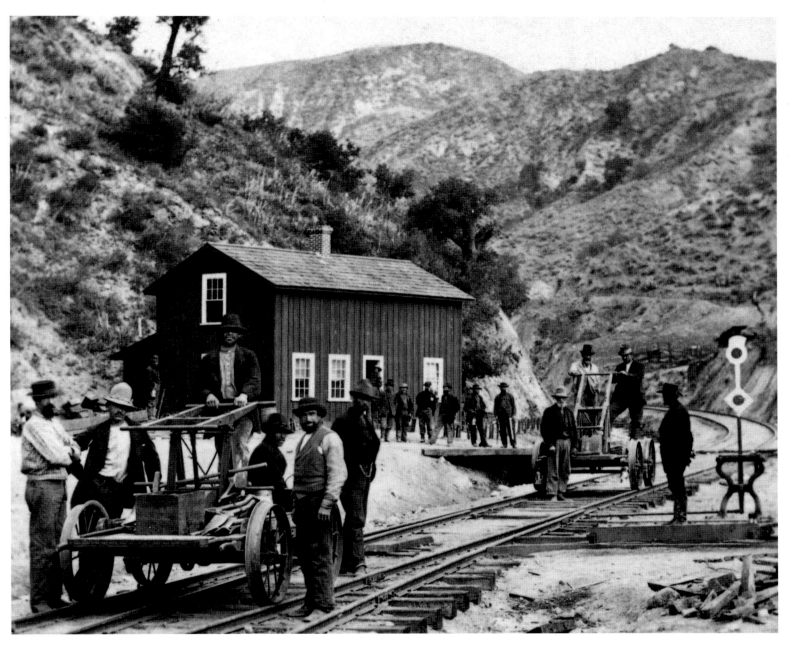

Shown here are railroad crews working for the Southern Pacific Railroad Company in San Gorgonio Pass, the major east-west corridor for rail traffic moving through the San Bernardino Mountains between Los Angeles and points east. During the later years of the nineteenth century, Mexican railroad workers lived in wooden boxcars that had been converted into living quarters. These "campo trains" transported crews from one area to another.

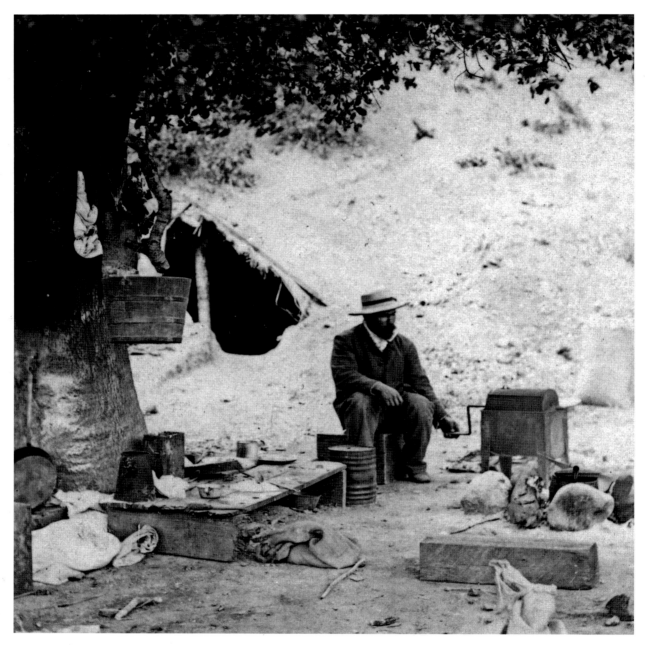

Cook areas, such as this one shown at Andrews Station on the Southern Pacific Railroad line, were tended to by crew members. The station, known at various times as Lyons, Fountains, and Hart's, was located at the south end of the Santa Clarita Valley. The road through San Fernando Pass was a difficult ascent but was navigated by the Butterfield and Overland Stage lines years before the railroad appeared on the scene.

Leland Stanford, founder of the university that bears the family name, had a lifelong interest in fine horses. In 1876, on a trip to the East, he bought several horses for his Palo Alto Stock Farm, seen in this 1881 photograph. Stanford's breeding and training techniques were considered radical by the standards of the day but were validated as when produced some of the world's fastest horses.

The author of an 1800s travel journal marveled at the pleasures afforded by the geyser springs in Sonoma County. Located just west of Pluto's Creek was a small bathhouse with hot springs running through it, along with a stream of pure, cold water. The traveler was at first reluctant to step into the "black liquid" of the hot springs, but after plunging in, declared the effects on her skin were "delightful."

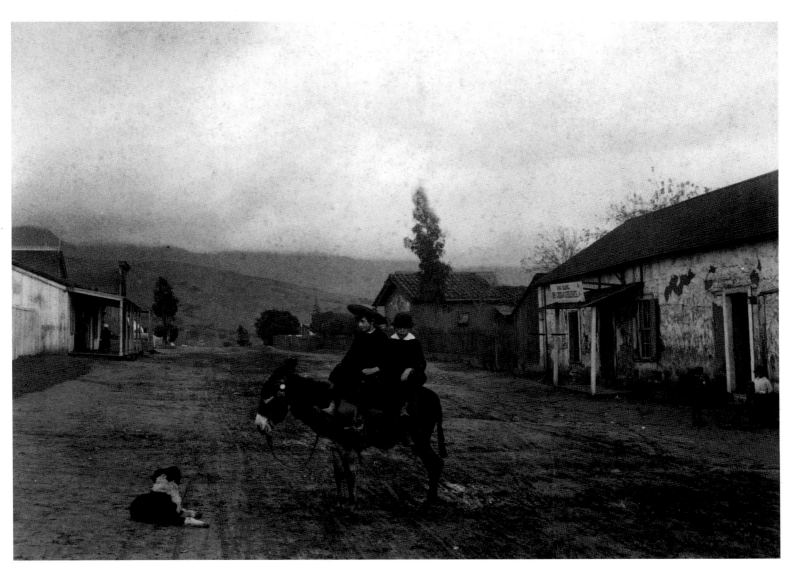

Santa Barbara's Royal Presidio was the last military fortress built by the Spanish along the coast of Alta (upper) California, following the forts in San Diego, San Francisco, and Monterey. Father Junipero Serra, founder of the San Diego Mission, blessed this site in 1782. By 1881, when this photograph of the Spanish Quarters was taken, Santa Barbara had become a tourist mecca for wealthy easterners seeking its temperate Mediterranean climate.

Early California governor Leland Stanford introduced his Palo Alto ranch colts to training at the age of 5 months. By running the colts around the track for 20 minutes a day, then gradually increasing their speed, he produced such legendary trotters as Sunol, Arion, and Electioneer. Following Stanford's death, the sale of the farm and horses helped struggling Stanford University survive.

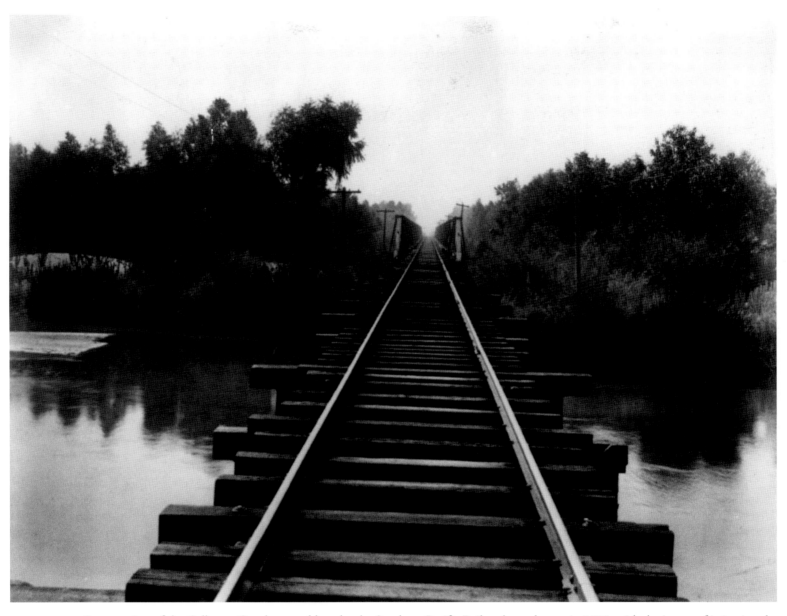

Construction of the Calloway Canal, crossed here by the Southern Pacific Railroad, was begun in 1875, with the intent of irrigating the land between Bakersfield and Poso Creek. A water war, which ended in 1888, broke out because the canal took most of the flow from the Kern River, depriving canals further south from water. Romantic images of the canal were used in a public relations ploy to lure settlers from England.

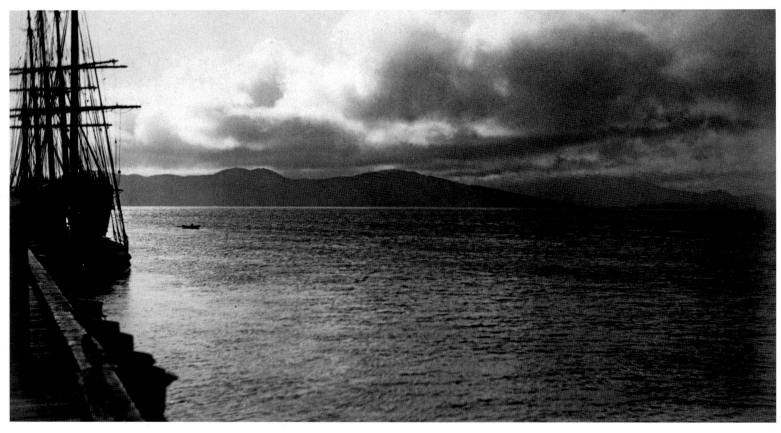

With the beauty of San Francisco Bay as evident in this 1884 photograph, it's a marvel that natives such as Jack London deserted the city for the far reaches of the globe. After London's 1897 trek to the Klondike gold fields, he returned to San Francisco and eventually made his fortune writing stories about his Yukon experiences, best-known among them *The Call of the Wild.*

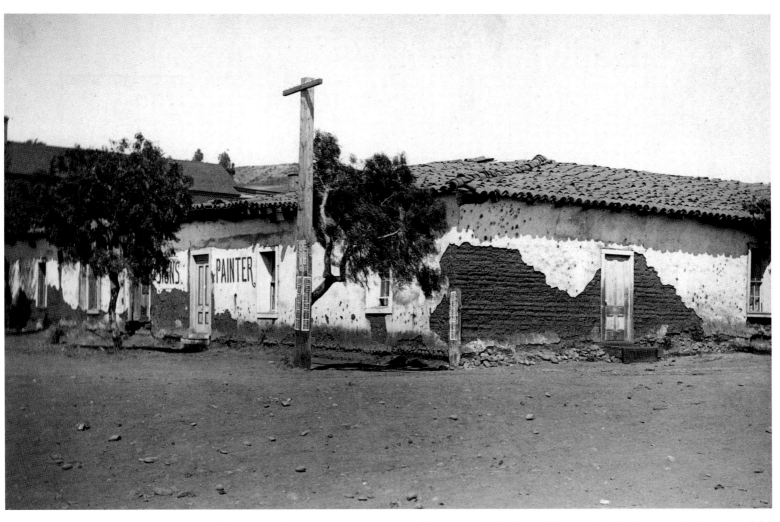

Casa de Estudillo was one of five original houses that are now part of San Diego's Old Town Historic Park. Built around 1827, the adobe structure was the home of Don Jose Antonio Estudillo, commandant of the San Diego Presidio, the first of the Spanish forts along the Pacific coast. Shown in this 1885 photograph, the house's peeling plaster exterior clearly displays the original adobe bricks.

In this view toward San Marcos Pass, the rolling hills and fields around Santa Barbara engender visions of lazy days, warm breezes, and a lifestyle far removed from the bustling cities of the East. During the 1870s, writer Charles Nordhoff promoted the town as a health resort and destination for well-to-do travelers. Once the railroad went through to Los Angeles and later to San Francisco, Santa Barbara quickly grew as a commercial and tourist center.

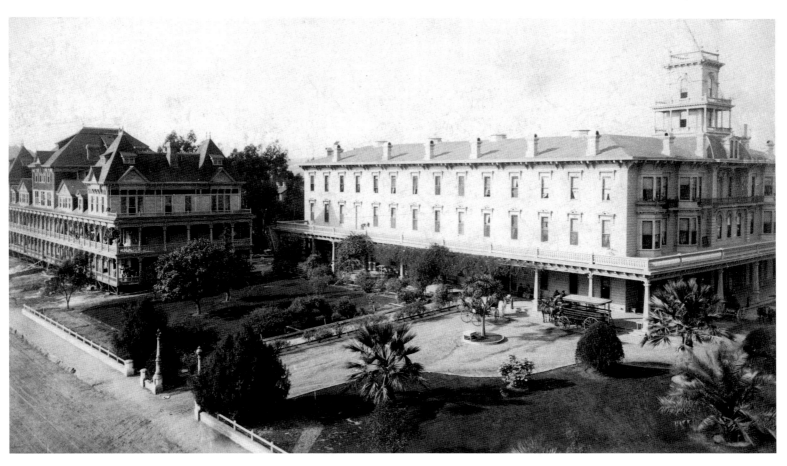

The Arlington Hotel, built in 1875 at 1317 State Street, was Santa Barbara's finest. When author Helen Hunt Jackson came to Santa Barbara to work on her novel *Ramona,* the hotel had no available rooms, forcing Jackson to stay in an unkempt boarding house. Although this event left her with a dislike of the city, the popularity of *Ramona* caused tourists to flock to Mission Santa Barbara.

This one-story adobe, located on South Main Street in Los Angeles, served as the headquarters for General John C. Fremont. In December of 1846, during the Mexican-American War, Fremont captured Santa Barbara and a few weeks later, Los Angeles. Fremont went on to become the military governor of California and the first presidential candidate of a major party to run on an anti-slavery platform.

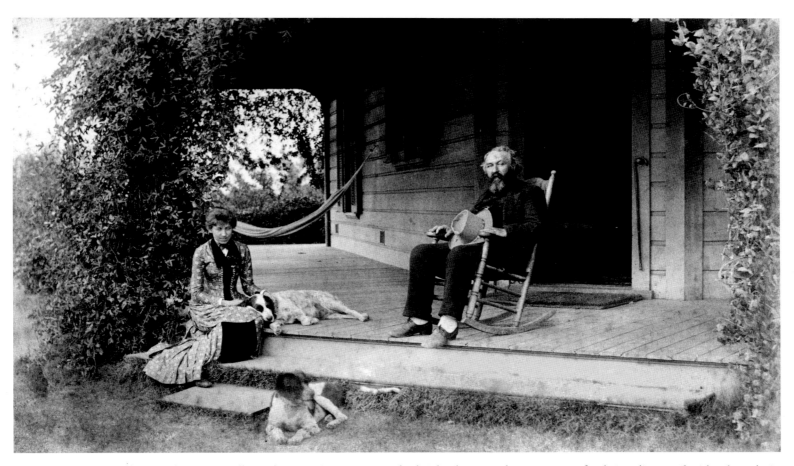

Pasadena resident Grace Ellery Channing Stetson was a Rhode Island native who came west after being diagnosed with tuberculosis. Stetson's writing career began when she edited the memoirs of her grandfather. She went on to write essays that featured infirm easterners who went west and found health and happiness. During World War I, Stetson traveled to France and Italy as a war correspondent. This 1887 photograph shows her at home with her uncle, William O'Connor.

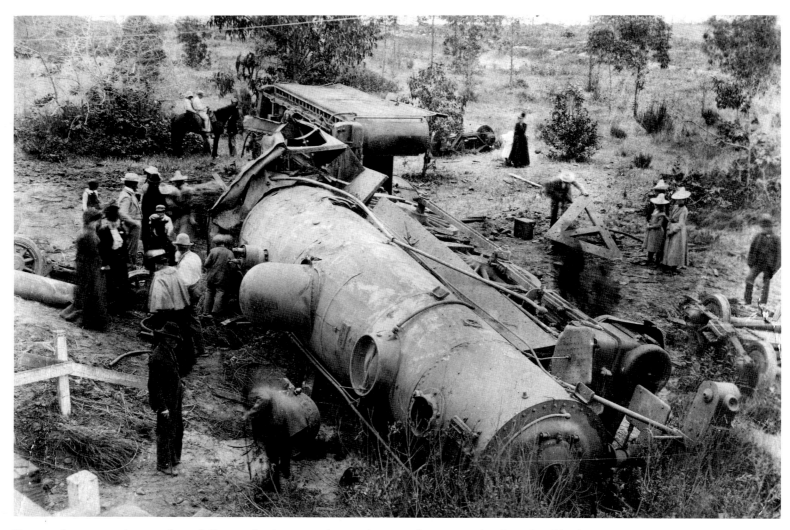

Because the stagecoach route through Summerland was too close to the ocean for train tracks, the railroad built its route up on a nearby ridge. The train like the one pictured in this wreck carried travelers to the spiritualist community built by H. L. Williams when he subdivided part of his Ortega Ranch into lots sold for $25 each. Summerland's name was derived from a popular spiritualist book of that title.

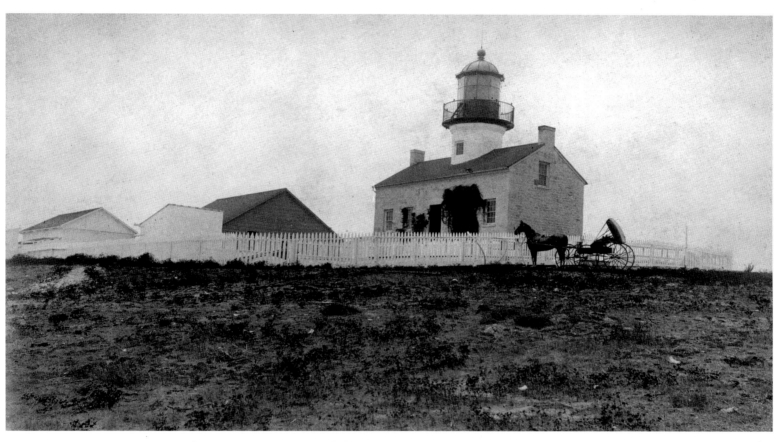

Although the location for San Diego's Point Loma lighthouse seemed ideal—442 feet above sea level—the 1855 structure saw service for only 36 years because fog and low clouds frequently obscured the light. The lighthouse sported the latest in Fresnel lens technology, but it was turned off on March 23, 1891, as the lighthouse keeper moved his family to a new station at the bottom of the hill.

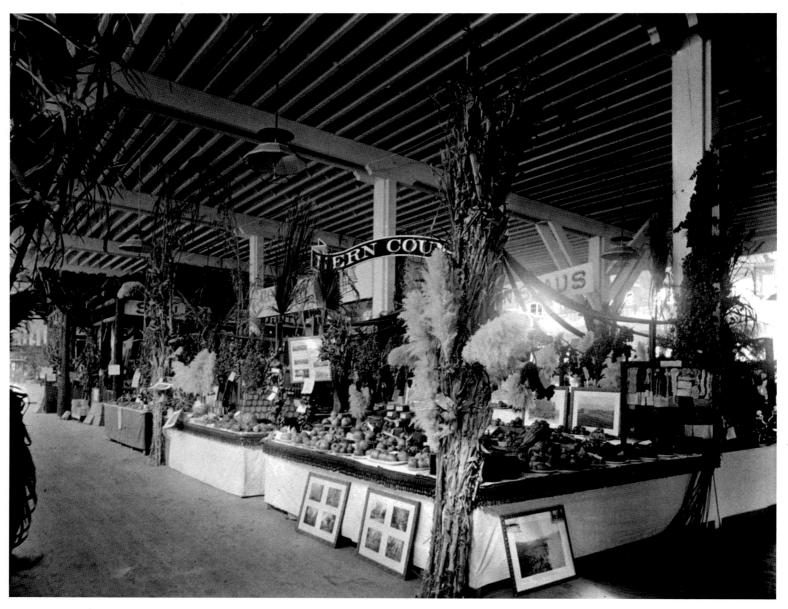

The agricultural products of Kern County were displayed at the 1887 Mechanics' Fair in San Francisco. The fair was held to promote local industry as well as provide a place where inventions and products of all kinds could be brought to the attention of consumers. Winning exhibitors in each of the 45 classifications were presented with awards. The Mechanics' Fair continued from 1857 to 1899.

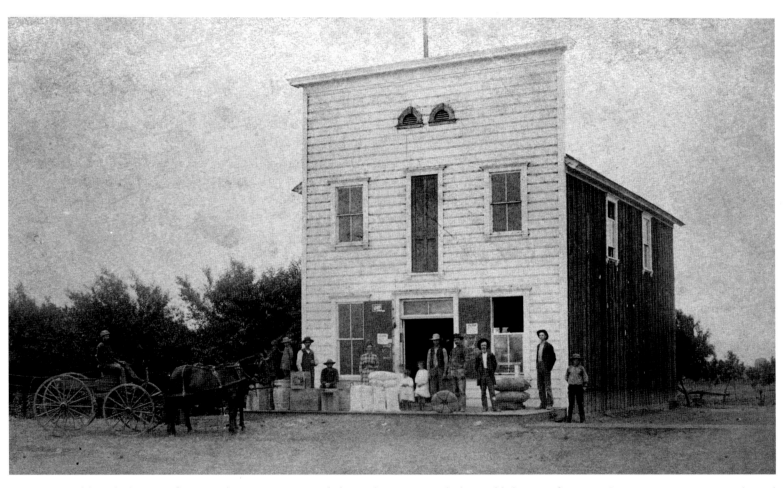

Although the area of present-day Ventura was settled as early as 1782 with the establishment of Mission San Buenaventura, it wasn't until after the Civil War that many pioneers put down roots. The building seen in this 1888 image is thought to be the merchandise store of Philip Haines.

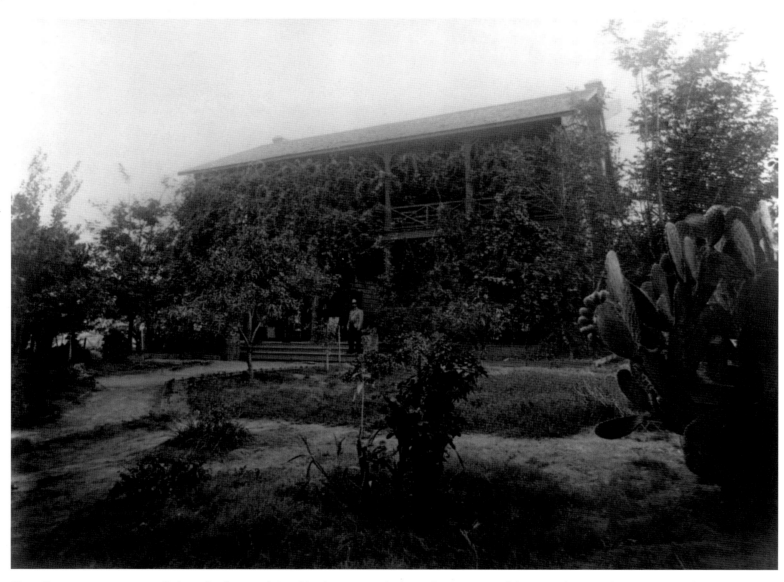

Kern County was once part of a huge land grant claimed by Spain in 1769, but it became part of the United States after the Treaty of Guadalupe Hidalgo, which ended the Mexican-American War. The Pioneer Canal, one of many canals critical to ranchers and farmers, flows through the entire length of the McClung Ranch, which is seen in this 1888 photograph.

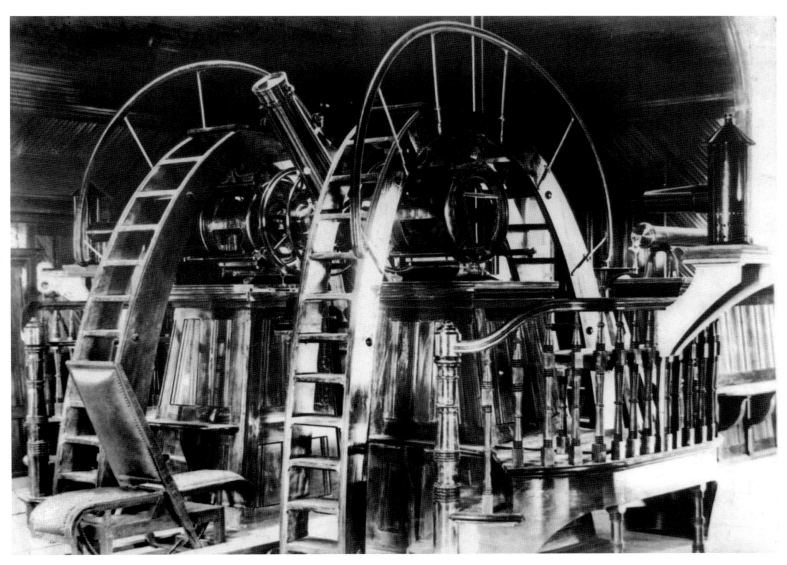

One frigid January night, the Lick Telescope on Mount Hamilton saw its first light. To the dismay of astronomers, the scope wouldn't focus because the tube was too long. However, the tube was immediately shortened with a hacksaw, and the "blazing red sun"—the naked-eye star Aldebaran—came into focus. Since then, the Lick Observatory has continued to be one of the world's foremost research observatories.

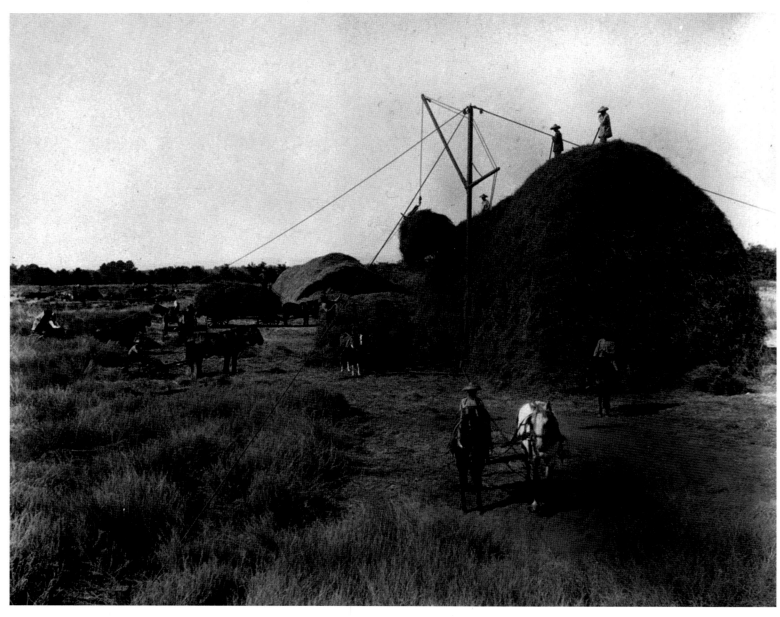

Stacking alfalfa with a derrick was done as early as 1888, as seen in this image taken at the Stockdale Ranch. High stacks such as this one proved that hay could be kept in open fields instead of inside a barn. Although a small amount would be lost to rain damage, the outer layers fell together to create a thatch-roof effect, and the steep sides made it difficult for rain to penetrate the center.

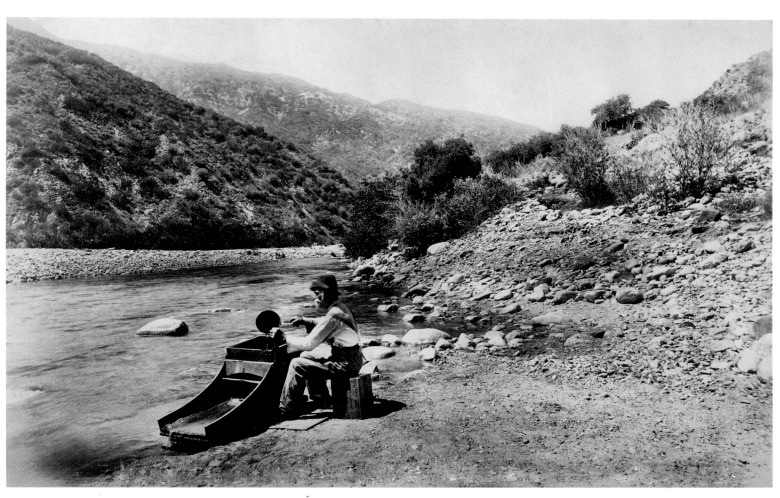

Although the northern California gold rush was long over by the time of this 1890 image, gold was still being mined in Southern California's San Gabriel Canyon. Pictured here in the canyon, an industrious miner is searching for placer gold—the kind that has flowed downstream from its original source, such as a gold vein. The easiest method of removing placer gold was panning or using a sluice box, as this prospector is doing. Placer gold was mined in this area from about 1834 to the early 1900s.

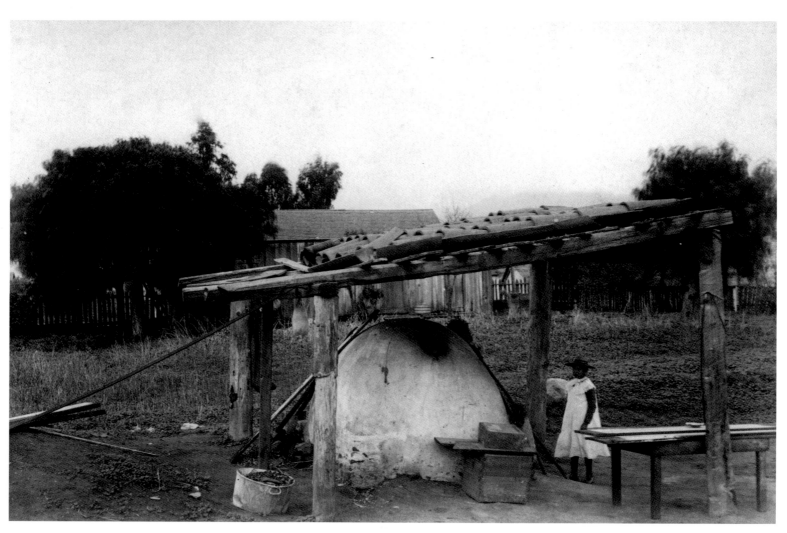

Although the last ten years of the nineteenth century saw the advent of the electric stove, traditional methods of cooking were still in use because the stove was considered unreliable. Here, an adobe oven, called a horno, was used for baking. Hornos were favored by Southwest Native Americans and early settlers of the region. After building up a hot fire, the cook removed the embers and ashes and placed bread in the oven for baking.

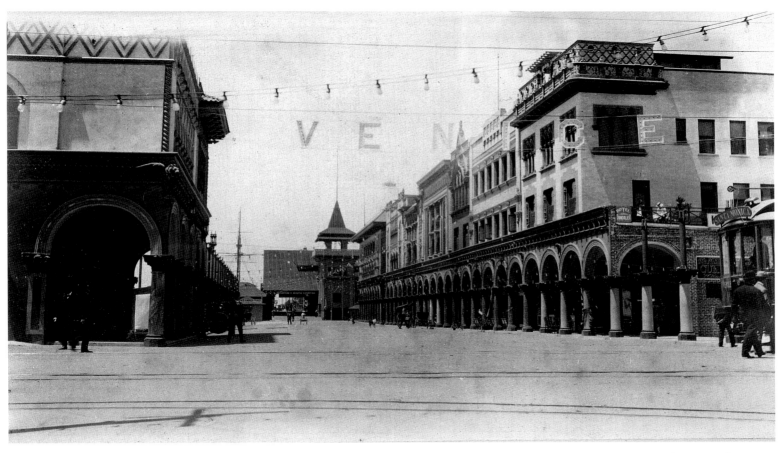

It took the dream of tobacco tycoon Abbot Kinney to turn a marshland west of Los Angeles into what would become known as the Coney Island of the Pacific—Venice. Kinney's plans were to build a resort town reminiscent of Venice, Italy, to include gondolas, canals, Venetian-style architecture, and amusement piers. His dream wasn't realized until 1905—about 15 years after this photo of the Gondolier Hotel was taken.

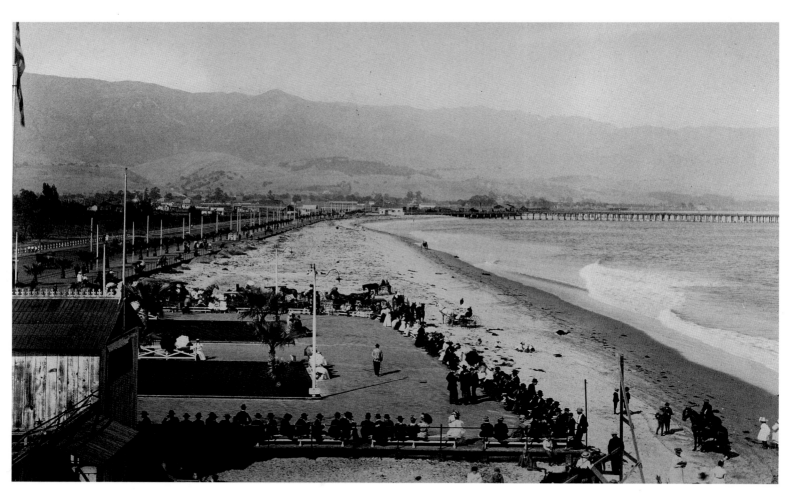

By the late 1800s, Santa Barbara's beaches were a popular destination for both residents and tourists. In this view facing south along palm-tree-lined Eastern Avenue (later called Cabrillo Boulevard) is one of the city's piers. Before Santa Barbara's growth as a fashionable resort town, freighters threw lumber overboard to float ashore with incoming tides. Now, with the advent of the piers, cargo could unload directly to warehouse located along the piers.

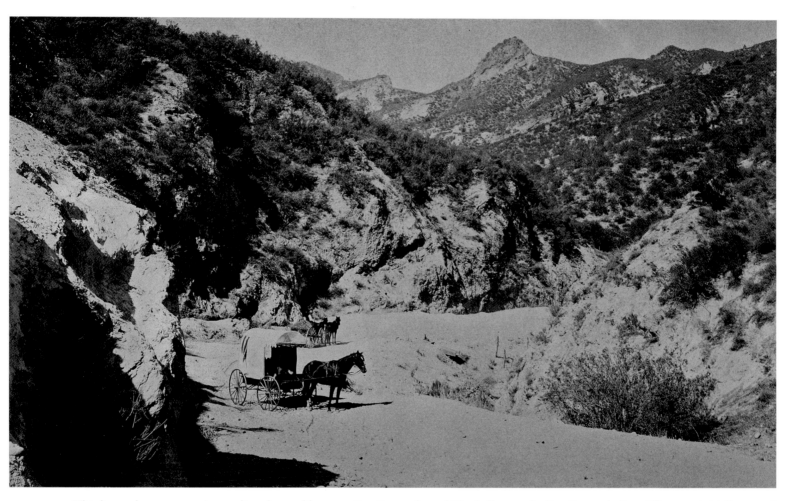

This horse-drawn wagon is traveling the road between San Fernando and Newhall, near the San Fernando Pass. The pass, initially named Fremont for the first military governor of California, was a main entry point into the Los Angeles area and was used by stagecoach lines and the Butterfield Overland Mail. Years after this photograph was shot, filmmakers John Ford and D. W. Griffith used this rugged, chaparral-covered landscape as the locale for at least five movies.

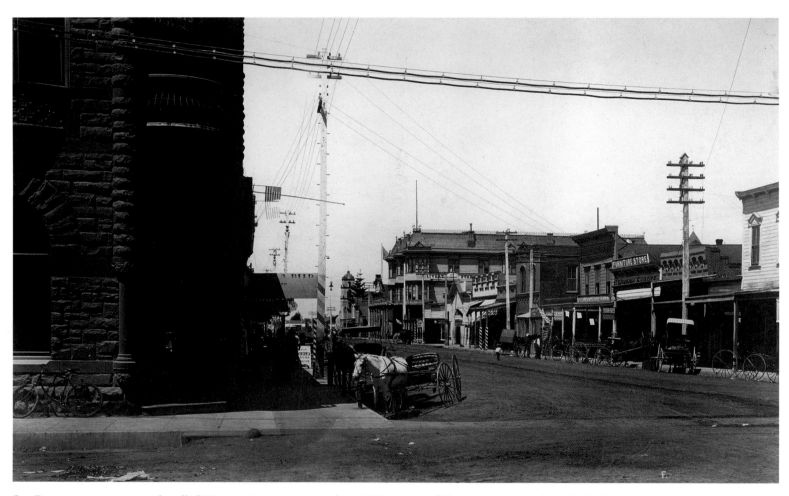

San Buenaventura, commonly called Ventura, was incorporated in 1866, one year following the close of the Civil War. Ventura's growth spurt is attributed to the oil fields drilled here in 1914 and the establishment of the Union Oil Company. Thanks to the luck of geography, the city's placement between the Ventura and Santa Clara rivers makes its soil the best in California for citrus crops. Shown here are businesses on East Main Street around 1890.

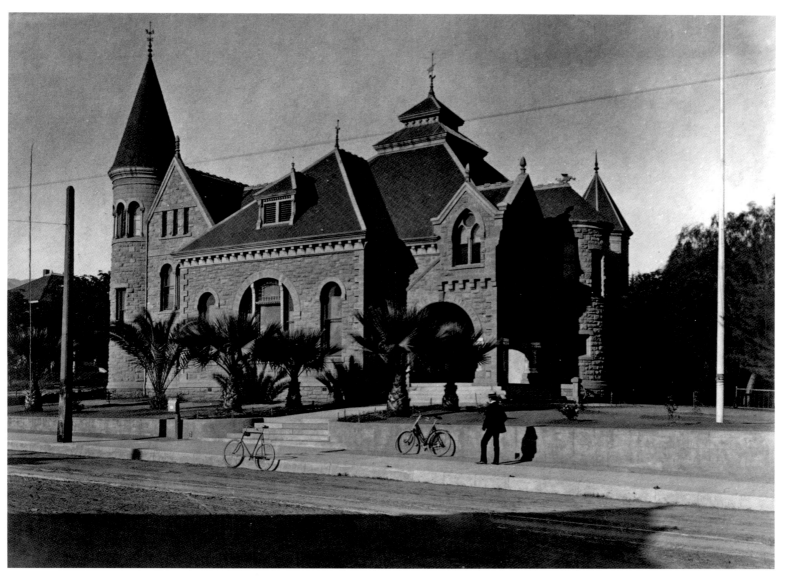

This impressive stone structure was the second building housing the Pasadena Public Library. Opened on September 9, 1890, the library was located on the corner of Walnut Street and Raymond Avenue. Although the library was expanded in 1901, it was still insufficient to house the collection; thus, in 1923, an architectural competition was held to design the third (and current) structure, with architects advised to use a Renaissance style found in the Mediterranean.

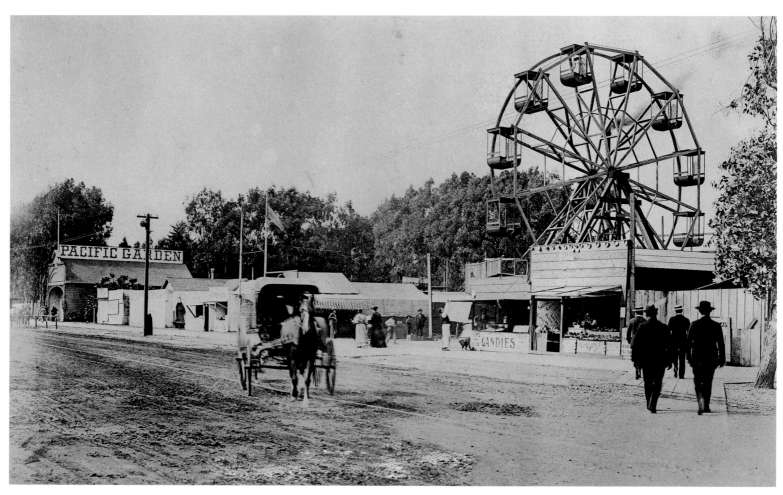

Santa Monica's history is tied to John Percival Jones, a Nevada senator who purchased Rancho Santa Monica in 1874. The following year, the city's layout was planned to include parks and promontories. By the time this 1890 photograph was taken of Ocean Avenue, the city of Santa Monica was incorporated, and Jones's fabulous Miramar mansion was built on a portion of the Avenue.

A Kinder, Gentler California

(1890–1899)

In the decade before the turn of the century, Californians put away half a century of gold fever and emerged as a state focusing on industry and tourism.

In Riverside, a variety of navel orange derived from a Brazilian tree took amazingly well to the semi-arid climate. Within 20 years of planting the first cuttings, an entire navel orange industry was spawned, and by 1895, Riverside was listed as the richest city per capita in the nation.

Twenty miles off the coast of Los Angeles, the island of Santa Catalina became the playground of both locals and eastern visitors. At Avalon, the island's newly built resort town, a hotel and casino were among the first structures erected, while folks of more modest means slept in tents on the beach. To easterners and Europeans, Avalon was as magical-sounding as its mythical namesake in Tennyson's poem "Idylls of the King."

In Pasadena, the first midwinter festival was held, an event that eventually became the Tournament of Roses. Up in San Francisco, 1894 was the year the city invited the world to its California Midwinter International Exposition. Held in Golden Gate Park—the first California state park—the expo was attended by more than two million visitors.

The final decade of the nineteenth century also saw renewed interest in California's early missions, many of which lay in ruins. The interest sparked a period of renovation, which included restorative work on the Mission of San Juan Capistrano.

Perhaps the most important event in this decade was the discovery of oil in Los Angeles by Edward Doheny. Although the oil discovery did not have the same impact on the country as the gold rush, it did attract the same breed of prostitutes, con-men, and gamblers. In the ten years between 1890 and 1900, L.A.'s population doubled.

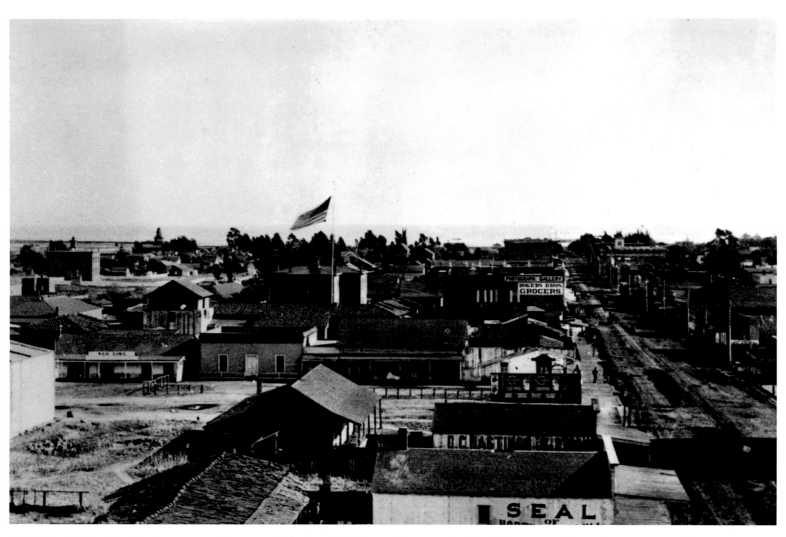

By the late 1800s, Santa Barbara was on the verge of a boom, with plans underway to build public sewers and paved streets. In another ten years, the Wells Fargo Stage Coach line would be replaced by the railroad, connecting the seaside town with San Francisco. State Street is still the main thoroughfare, as it was when this 1890 photograph was taken.

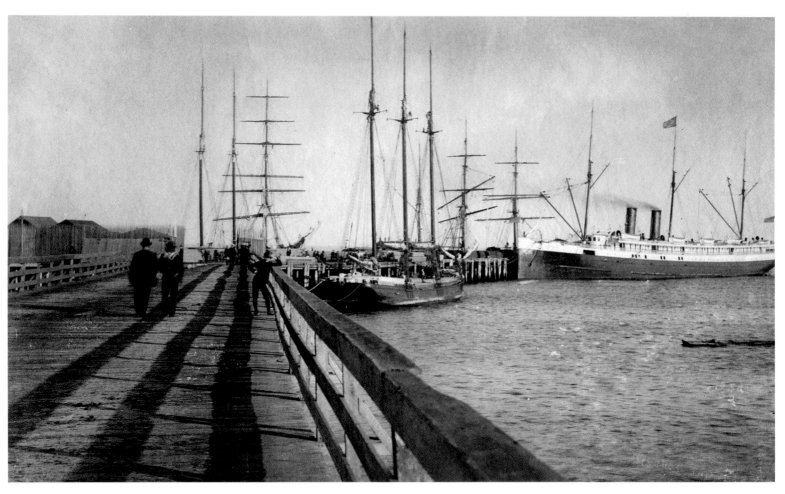

The ship *Santa Rosa,* known to carry passengers to the Redondo Beach pier, was docked at this Southern California pier in 1890. Redondo was the first port of Los Angeles County, and steamers from the Pacific Steamship Company stopped here four times a week as part of their regular run between San Francisco and San Diego. As the Pacific Coast became "the" destination for tourists, thousands streamed into the region by rail or by ship.

Edward Beale, one of the heroes of the Mexican-American War's Battle of San Pasquale, became the first superintendent of Indian Affairs for California and Nevada. During his travels in the West, Beale acquired the 270,000-acre Rancho Tejon, in Kern County, located close to the area Beale selected for the establishment of Fort Tejon. Beale split his time between Rancho Tejon, shown here, and his Washington, D.C., home.

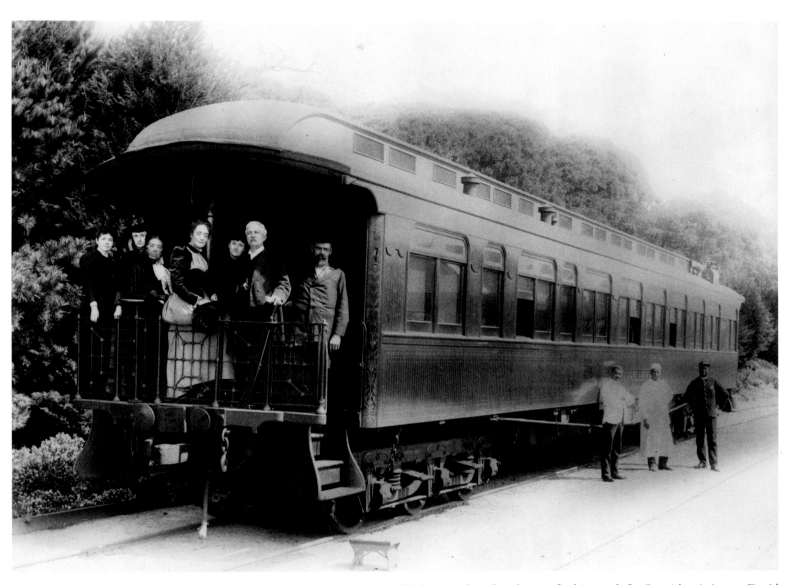

Sir Henry Morton Stanley, born John Rowlands, was a Welsh-born explorer best known for his search for Scottish missionary David Livingston in Africa. Born into poverty, Stanley came to the United States where he served in the Confederate Army during the Civil War. A naturalized U.S. citizen, the journalist-explorer again became a British subject in 1892, one year after this photo was taken in Monterey. He then went on to sit in Parliament and was awarded a knighthood.

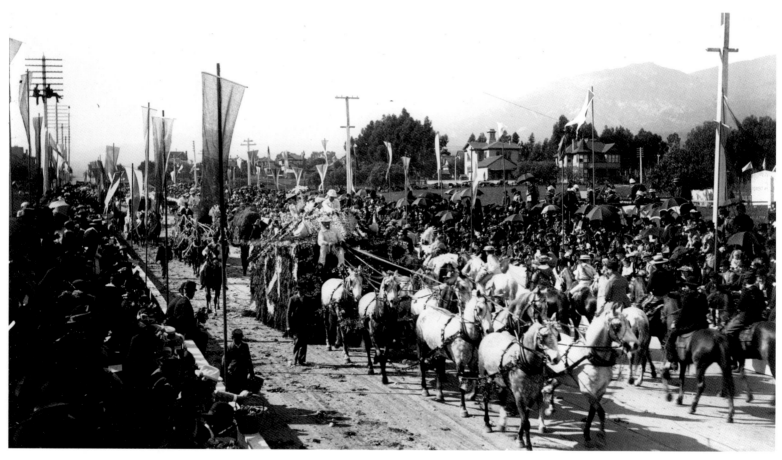

This floral celebration may picture the 1891 parade that Santa Barbara citizens threw to honor President Benjamin Harrison and the First Lady on their visit to the coastal town. The parade was the city's first Battle of the Flowers Pageant. Arches were placed over State Street and then covered with flowers. Unfortunately, some of the pampas grass plumes caught fire, prompting a city ordinance that forbade the use of the plumes for future public decorating.

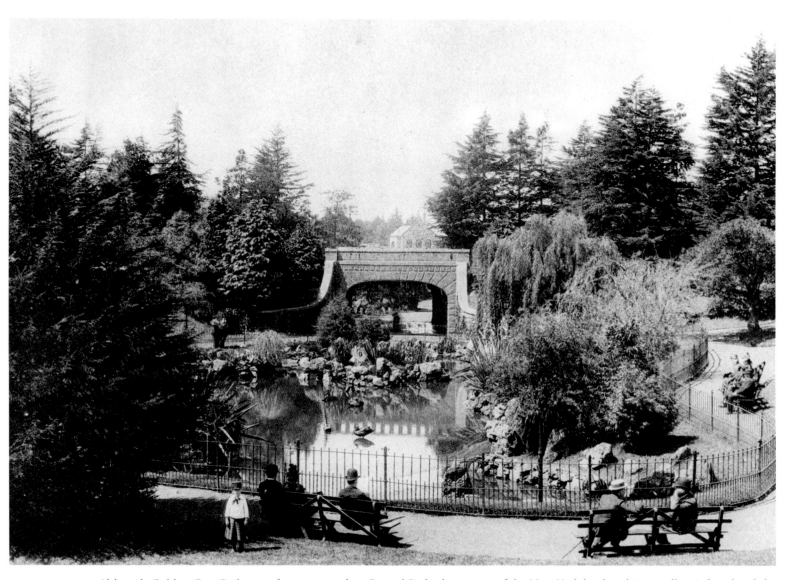

Although Golden Gate Park was often compared to Central Park, the creator of the New York landmark ironically tried to derail the California park plan by declaring the proposed site hopeless. A measure of Golden Gate Park's popularity was seen in 1886 when streetcars delivered more than 47,000 people there over a single weekend. This 1892 photograph shows one of the park's features, Alvord Lake and Tunnel.

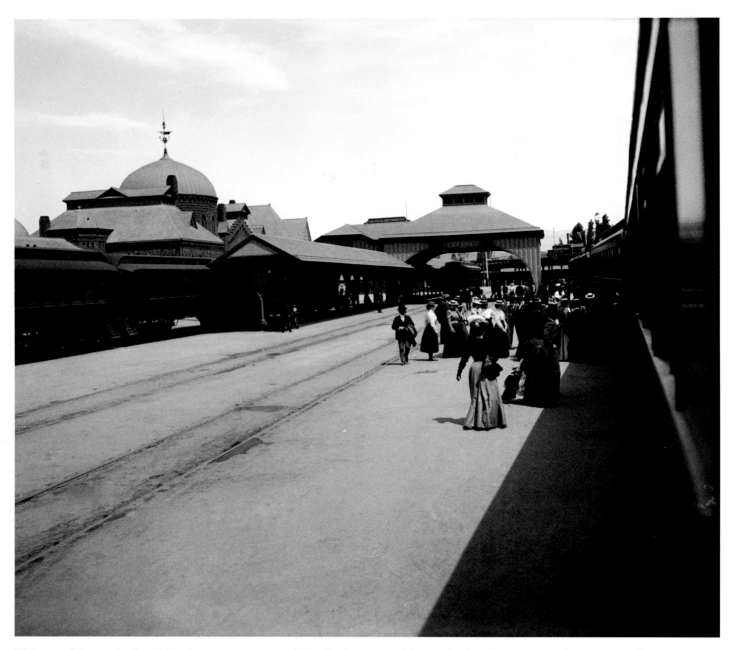

This peaceful scene in the 1890s shows passengers awaiting the departure of the overland train in Los Angeles. Due to violence by striking railroad workers in 1894, the *New York Times* reported that "the overland trains brought Pullman, express, and mail cars, and a large number of passengers, under guard of regular troops" into Los Angeles. Meanwhile, the local grand jury brought indictments against two union men who beat a non-union engineer.

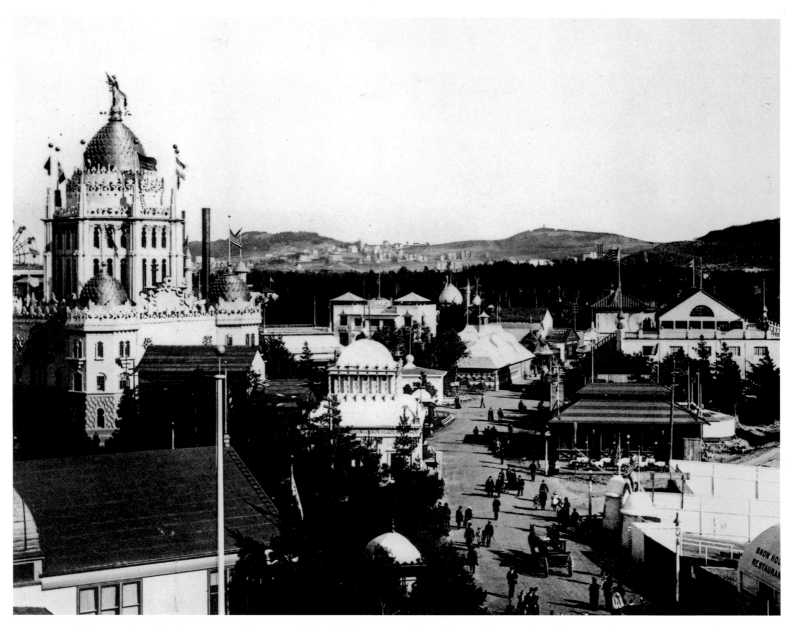

This view from the San Joaquin County Building looks out over the Midway of the 1894 California Midwinter International Exposition, a world's fair that operated for six months. The fair featured exhibits by California counties and several states. Many foreign countries who had participated in the Columbian Exposition a year earlier brought their displays to the fair. Remnants of the expo, including the Japanese Tea Garden, can still be seen in Golden Gate Park.

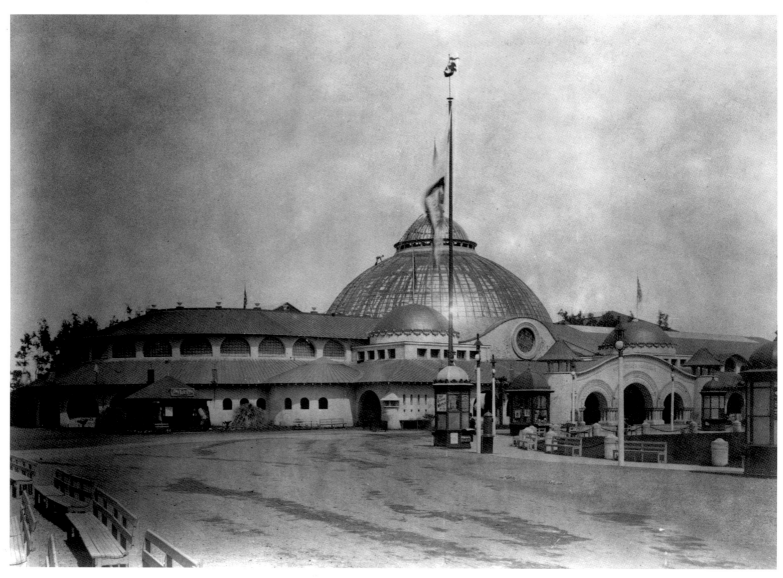

Nevada was one of the states with an exhibit in the Agricultural and Horticultural Building of the California Midwinter International Exposition. As described by fair commissioners, one such prominent display from the Experiment Station of the State University at Reno consisted of stands exhibiting "grasses and their seeds; insects injurious and beneficial to the farmers of the State, arranged in glass cases, showing their effect upon the wood, tree or cereal attacked by them."

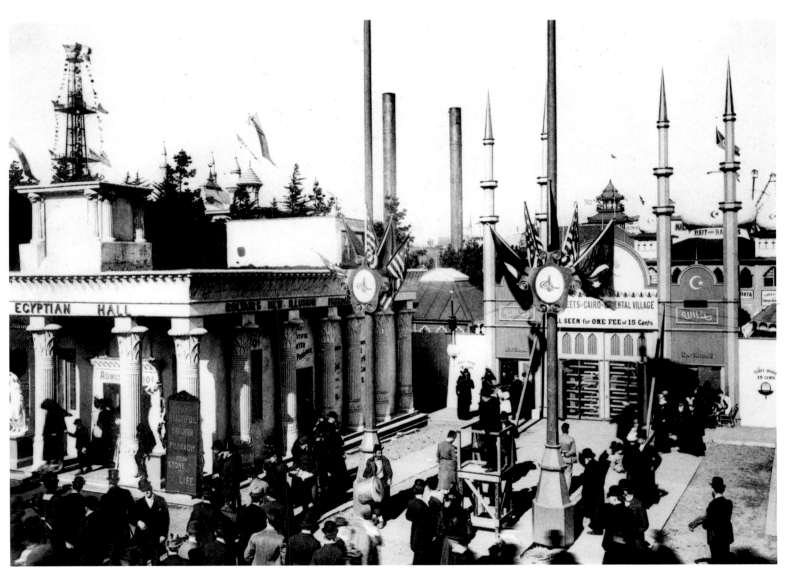

America's fascination with exotic places was mirrored in the Egyptian Hall and Oriental Village at the California Midwinter Expo. The hall was decorated with palm and lotus leaves, complete with Egyptian and Assyrian deities carved in low relief, sphinxes, and a pyramidal roof. The village's teahouse served visitors a variety of Chinese beverages and sweetmeats to be enjoyed at ebony tables. Silk-embroidered robes, gilded carvings, and furniture inlaid with mother-of-pearl completed the Oriental fantasy.

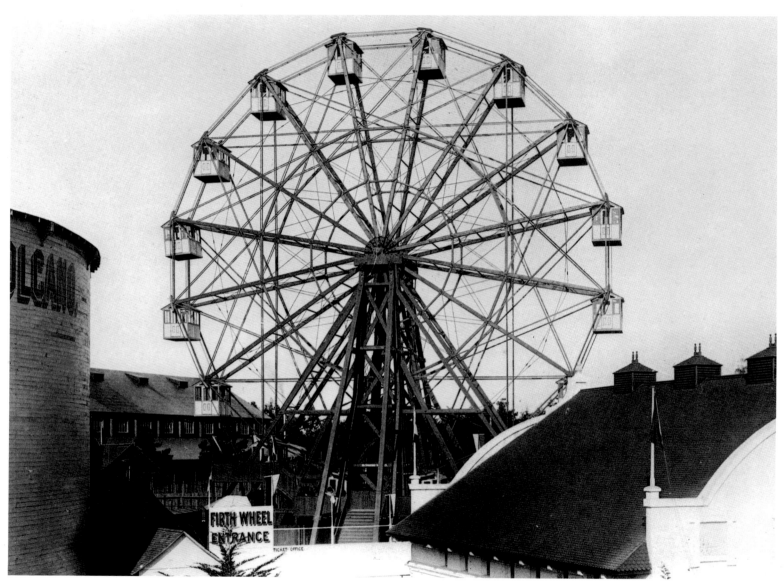

What international exposition would be complete without a Firth wheel, a smaller version of the Ferris wheel found at the 1893 Columbian Exposition? The wheel was 100 feet in diameter, with an added 50 feet of foundation. Each of the 16 cars held 10 persons, giving each an unparalleled view of the fair, particularly at night when the buildings and grounds were lit with a "tracery of fire."

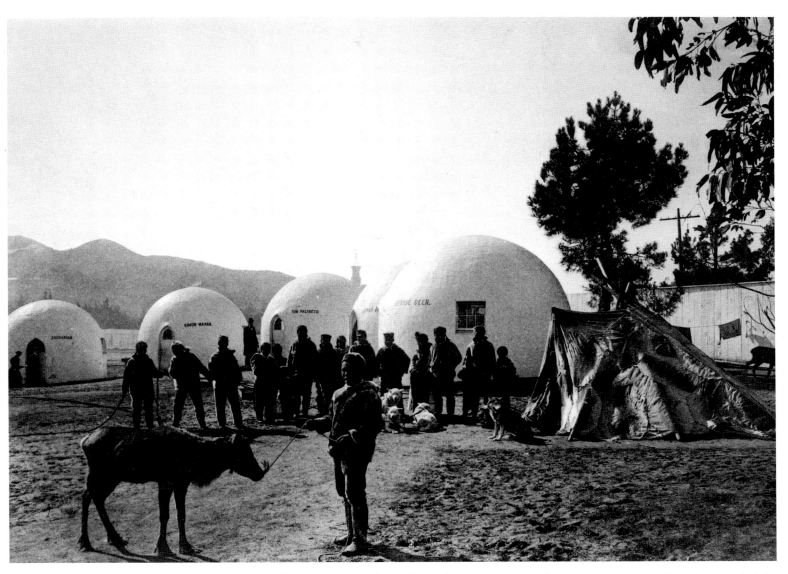

How strange an "Esquimaux" (Eskimo) Village, complete with reindeer and a dog team, must have seemed to the tourists who attended the Midwinter Exposition. The igloos were built to represent how natives of Labrador (near Newfoundland) lived in their dome-shaped huts of "snow"—created by exhibitors with a liberal coating of whitewash.

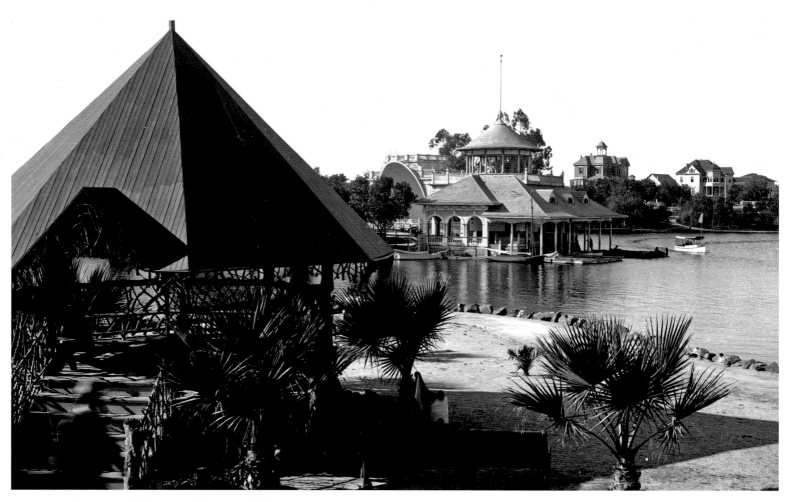

Little does this 1890s idyllic setting forewarn of a bizarre moment in the history of Westlake Park. When a discharged coachman murdered the wife of his employer in 1906, he chose this boathouse as his hideout. After capture and conviction, he was hanged the following year at San Quentin. The park was acquired by the city of Los Angeles in 1886, the lake expanded in 1890, and in 1942 it was renamed MacArthur Park.

The man driving his carriage across the lake at Eastside Park (renamed Lincoln) had only to wait a few more years before the miniature Eastlake Park Scenic Railroad would have carried him across. Built by John Coit, the little train didn't stay long in Los Angeles; in 1905, it was moved to Venice. Coit's little engine was 19 feet long and only 51 inches from the top of the rail to the top of the stack.

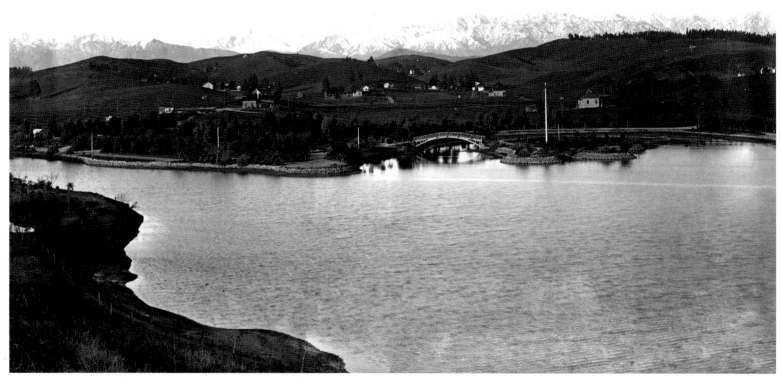

Echo Park Lake's origin was Reservoir No. 4, part of a tract of real estate purchased by Thomas Kelley in 1880. The land was named the Montana Tract and sold off for the development of businesses and homes. Local legend says the lake got its name from the workers who built the original reservoir, claiming that their voices echoed off the nearby canyon walls. A Victorian-style boathouse was constructed in 1896.

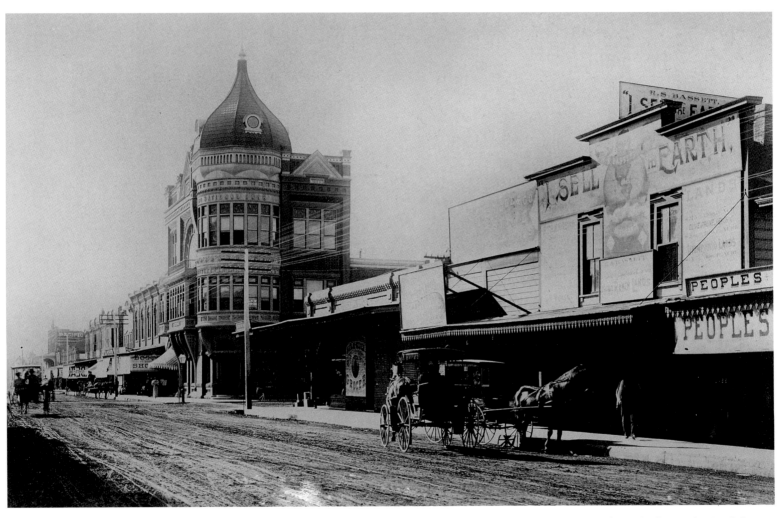

Pomona, named for the Roman goddess of fruit, was the winning entry in a contest to name the city, and won by horticulturist Solomon Gates. With the arrival of the railroad in the 1880s, Pomona became the westernmost keystone of the citrus-growing industry. Shown here is the turreted First National Bank building, located on the corner of Second and Main.

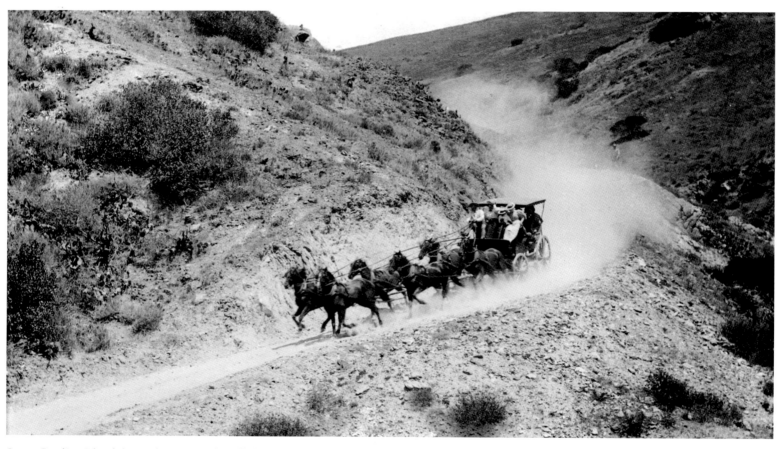

Santa Catalina Island, located just 20 miles off the California coast, has been a favorite destination of tourists, smugglers, and Spanish explorers. Named for Saint Catherine, the island was originally owned by Mexico, then a series of private individuals. In 1892, it was purchased by the Banning brothers who built roads, a telegraph system, aquarium, Greek amphitheater, and bandstand. The stagecoach shown in this photograph from around 1895 is probably the one used for sightseeing.

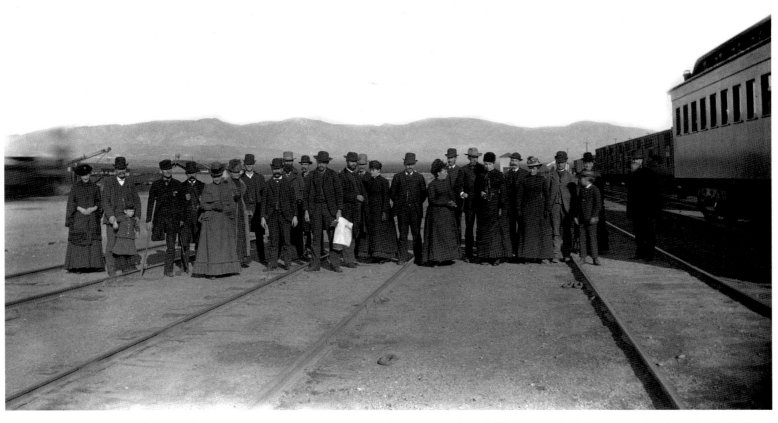

A gathering of men and women waits near a passenger car at the Mojave rail yard. The town, which began as a Southern Pacific Railroad camp in 1876, became the western terminus of the famous 20-mule-team Borax wagon route. Is this group waiting for a train to Los Angeles, or did they come to Kern County after the 1895 discovery of gold?

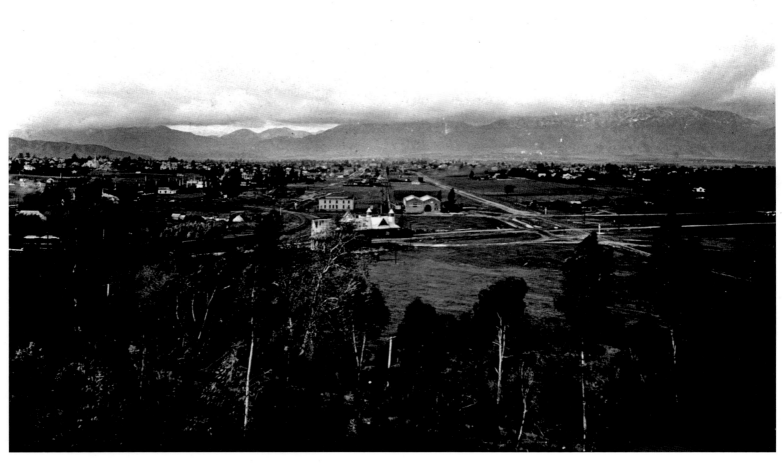

Pasadena, seen here from Raymond Hill, was home to the fourth of the California missions. By 1883, the first issue of the *Chronicle* noted that recent improvements had given Pasadena "the appearance of a town." Two years later, with the arrival of the railroad, future growth was assured. Following incorporation, Pasadena continued its rapid growth, building a Shakespeare club, an opera house, and what would become the California Institute of Technology.

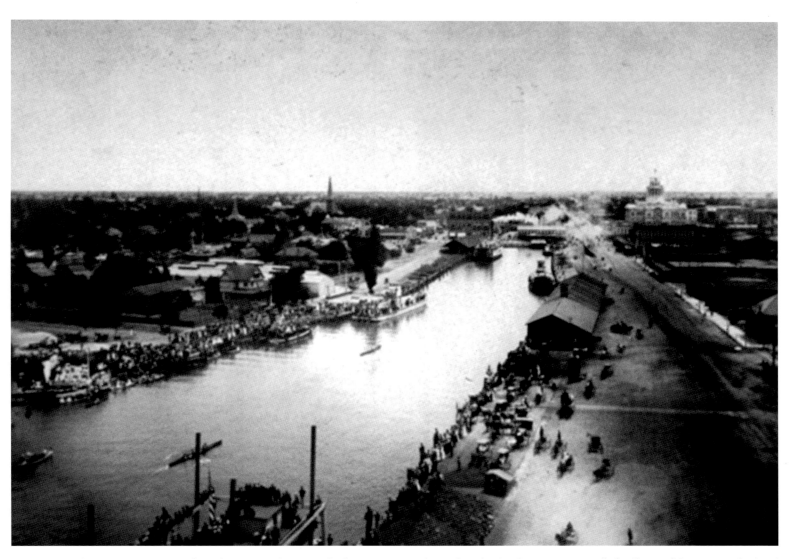

This panoramic view of Stockton was taken on July 4, 1895. Located on what the *Stockton Directory* called a "beautiful prairie at the head of the Stockton Slough, a wide and deep arm of the San Joaquin River," Stockton's harbor was seen by early Californians as the best among those of the inland cities. Founded in 1849 as part of a Spanish land grant, Stockton became a boomtown during the gold rush, then later emerged as an agricultural capital.

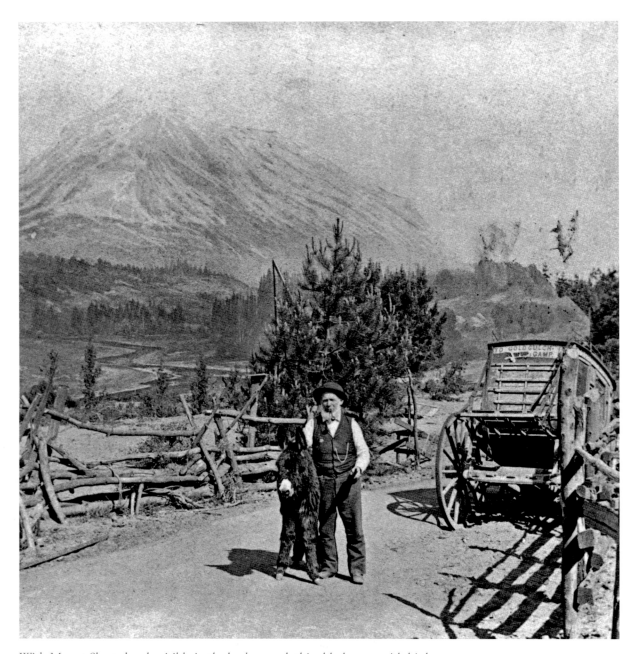

With Mount Shasta barely visible in the background, this elderly man with his burro poses near a stagecoach with the banner "Gold Gulch Camp." At the 1935 California Pacific Exposition, a mock Gold Gulch mining town was built in San Diego, complete with shooting gallery, a dummy suspended from a hanging tree, a Chinese laundry, an iron-barred bank, and dance hall.

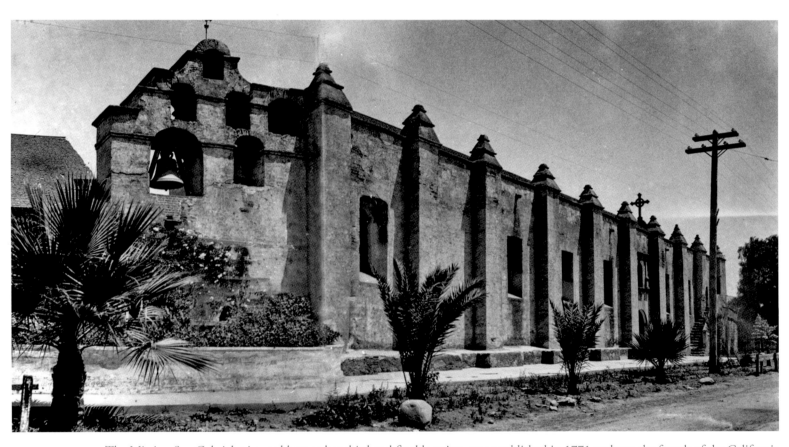

The Mission San Gabriel, pictured here at her third and final location, was established in 1771 and was the fourth of the California missions. Built in a fertile area, the mission enjoyed an abundance of orchards and vineyards, becoming the wealthiest of all the early missions. Named for the archangel Gabriel, the mission today houses a collection of early relics, including six altar statues that were brought around the Horn in 1791.

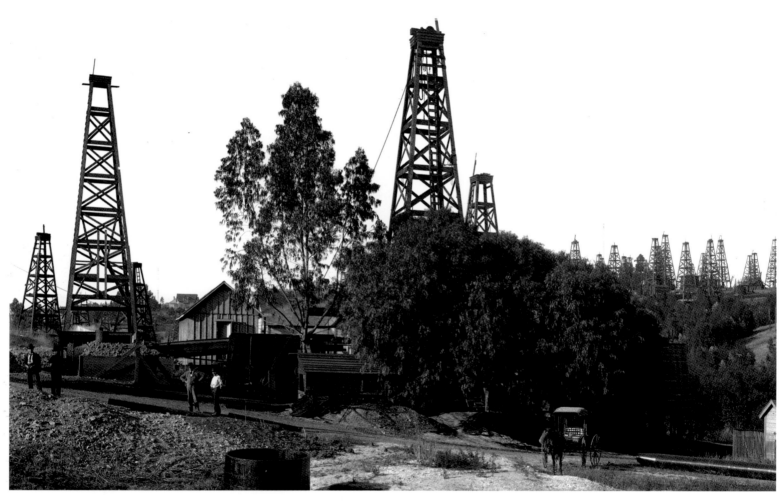

For centuries, natives in the Los Angeles area used tar seeping out of underground deposits to waterproof their canoes—the same tar that ensnared animals for thousands of years in tar pits, such as the famous La Brea tar pits containing prehistoric animal skeletons. When an enterprising miner named Edward Doheny drilled into the tar, he struck oil, establishing the first of hundreds of oil wells in the Los Angeles Field. Oil well hoists and derricks, such as those shown here, sprang up around the city.

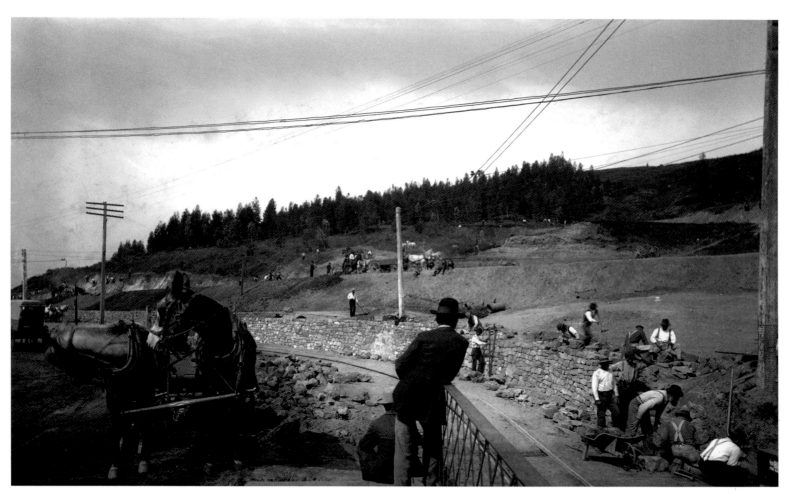

Unemployed laborers built a rock retaining wall at Elysian Park, the oldest Los Angeles public park. When surveyed in 1849, the area known as Rock Quarry Hills was preserved for public use rather than auctioned for city revenue. Nearly 40 years later, the city council dedicated the 575-acre Elysian Park, named for the Greek word for paradise. Over the years, city charters have ensured the parklands are protected forever.

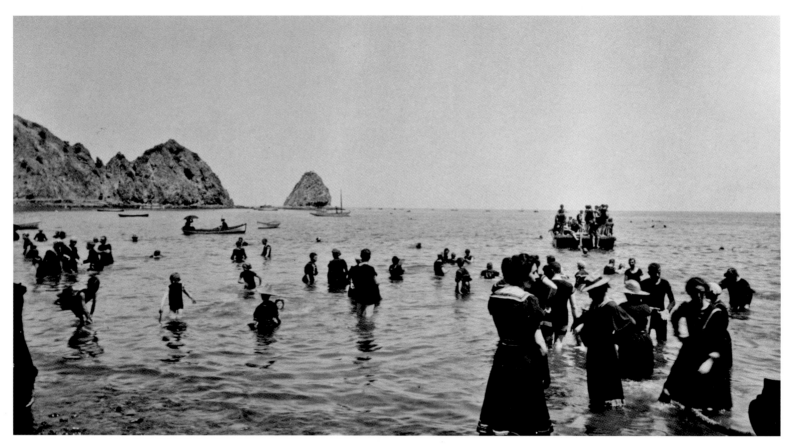

These women bathers in this 1895 photograph taken at Avalon, Santa Catalina Island, wore the latest in beach attire: calf-length dresses with long sleeves, bloomers slightly longer than the dresses, and hats. Although the 1895 Montgomery Ward catalog sold only men's bathing suits, by 1902, Sears, Roebuck & Co. was selling women's suits for $2.50 to $3.50.

The natural scenery from images like this helped developers position Catalina Island as an idyllic resort town. Beaches were improved for swimmers by erecting a sea wall, adding a covered bench, and building a bathhouse. Dozens of tents were erected in the canyon and rented for $7.50 a week to tourists who couldn't afford to stay in the hotel. The famous Sugarloaf Rock landmark is seen at the right in this 1895 photograph taken off of Avalon.

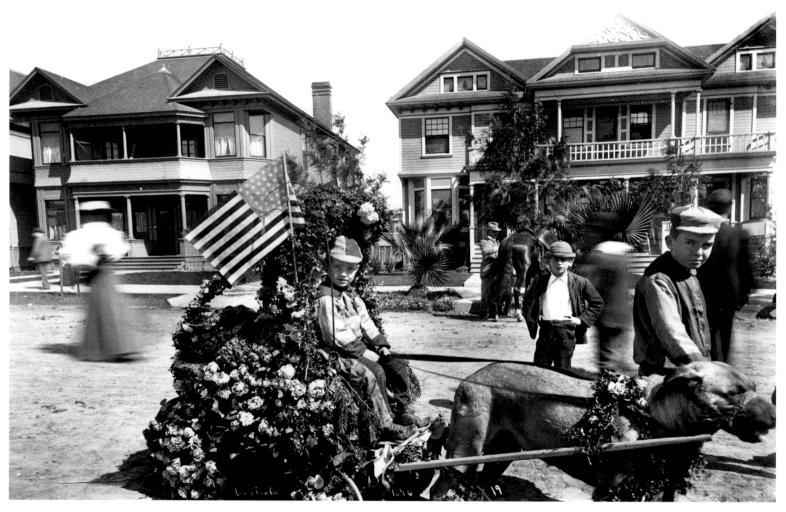

Celebration! La Fiesta de Los Angeles, with its origins in 1894, was a street carnival held to celebrate the city's Spanish heritage and to attract tourists visiting the San Francisco Fair. The fiesta included flower-decorated carriages, parades, a Grand Ball, and fireworks. Held annually for ten years, the Fiesta was revived in 1931, with more than 300,000 attending, generating a much-needed $3 million as the city moved into the Great Depression.

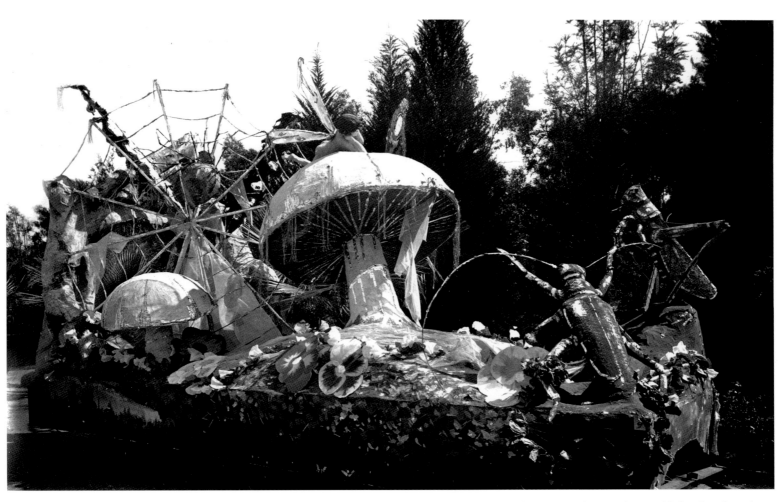

Giant beetles, crickets, spiders, and mushrooms deck this float entry in the 1896 Fiesta de Los Angeles parade. Could this float have been competing in an agricultural category?

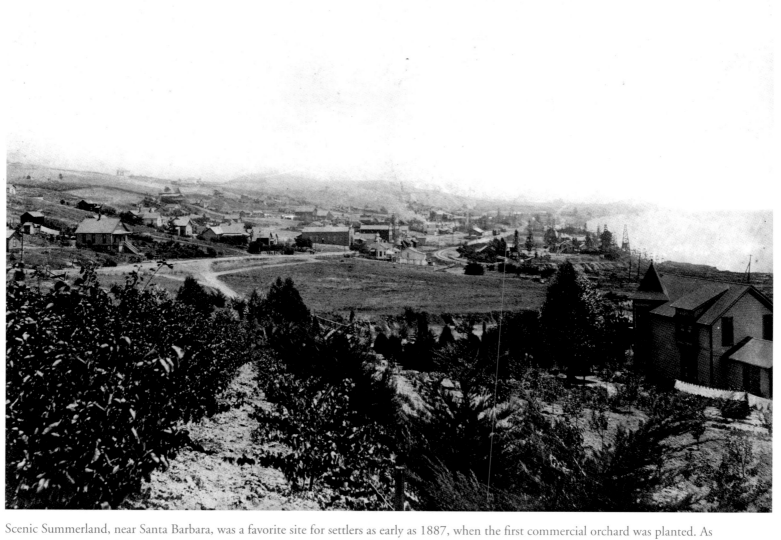

Scenic Summerland, near Santa Barbara, was a favorite site for settlers as early as 1887, when the first commercial orchard was planted. As the town grew around the lakeshore (seen here on the right), the agricultural community was exporting fruits via a stern-wheeler boat. By the time this photo was taken in 1896, Summerland boasted a depot, store, bakery, hotel, and a library.

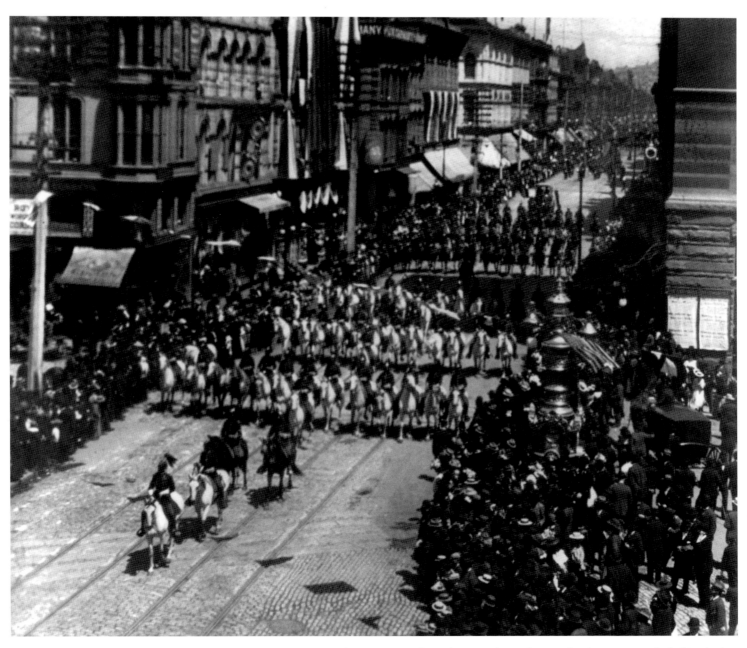

Membership in the Christian Endeavor Society, a nondenominational youth group formed in Portland, Maine, exploded in the last five years of the nineteenth century. By 1895, it had more than two million members participating from 41,229 local societies. The 1897 annual conference, held in San Francisco, included a parade, seen in this photograph. Total attendance at the conference was 300,000, with more than 40,000 riding the trains to reach the city.

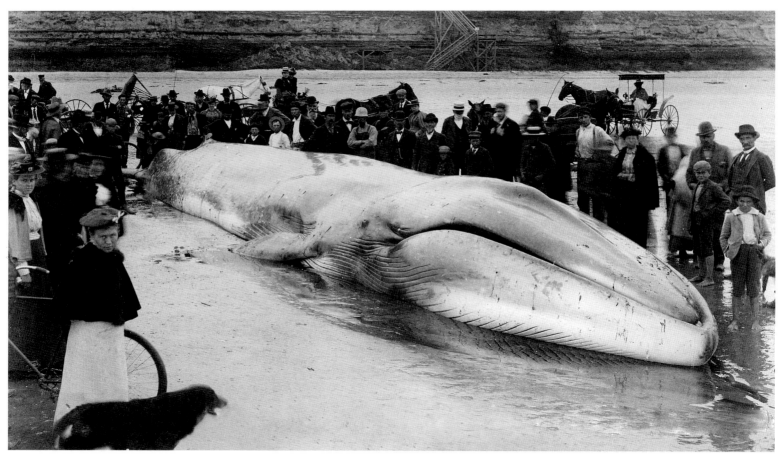

This crowd of men, women, and children gathered around a beached Fin Whale that came ashore in Long Beach in 1897. According to local stories, the 63-foot-long whale was nicknamed Minnie and became a tourist attraction, with the skeleton eventually going on display at the end of a local pier.

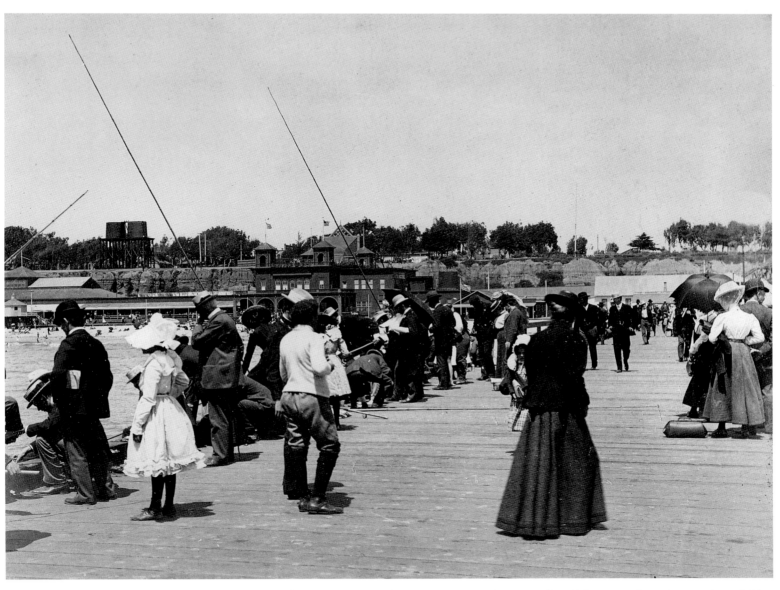

Amusement piers were a favorite diversion of Santa Monica residents. At one time, there were five of these piers featuring a variety of rides, such as carousels and roller coasters, as well as eateries and ballrooms. The end of the Santa Monica Pier was also a popular destination for local anglers, well-dressed in suits and bowler hats.

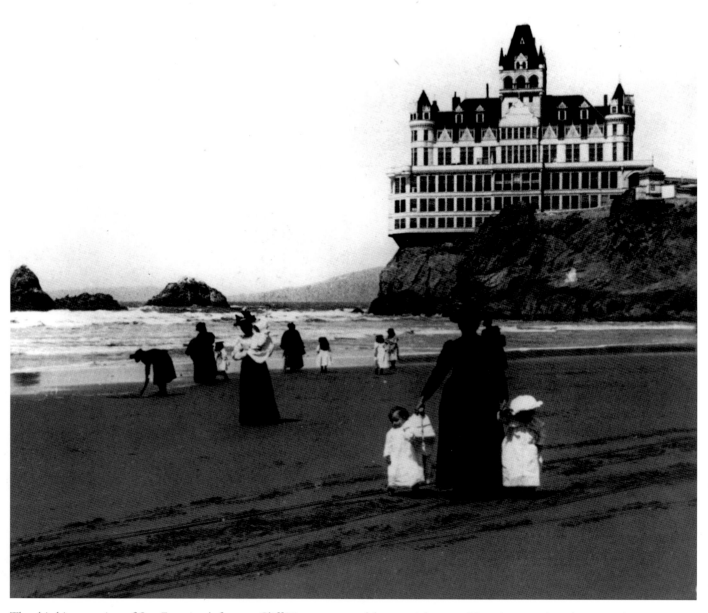

The third incarnation of San Francisco's famous Cliff House was an elaborate eight-story Victorian mansion that, over the years, housed dance halls, restaurants, and gift shops. From its vista, visitors had spectacular views down the coast as well as a vantage point to see ships sailing in and out of the harbor. In later years, trolleys would take riders out to Cliff House, replacing the horse-drawn carriages that once ran from downtown to the oceanfront attraction.

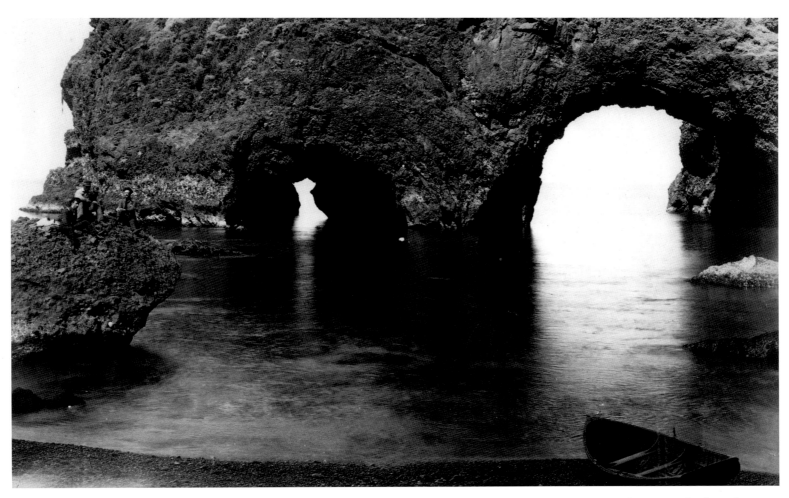

The three adventurous men in this photo are posed in front of famed Arch Rock on Anacapa Island. Located just 12 miles from the coast, the island comprises three islets five miles long, with a total land area of one square mile. The volcanic island has eroded over time, with wave action creating sea caves, steep cliffs, and natural bridges, such as Arch Rock. A historic lighthouse still lights the channel waters.

Thanks to the philanthropy of twin brothers Albert and Alfred Smiley, the city of Redlands was gifted this $60,000 public library, designed in mission style. Albert donated all the tables, chairs, desks, and stacks, as well as the fanciful gargoyles and griffins that adorned the interior. Stained-glass windows depicted library and learning symbols. To honor the brothers, each year the flower beds are planted with pansies— their favorite flower.

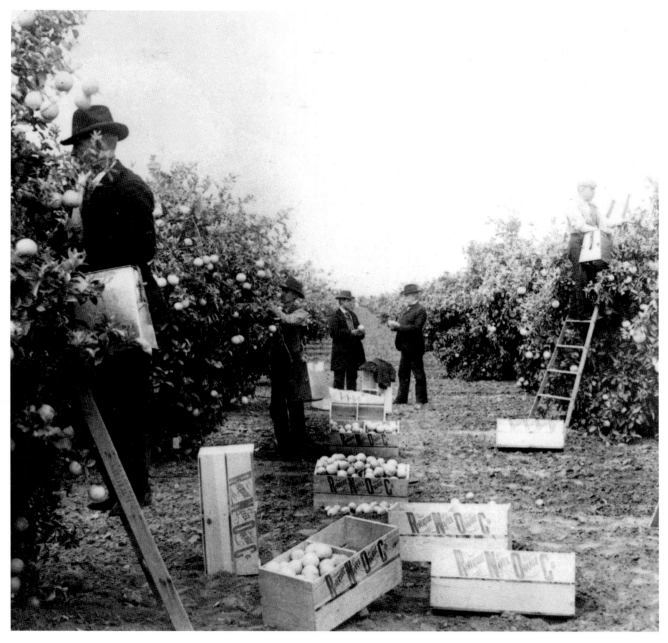

An 1888 book, *California of the South,* declared the Riverside orange had the greatest reputation and the highest price of any on the market, with the 1887-88 crop worth half a million dollars. At the New Orleans World Fair, the Riverside orange won gold medals for the best varieties internationally, in the United States, and in California.

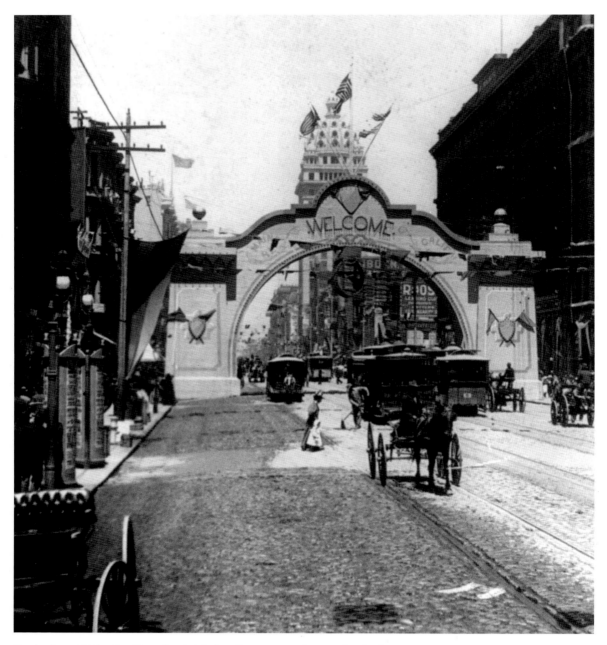

By the late 1800s, San Francisco's Market Street was a favorite locale for city pageants. It witnessed a wild celebration in honor of Ulysses Grant, a gathering of the Knights Templar in 1883, and an 1886 parade by thousands of Civil War veterans of the Grand Army of the Republic. Presidents Hayes, Harrison, McKinley, Roosevelt, and Taft all rode carriages down its length, through triumphal arches and past elaborately-decorated buildings.

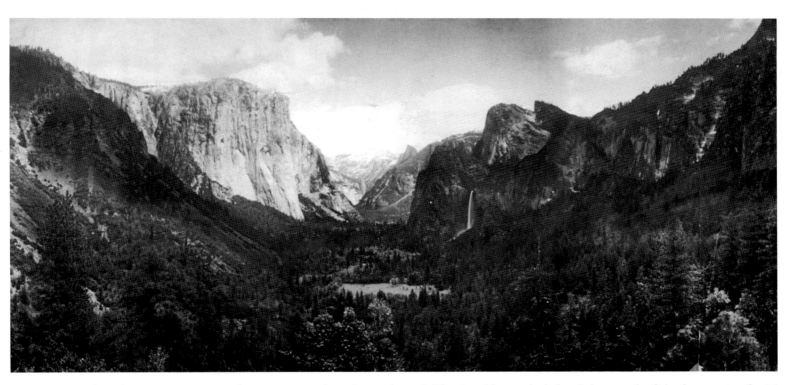

When this panoramic image of Yosemite was taken, the northern California wilderness had already been under federal protection for 35 years, thanks to the Yosemite Grant signed by Abraham Lincoln in 1864. Dominating this image is the park's most distinctive monument, Half Dome, standing at the eastern end of Yosemite Valley. The top of the granite dome is reached by thousands of hikers each year by following a trail from the valley floor.

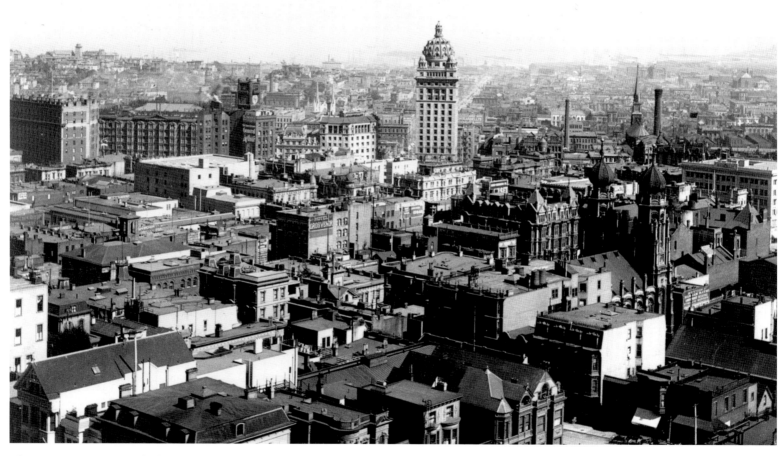

This 1900 panorama overlooking San Francisco, three years before the Wright Brothers' historic flight at Kitty Hawk, was either taken from a rooftop or recorded from a balloon or camera suspended from a string of kites. Central in the image is the Call Building, home of the *San Francisco Call* newspaper. Because of earthquake risk, the blueprint required a foundation 25 feet below street level, giving it enough stabilityto support its 18 stories.

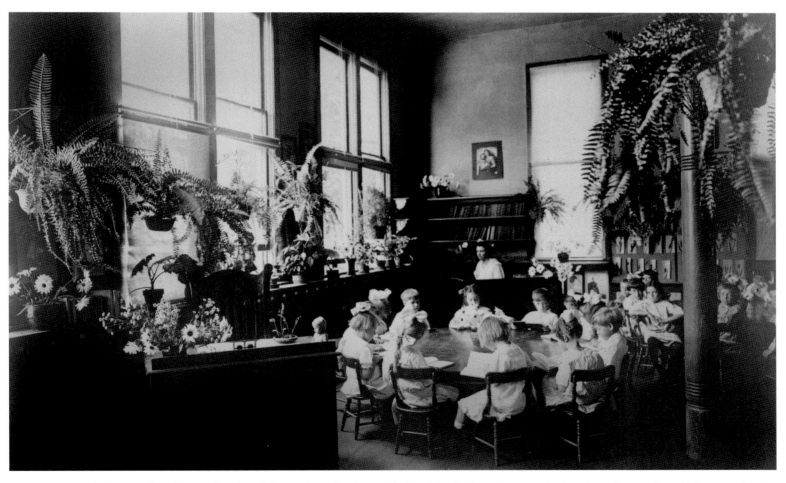

Long before earthquake-mandated building codes, schools were built with windows that stretched to the ceiling and could be opened to let in fresh air. Many structures built around 1900 featured the mission revival style and stone-block foundations. Common to Victorian-era homes and schools were huge Boston ferns, seen hanging in this Sacramento classroom.

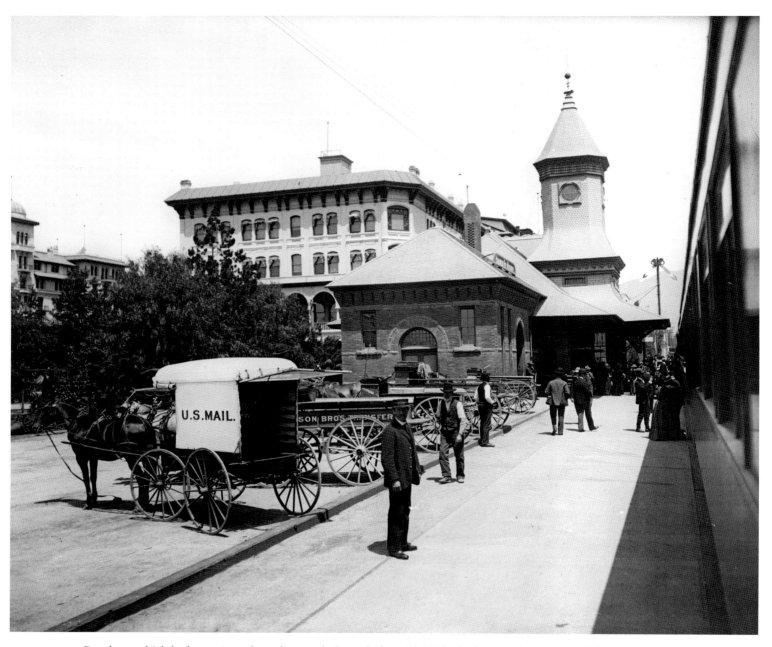

Pasadena, which had experienced steady growth through the mid-1800s, had a growth spurt once it became a stop on the Atchison, Topeka and Santa Fe Railway line. Grand hotels sprang up to house wealthy easterners who wintered here, as well as patients whose lung ailments required a mild climate. The original Victorian train station was replaced in the mid-1900s by a depot designed in the southwestern style.

Built in 1798, Mission San Luis Rey, known as the King of the Missions, is the largest of the 21 California missions. In its early years, the mission enjoyed great wealth, including 16,000 cattle, 25,500 sheep, and 2,150 horses. An aqueduct system supplied water for the mission gardens and bathing and laundry pools. The buildings fell into disrepair over the years until 1895, when Father Joseph O'Keefe, seen here around 1900, began restoration.

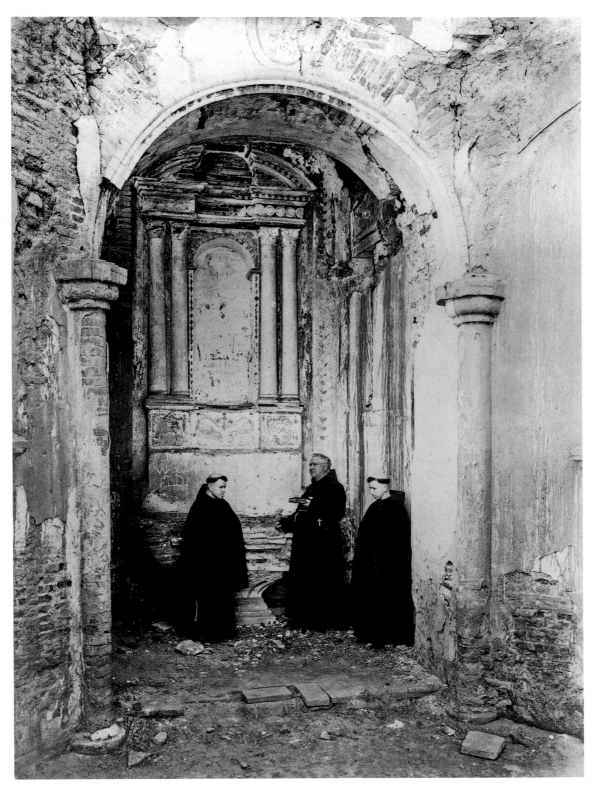

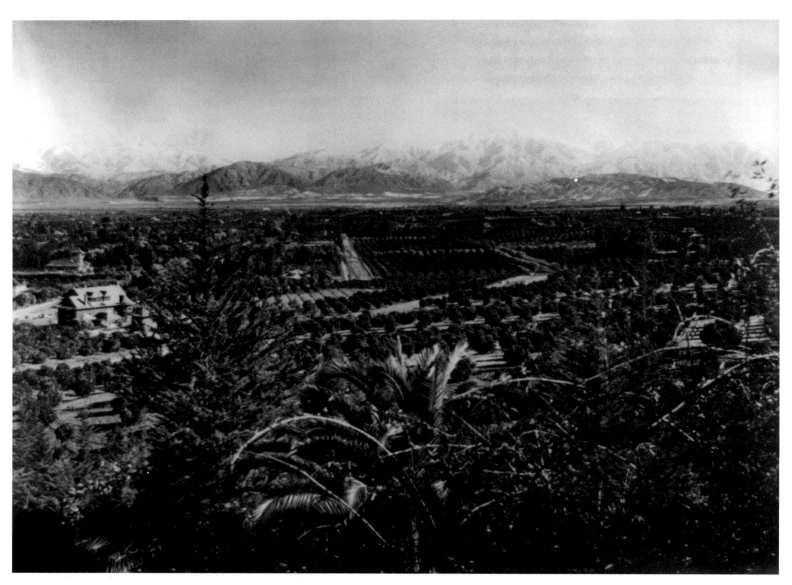

At the turn of the century, Redlands was known as the Jewel of the Inland Empire and considered among the most scenic of California cities. Palms and roses were planted along many main streets, while center medians featured trees or gardens. The sweet smell of oranges from local groves filled the air. Smiley Heights, the vantage point for this photo, was named for one of the main benefactors of the Redlands Public Library.

FROM DISASTER TO REBIRTH

(1900–1920)

Twentieth-century California began with promise: tourists flocked to its beaches and mountains, professional sporting events drew thousands, and the state seemed perched on the brink of becoming America's favorite playground. Then, disaster struck.

At 5:12 A.M. on April 18, 1906, a violent earthquake awoke the sleeping city of San Francisco. Rupturing the northernmost 296 miles of the San Andreas Fault, the quake was felt from southern Oregon to Los Angeles and inland as far as central Nevada. In seconds, buildings began to tumble, and for the following four days, fires raged out of control. According to the *San Francisco Chronicle,* "522 city blocks, 4 square miles . . . 2,593 acres, [and] 28,188 buildings" were utterly destroyed. But falling back on its fearless gold-rush era traditions, the city cleared the rubble and quickly rebuilt. Within a few months, the cable cars were carrying passengers again.

Less than ten years later in 1915, San Francisco hosted the Panama-Pacific International Exposition in celebration of the completion of the Panama Canal. The exposition was the city's way of telling the world that even the worst events couldn't damper the spirits of the "Paris of the West."

That same year, San Diego (the first American port north of the canal on the Pacific side) hosted a similar Panama-California Exposition that bolstered the local economy as well as introduced the Southern California city to a country far more familiar with its northern neighbors.

These decades saw a procession of presidential visitors, including William McKinley, William Howard Taft, and most famously, Theodore Roosevelt. Roosevelt's days in Yosemite with naturalist John Muir have been credited with persuading the president to create more national parks and wilderness areas.

The first twenty years of the new century saw California stabilizing its position as an important player in national affairs. Its industries flourished, tourism skyrocketed, and hundreds of thousands again flocked to the shores of what must have seemed like an idyllic Paradise on the Pacific.

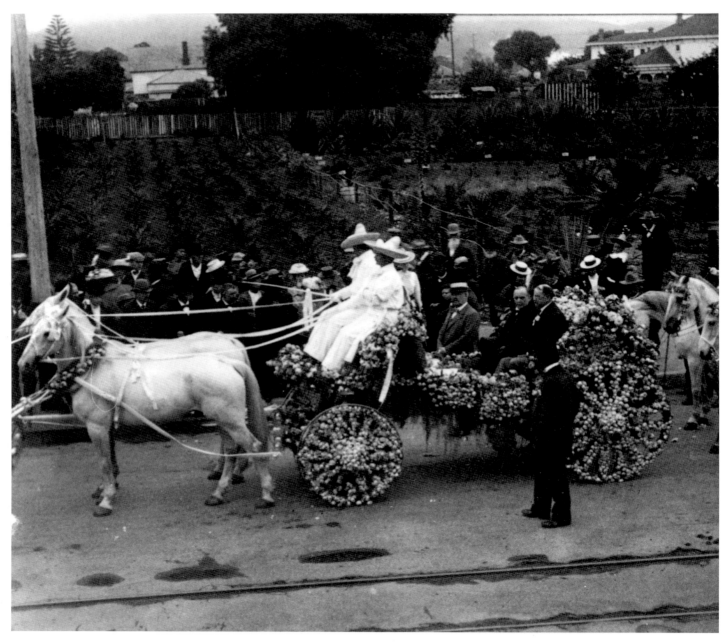

The route of President William McKinley's 1901 trek from Los Angeles to Santa Barbara was a flower-filled occasion. A *New York Times* article noted that at Santa Barbara, where this image was recorded, the president was "simply overwhelmed with flowers" that lined his carriage and paved the streets over which he rode. On this day in May, the President took time to visit the local mission.

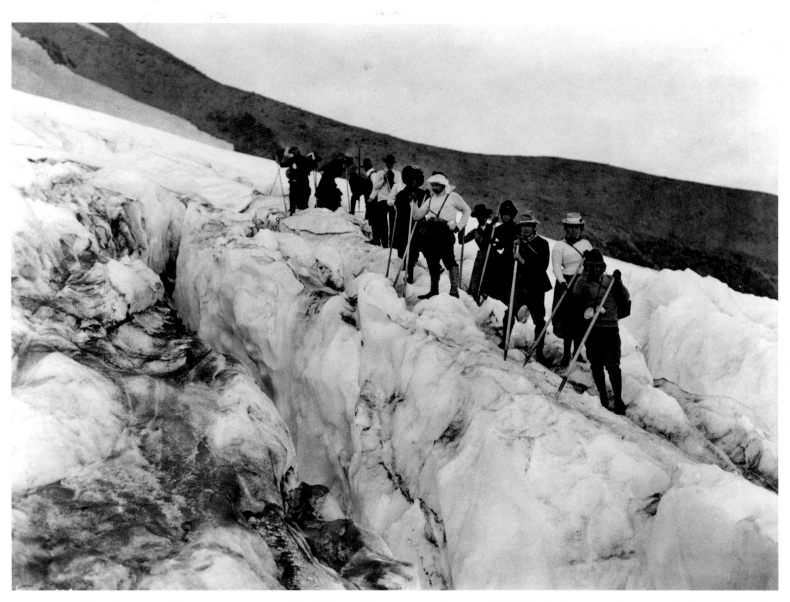

Although nineteenth-century attempts to climb Mount Shasta were made more difficult by the logistics of getting to Siskiyou County, by the early twentieth century the Pacific Highway passed the base of the mountain, opening up access for climbers. Mountaineering clubs were formed with the goal of reaching the 14,179-foot peak. Theodore Roosevelt wrote, "I consider the evening twilight on Mt. Shasta one of the grandest sights I have ever witnessed."

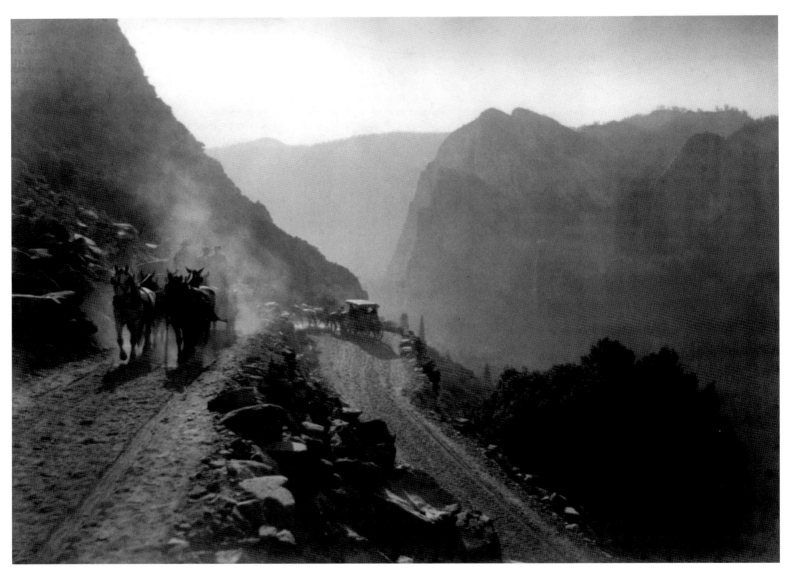

Tourism in Yosemite Valley began as early as 1855, when San Franciscans organized an expedition whose later-published accounts drew visitors and homesteaders. By 1864, in an attempt to protect the valley, the Yosemite Land Grant was established to create a protected park. In 1890, thanks in part to efforts by John Muir, Yosemite became a national park. The U.S. Cavalry was given the job of protecting Yosemite in its natural condition.

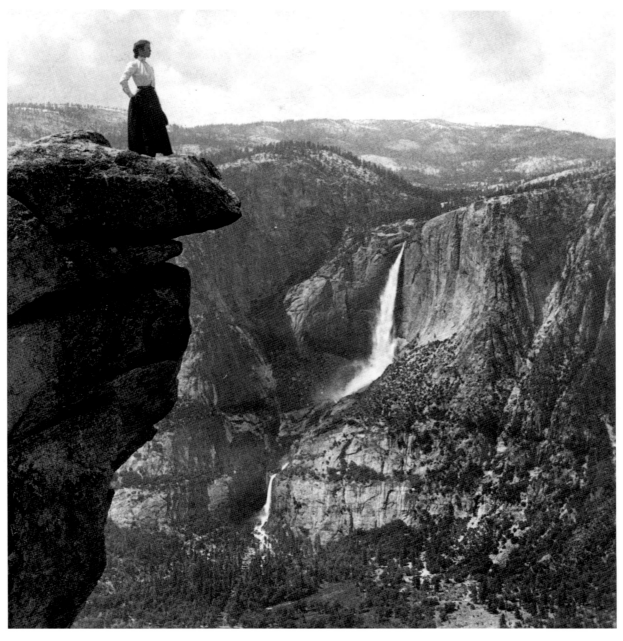

Perched atop Glacier Point in 1902, this tourist looks out across the valley to Yosemite Falls, the highest waterfall in North America. Yosemite Falls comprises three sections: the Upper Falls with a 1,430-foot drop, the Middle Cascades, a drop of 670 feet, and the Lower Falls, whose 320-foot length drops into a pool. From her vantage point, this tourist could also see Half Dome and Vernal Falls.

These early twentieth century tourists enjoy the Victorian version of "roughing it" in Yellowstone National Park. In 1901, about the time this image was taken, naturalist John Muir wrote, "Climb the mountains and get their good tidings. Nature's peace will flow into you as sunshine flows into trees. The winds will blow their own freshness into you, and the storms their energy, while cares will drop off like autumn leaves."

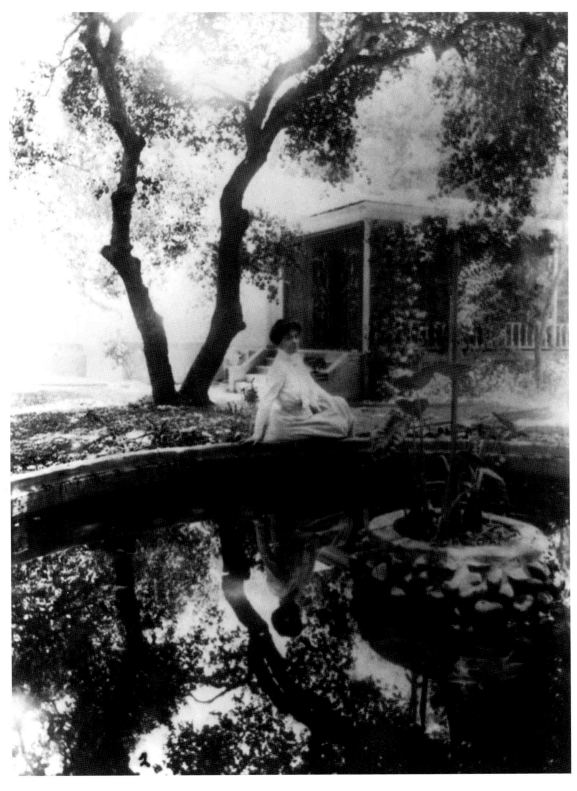

When Polish actress Helen Modjeska and her husband arrived in America, their goal was to live an idyllic life on their Anaheim ranch. However, the realities of ranch life set in, so Modjeska returned to the stage, performing the Shakespearean roles she had performed in Poland. She went on to become the leading Shakespearean actress of her day. Today, her Queen Anne–style home, Arden, seen here in 1902, is a National Historic Landmark.

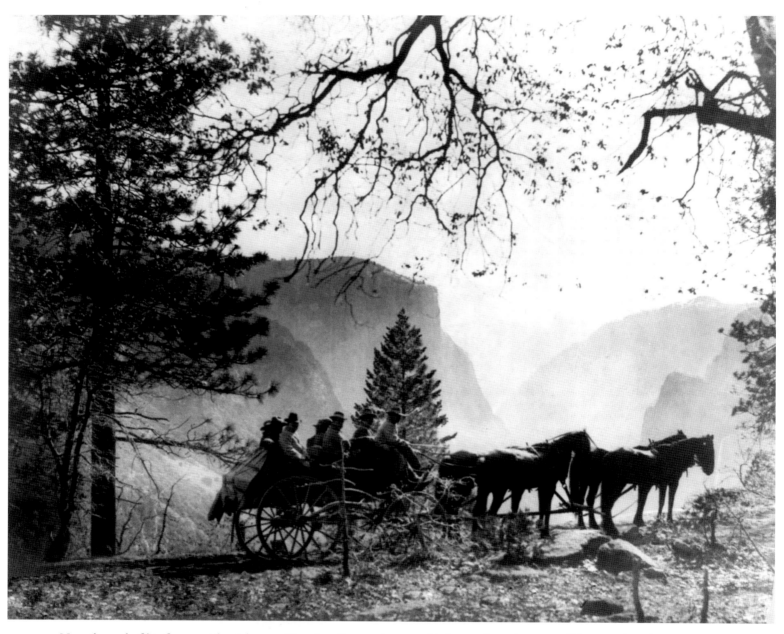

Near the end of his first presidential term, Theodore Roosevelt was guided on a three-day tour of Yosemite by John Muir. Muir used the evenings around the campfire to preach the cause of protecting America's wilderness areas and establishing more park systems. Muir's pleas found a sympathetic ear in conservation-minded Roosevelt. During his presidency he established 5 national parks, 150 national forests, and 55 national bird sanctuaries and wildlife refuges.

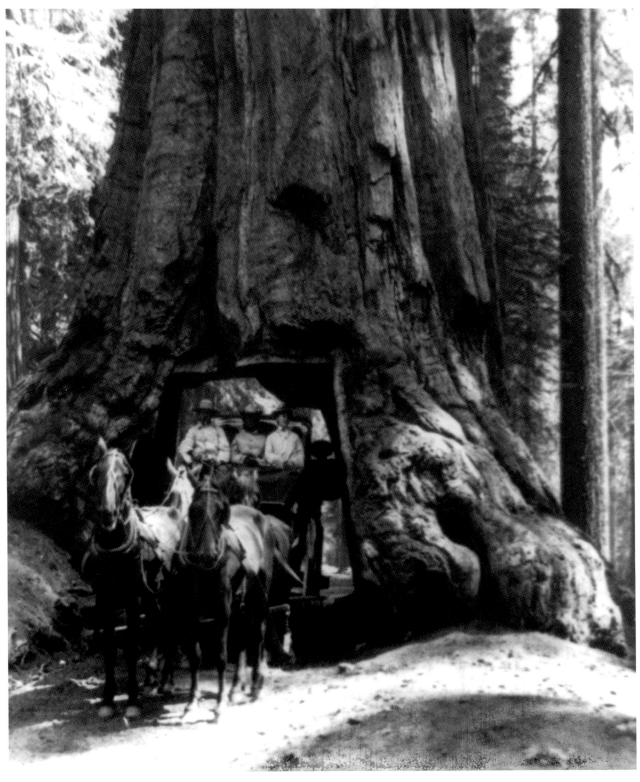

During Theodore Roosevelt's 1903 visit to Yosemite, he said, "There can be nothing in the world more beautiful than the Yosemite, the groves of the giant sequoias . . . our people should see to it that they are preserved for their children and their children's children forever." Seen in this 1905 image is famous Wawona tunnel tree and a stagecoach. Two brothers were paid $75 to cut the tunnel for the Yosemite Stage and Turnpike Company in 1881.

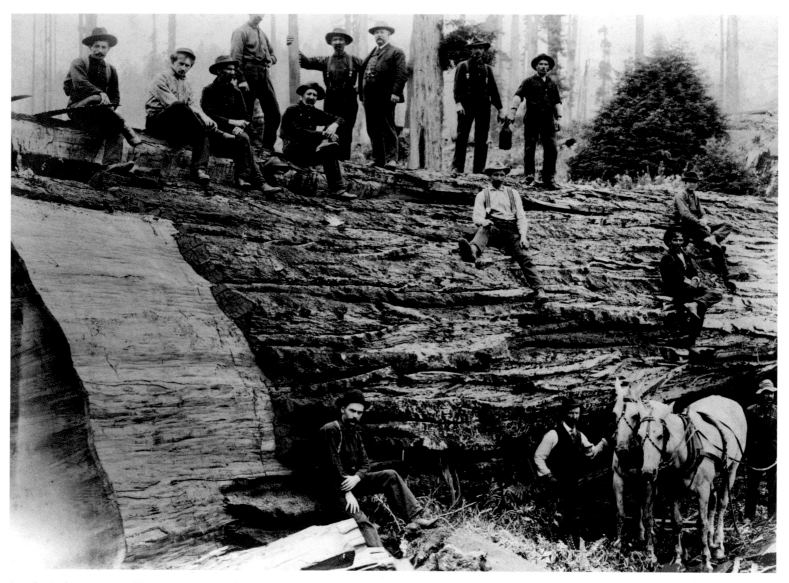

Lumberjacks pose on a fallen giant sequoia for a photographer around 1905. Logged in the late 1800s, sequoia wood was too weak and brittle for structural use, with many of the trees shattering upon impact when they were felled. Whole groves were destroyed before lumber companies realized there would be little financial gain from logging the giant sequoia.

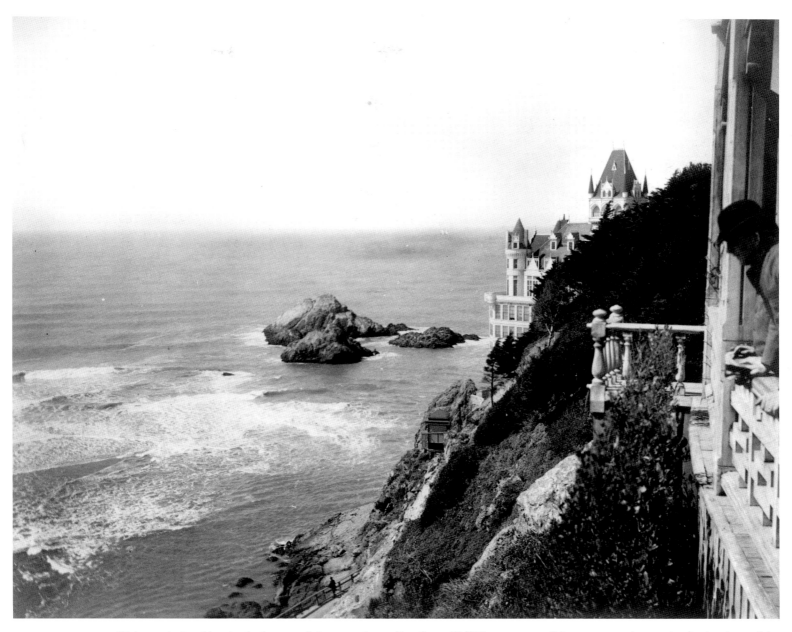

This tourist is taking in the beauty of the rugged coastline from Cliff House—one of the most popular tourist destinations of the early twentieth century. Cliff House's origins began in 1858, when it was built by lumber salvaged from a nearby shipwreck. The 1896 incarnation, called the Gingerbread Palace, was a seven-story Victorian chateau with indoor swimming pools, a museum, and a skating rink. Although the chateau survived the 1906 earthquake, it burned to the ground in 1907.

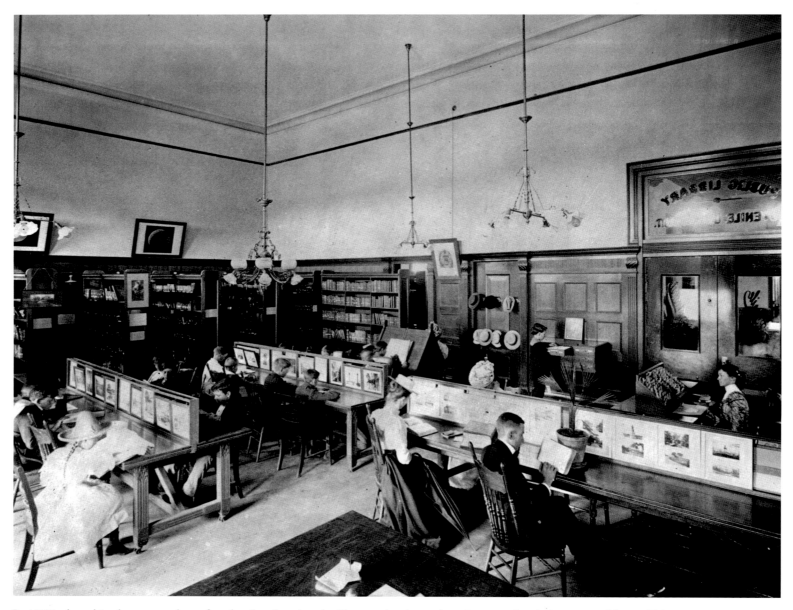

In 1905 when this photo was taken of readers in a Los Angeles library, a battle was looming over the city's water problems. Citizens were warned that unless they voted for building an aqueduct from the Owens River, the county would dry up, and further growth beyond 225,000 would be impossible. Although city hall was inundated with charges of political malfeasance, voters passed a $22.5 million municipal bond, and construction of the aqueduct began.

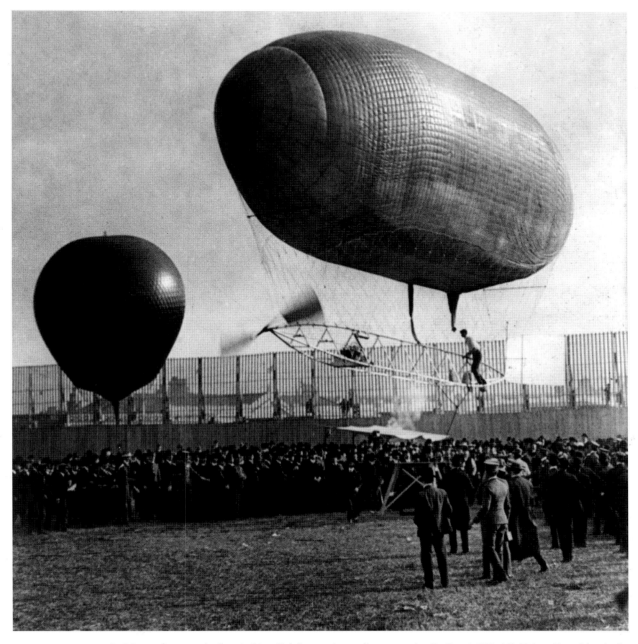

In November 1904, the airship *California Arrow* flew over the St. Louis World's Fair, piloted by A. R. Knabenshue of Toledo, Ohio. After its 36-minute flight, it descended into the fair stadium with thousands cheering its arrival. Flying at 1,600 feet, the airship thrilled crowds with its ability to undertake a series of precise maneuvers, including an "S" course and turns so tight that it appeared to spectators that the ship was on a pivot.

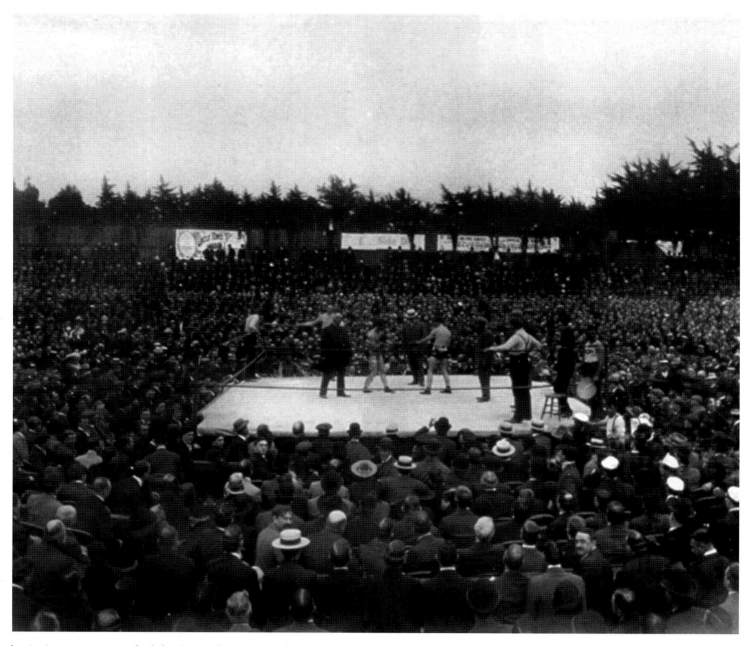

Enthusiastic spectators watched this September 9, 1905, lightweight championship Nelson-Britt boxing match in Colma, on the San Francisco Peninsula. During the match, "Battling Bat Nelson" took in a whopping $18,841 for beating his hated rival, Jimmy Britt. Years after retirement, "Bat," who had wasted away to 80 pounds, was declared insane and committed to a mental institute. Following retirement, Britt went into vaudeville then became the boxing coach at Stanford College.

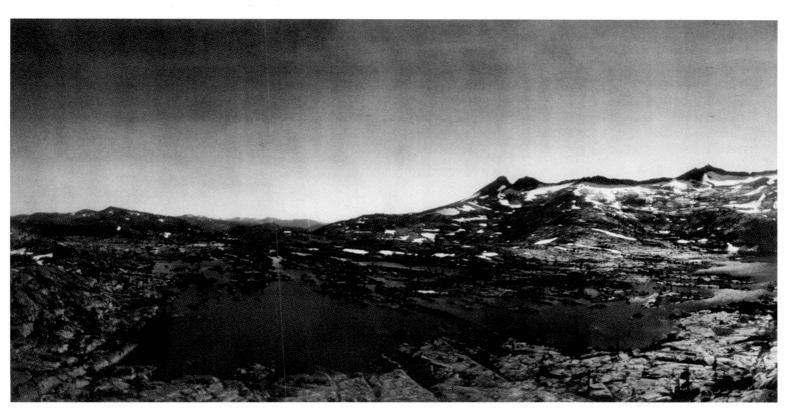

Located along the crest of the Sierra Nevada and west of Lake Tahoe, Desolation Valley is rimmed with rocky terrain. The clear and shallow waters of Lake Aloha are seen in this 1906 panorama. The lake is frequently no more than 10 feet deep, with the water level dropping in late fall to truly create a "desolation wilderness."

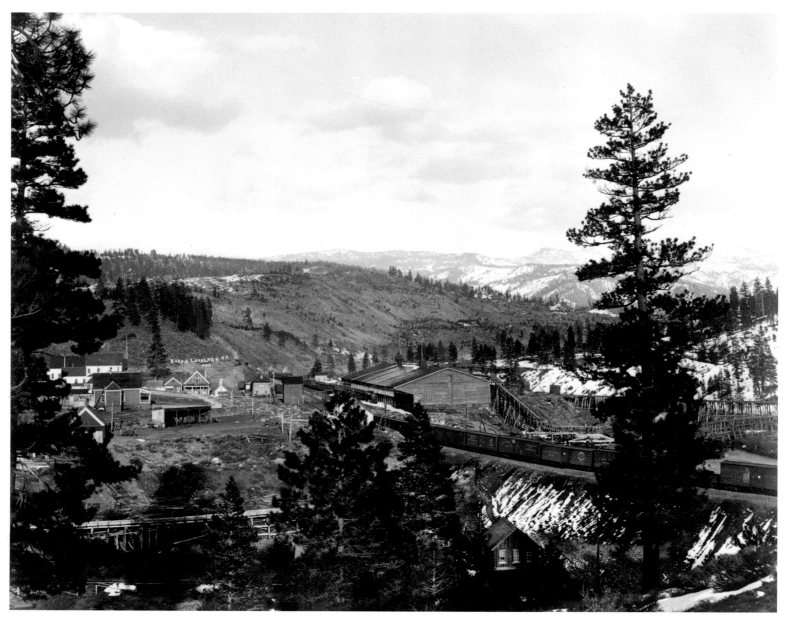

The town of Boca started as an 1868 construction camp for the Central Pacific Railroad. Named for the Spanish word for "mouth" because of its position at the mouth of the Little Truckee River, Boca's frigid winter temperatures made it an important ice-producing center for railroad cars shipping produce both east and west. Boca holds the California record for low temperature, reaching -45 degrees Fahrenheit in January of 1937.

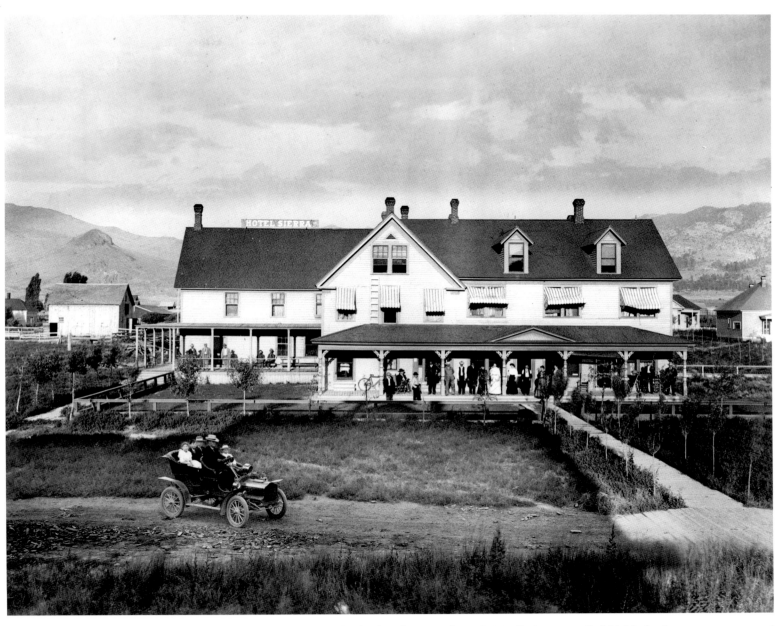

Tourists gather on the front porch of the Sierra Hotel, a landmark in Loyalton. Originally known as Smith's Neck, the town was renamed Loyalton to mirror the area's fierce loyalty to the Union during the Civil War. The town had a short boom after the Boca & Loyalton Railroad arrived, but the boom quickly diminished once the local timber was cut down. Today, Loyalton is the only incorporated city in Sierra County.

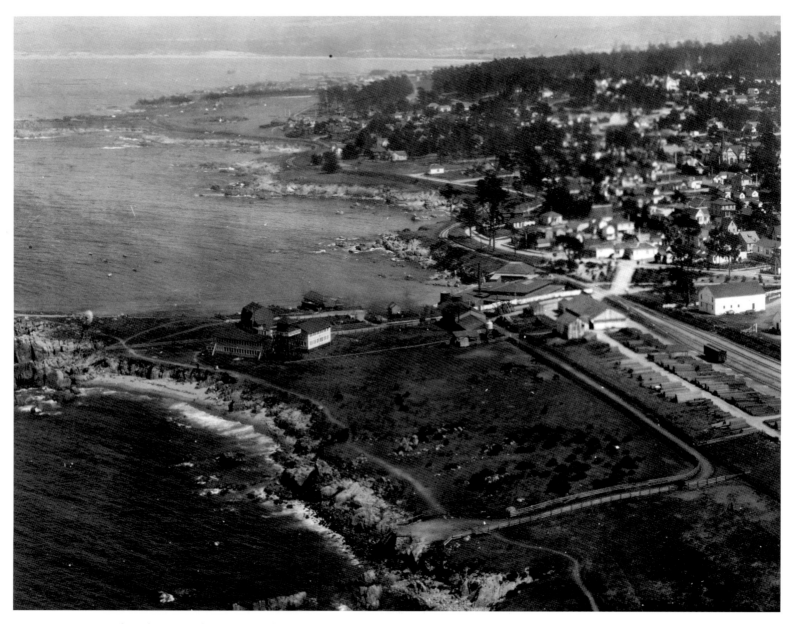

Like other coastal towns, Pacific Grove's fresh sea air and mild climate enticed easterners seeking a restful retreat. Established as a Methodist camp then later as a branch of the Chautauqua Literary and Scientific Circle, Pacific Grove grew into an artist's community. Among its later residents was author John Steinbeck. In 1879, when the summer visitors were gone, Robert Louis Stevenson noted that he had "never been in any place so dreamlike."

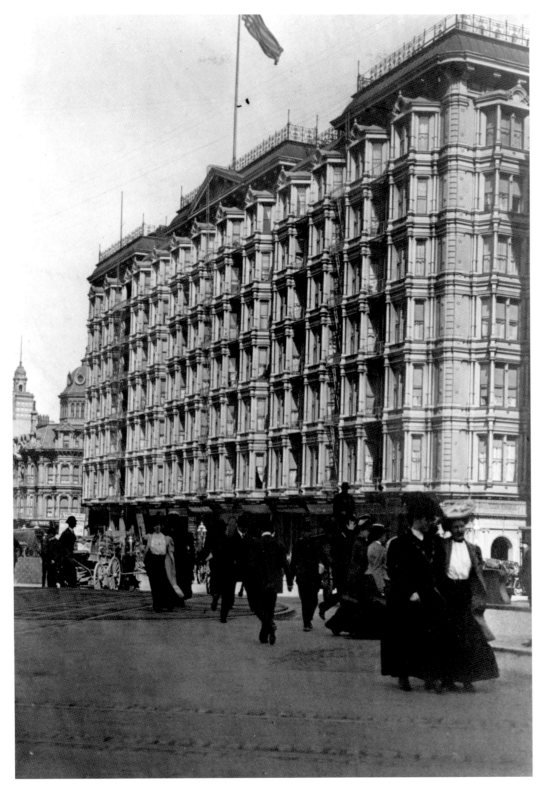

This photo, taken only three days before the Great San Francisco Earthquake, shows the Palace Hotel, considered the largest, most luxurious and costly hotel in the world. Opened in 1875, it was the favored hotel of famous guests, including Enrico Caruso, who was in residence the day of the earthquake. Like many other buildings in San Francisco, the Palace survived the earthquake, only to be destroyed by the ensuing fire that ravaged the city.

A city ablaze! Onlookers view the devastation of the Great San Francisco Earthquake of 1906, when San Francisco was ravaged by fires that raged for days. It's been estimated that over 80 percent of the city was demolished, with a loss of 3,000 lives. The more than 30 fires that swept through the streets were caused by ruptured gas mains, burning more than 25,000 buildings.

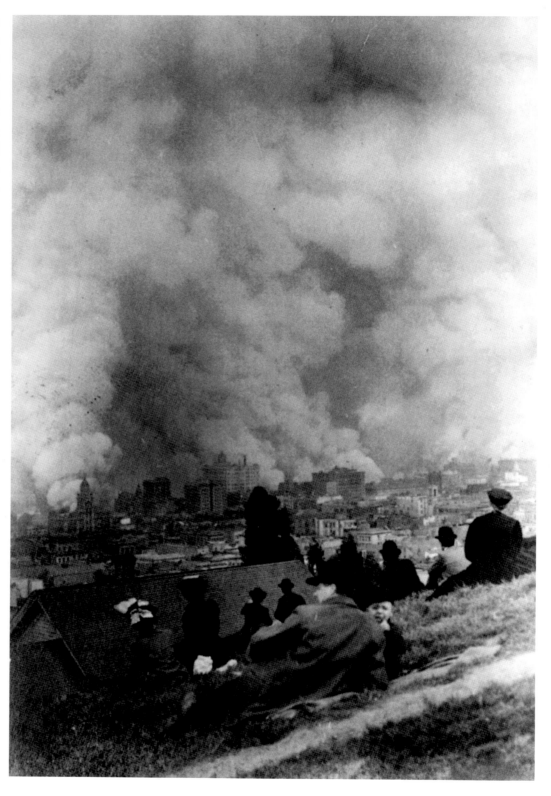

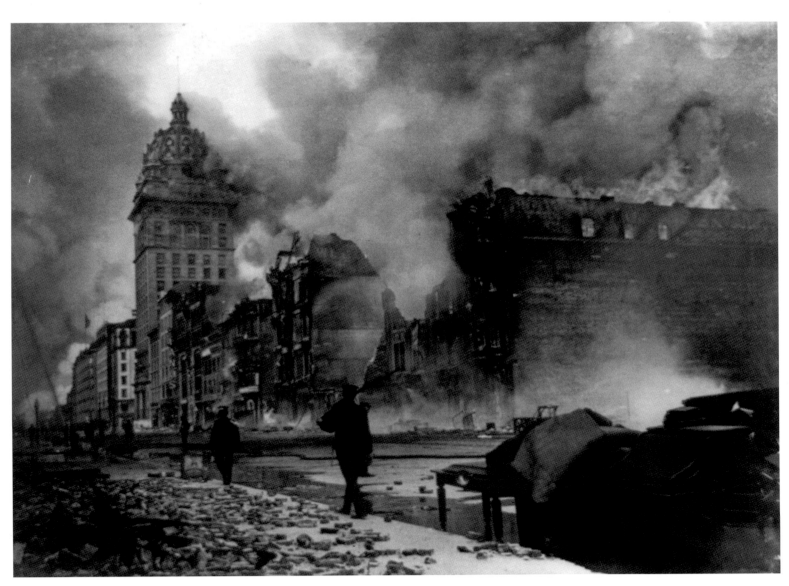

This view of Market Street following the Great San Francisco Earthquake shows collapsed and burning buildings. The quake, estimated at a magnitude of 7.7 to 8.25, had its epicenter two miles off the coast. Jolts from the quake were felt as far north as Oregon, south as Los Angeles, and east as Nevada. The city's Chinatown was entirely destroyed—an event many locals applauded, saying "the worst was cleared away with the best."

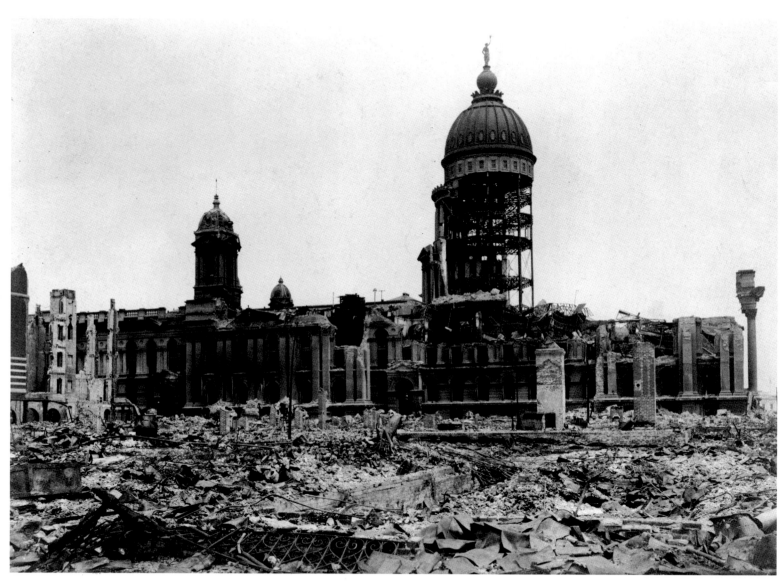

San Francisco's city hall lay in ruins following the 1906 earthquake, its walls down and central tower exposed to its structure. Mayor Schmitz, who met with leaders in the still-standing Hall of Justice, ordered soldiers and police to shoot down looters and "all miscreants who may seek to take advantage of the city's awful misfortune." Later that day the Hall of Justice was damaged from explosives attempted to slow the spread of the fire.

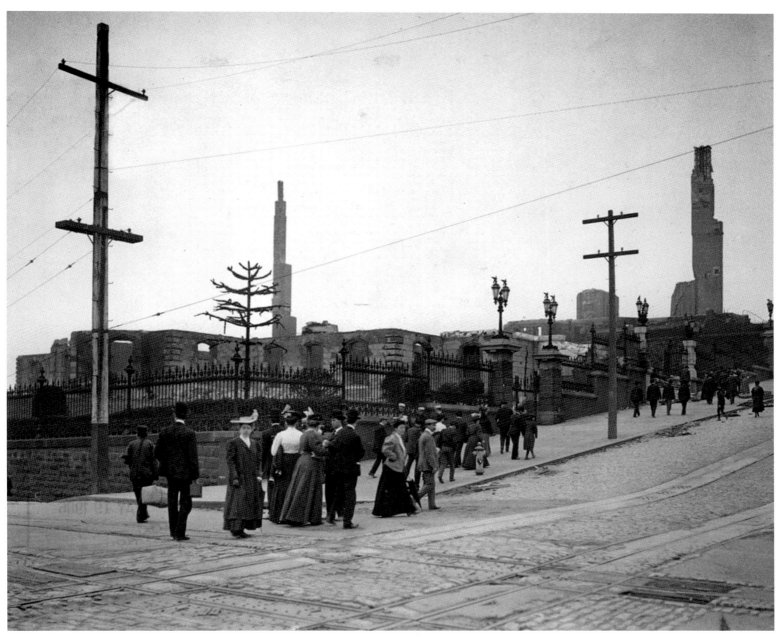

A group of men and women walk by the ruins of the Hopkins Art Institute and the Stanford Mansion, both buildings victim to the 1906 earthquake. Thousands of refugees—now homeless—were sent to Oakland, where relief stations were established. The Southern Pacific ran 129 trains with over 900 cars, carrying 225,000 refugees out of the city. A train from Chicago brought 75 doctors and nurses to help in the relief camps.

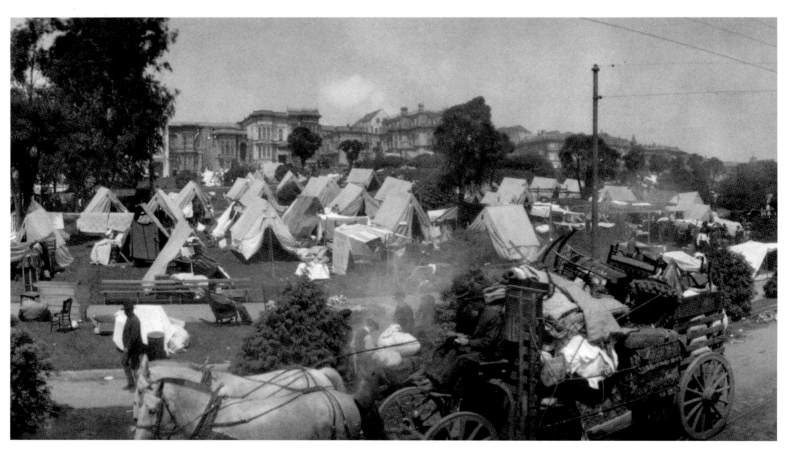

Refugees from the Great Earthquake gather here in Jefferson Square, setting up a temporary tent city. A personal account by Adolphus Busch (one of the founders of the Anheuser-Busch brewing company) reads, "The earthquake which shook San Francisco made all frantic . . . I quickly summoned my family and friends, and urged them to escape to Jefferson Square, which we promptly did."

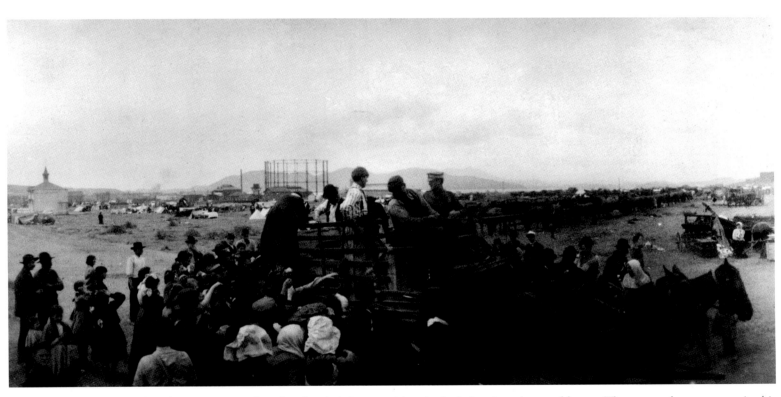

Many earthquake victims were forced to flee their homes with only the belongings they could carry. The men and women seen in this photograph gathered at Fort Point, known as the Gibraltar of the West Coast, where clothing was distributed. After leaving the city, the population dispersed, some to Oregon and others to Los Angeles, while thousands sought shelter across the bay in Oakland.

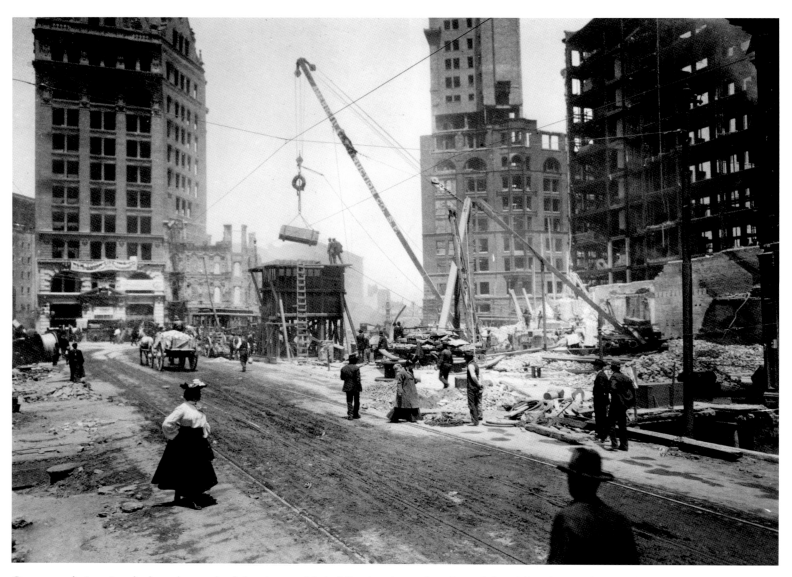

One can only imagine the herculean task of cleaning up debris following the earthquake and fires. This photo, taken at Third, Kearney, and Market streets, shows crews beginning the debris removal. It took a little more than a year to complete the cleanup; wooden structures had burned to the ground, so there was no salvageable material. However, scrap metal, bricks, and pipes were reused in rebuilding or sold to junkmen.

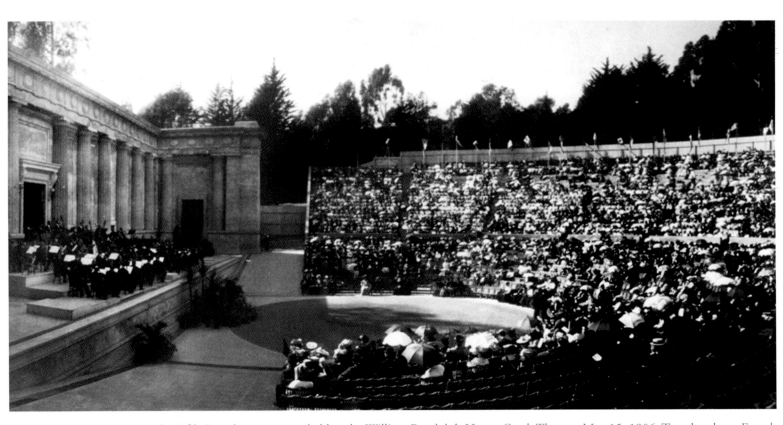

Spectators enjoy the Fifth Symphony concert, held at the William Randolph Hearst Greek Theatre, May 15, 1906. Two days later, French star Sarah Bernhardt performed Racine's *Phèdre* as a benefit for victims of the San Francisco earthquake. The 8,500-seat amphitheater, owned by the University of California, Berkeley, was built in 1903 on the site of an "outdoor bowl" already in use.

Naturalist and early Yosemite resident John Muir wrote that the Three Brothers (the rock formations seen in this photo) were an immense mountain mass with three gables fronting the valley, the topmost nearly 4,000 feet high. The formations were named for the three sons of Old Tenaya, the Yosemite chief captured here in 1852. Pouring down from the rocky heights is Bridal Veil Falls.

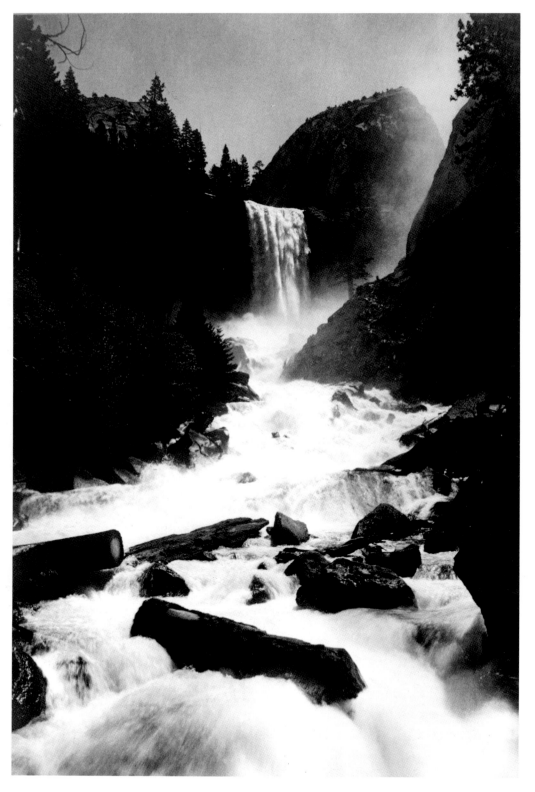

This is the interior of the old Spanish mission at Santa Barbara, the tenth of the 21 Franciscan missions in California. The original church buildings composing this Queen of the Missions were constructed of adobe, a mixture of clay, sand, water, and another natural material such as straw. The church seen here is the fourth one built, replacing the third structure that was destroyed by an 1812 earthquake.

In April 1907, members of the Santa Clara County Historical Society placed a cross commemorating the first mission site near the confluence of Mission Creek and Guadalupe River. The plaque reads, "Monument site First Santa Clara Mission January 12, 1777." In 1779, the Guadalupe River overflowed, causing a temporary mission compound to be built on higher ground.

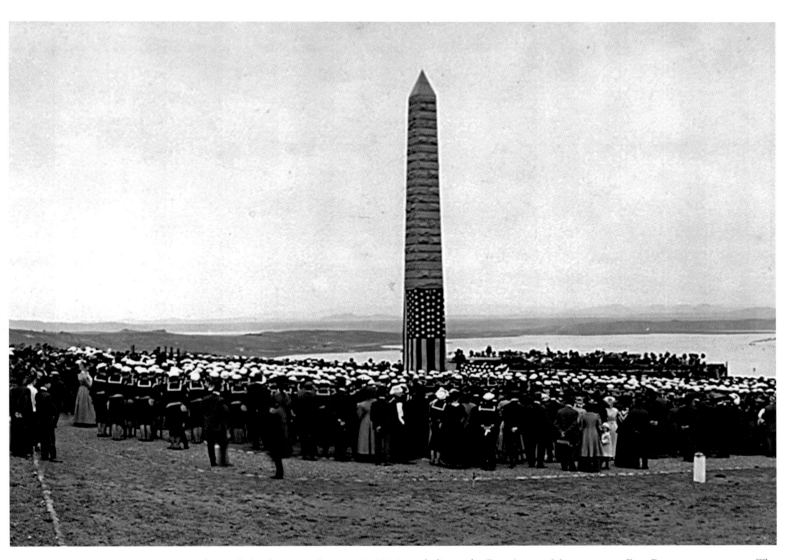

San Diego citizens gather at Point Loma on January 7, 1908, to dedicate the Bennington Monument at Fort Rosecrans cemetery. The monument was erected to honor the 60 sailors who were killed following a boiler explosion on board the gunboat *Bennington*. Fort Rosecrans, named for a Civil War general, overlooks San Diego Bay, the downtown area, and North Island (seen at right).

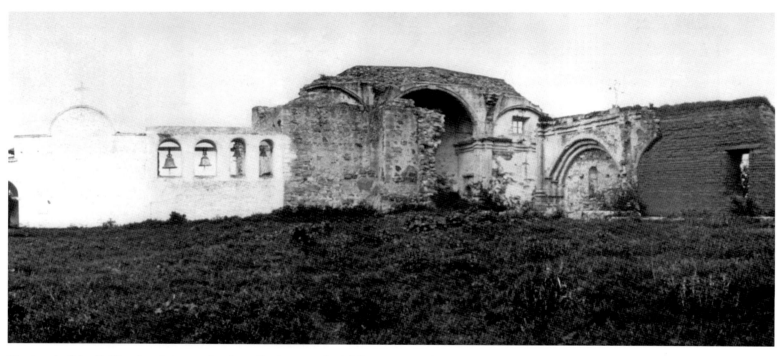

The jewel of the California missions—San Juan Capistrano—had fallen into ruin following an 1812 earthquake felt from Oceanside to San Luis Obispo. Claimed by the Mexican government, the mission eventually passed into private ownership until 1865, when Abraham Lincoln returned the property to the Catholic Church. Thirty years later, restoration work began, thanks in large part to Father John O'Sullivan, who came west as a treatment for his tuberculosis.

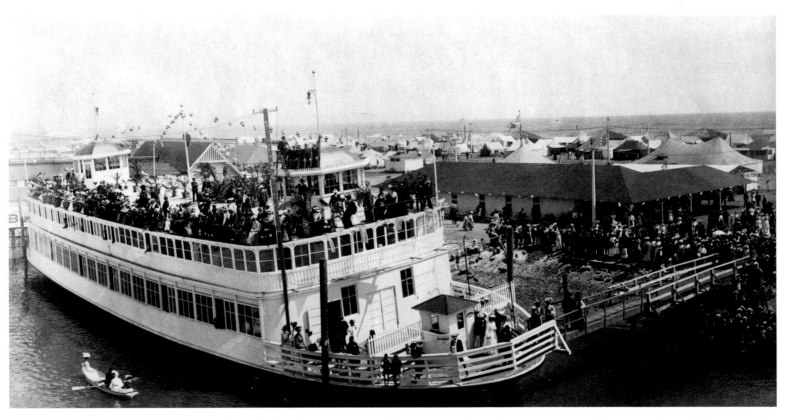

Men, women, and children line the dock, waiting to book passage on the Silver Gate ferry, which ran back and forth across the bay between San Diego and Coronado. The Silver Gate was the first propeller-driven ferry on the Pacific Coast. Coronado's tent city, seen in the background, was a popular summer destination, with tents renting for about $4.50 a week. Each tent had a wooden floor, bedstand, wash bowl, pitcher, dresser, and chair.

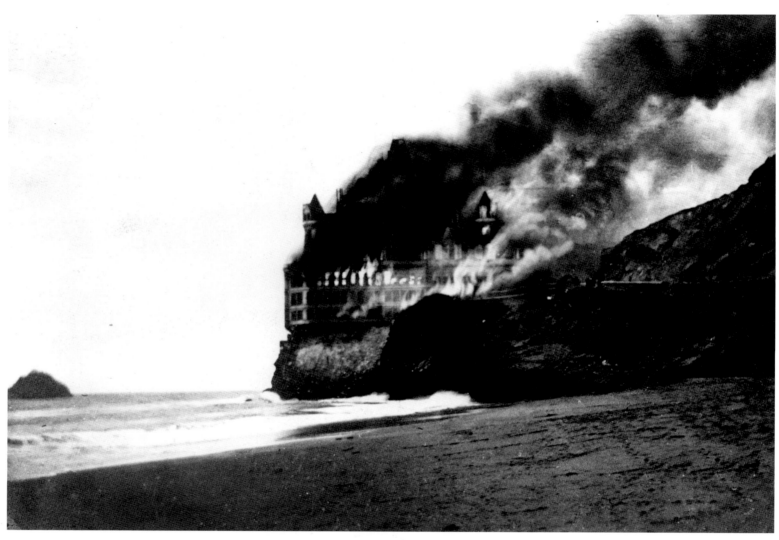

Cliff House, long among America's favorite resorts, burned to the ground on September 7, 1907. The cause of the fire was a mystery. Local accounts noted the fire was so out of control by the time firemen arrived that they turned their attention to saving adjoining properties. A newspaper account noted that the structure, perched on a cliff overlooking Seal Rock, gave "hundreds of thousands of people . . . their first view of the Pacific."

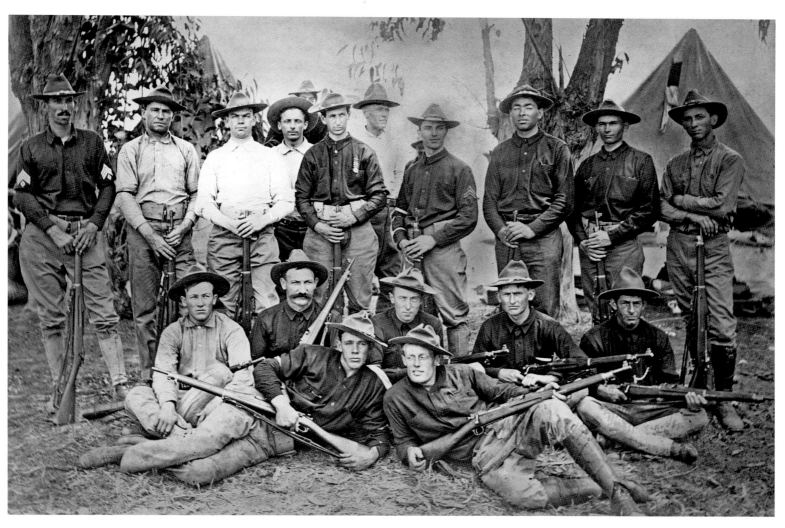

Since 1907, and only interrupted twice for World War I and II, Camp Perry, Ohio, was the home of the National Matches, an annual competition consisting of rifle and pistol matches for a National Trophy. Camp Perry sits on the shores of Lake Erie, near the scene of Commodore Perry's great triumph over the British in 1812. Striking a pose is the California Rifle Team, who competed in the 1908 Nationals.

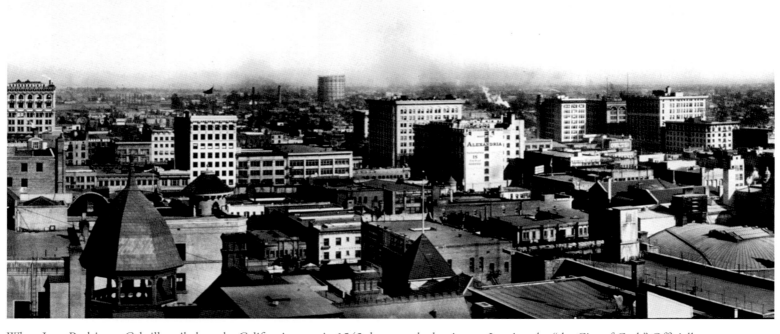

When Juan Rodriguez Cabrillo sailed up the California coast in 1542, he named what is now Los Angeles "the City of God." Officially formed in 1781, the Mexican village was a melting pot for a population of Hispanics, Africans, and Native Americans. Once the railroad arrived in 1876 and oil was discovered, tremendous growth was inevitable. By the time this image was taken, Los Angeles had grown to well over 100,000 people.

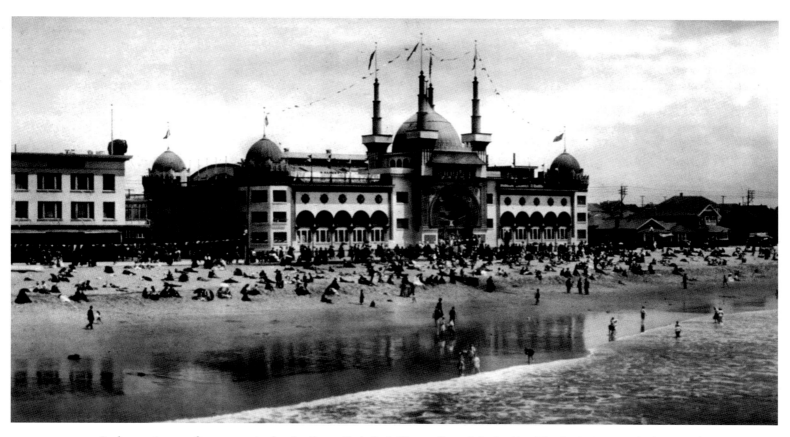

Bathers enjoy an afternoon swim by the Ocean Park Bath House, Santa Monica Bay. The Bath House, which opened in 1905, was a monumental structure that stood on the beach and offered heated salt water swims for those who found the Pacific Ocean too cold. Designed with a barrel roof with abundant skylights, visitors could enjoy the feel of the outdoors while staying in the heated water. The building was destroyed by a 1912 fire.

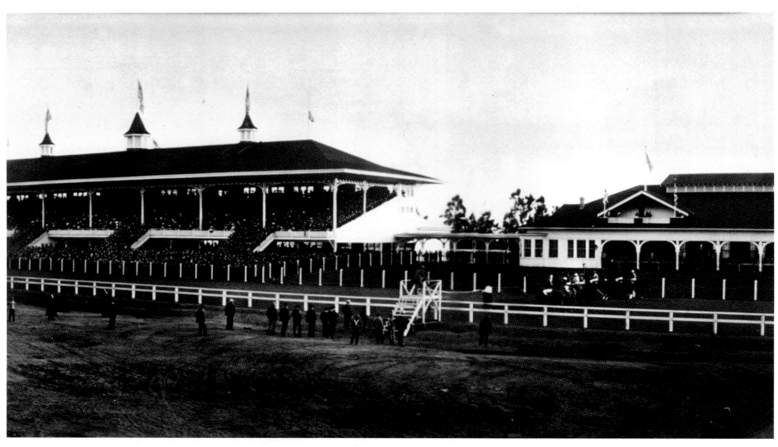

This March 1908 photograph of the Santa Anita Race Track grandstand was taken three months following its opening. Built by E. J. "Lucky" Baldwin, the track was lightning fast, as racing aficionados reported, and at least three world records were broken in its two seasons of operation. Santa Anita closed in 1909 when the Hart-Agnew Bill banned gambling in the state, and it wasn't until 1934 that the second Santa Anita Race Track debuted.

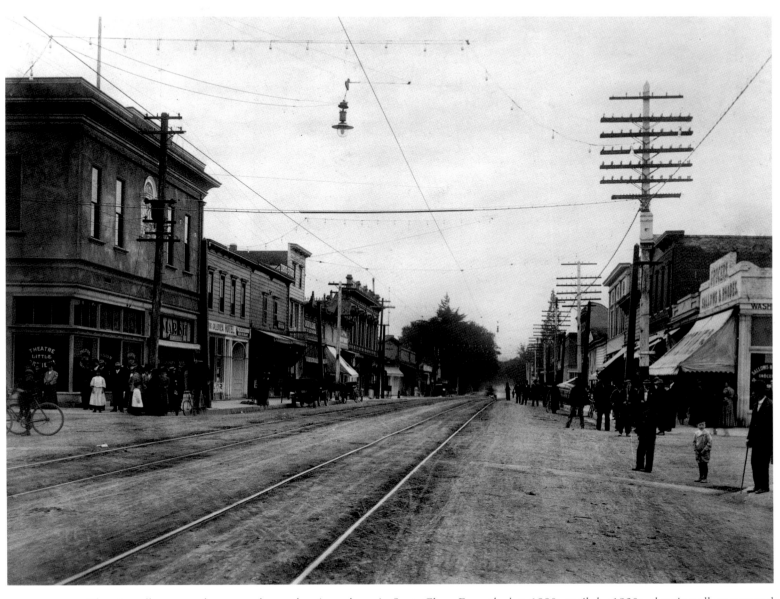

Electric trolley car tracks pass under an electric arc lamp in Santa Clara. From the late 1880s until the 1930s, electric trolleys operated throughout the city. With the advent of bus lines and automobiles, trolley service came to an end.

Now a ghost town, Betteravia (French for "beet roots") was once a thriving community whose residents were employed by the Union Sugar Company. Although the first few years of production looked promising, worldwide overproduction, drought, and white fly damage cut the yield. When the factory finally closed, the town died with it. Seen in this photograph are workers in the factory's general analytical lab.

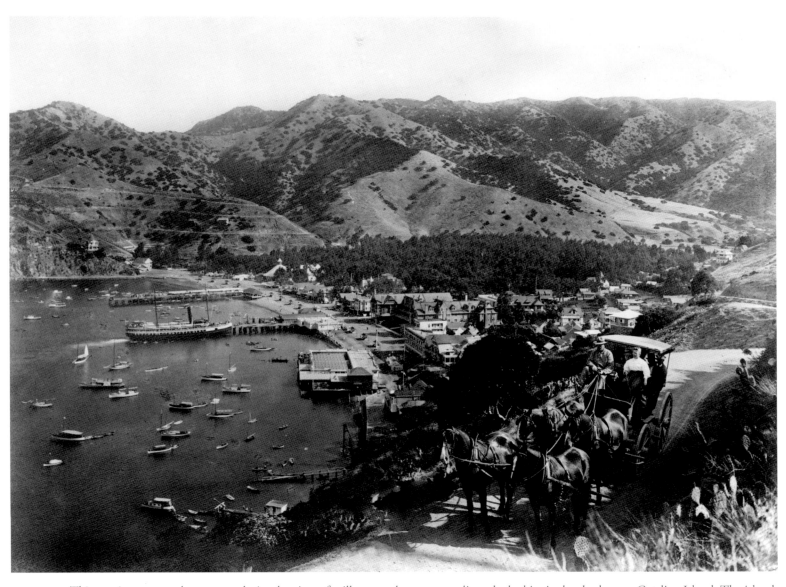

This tourist stagecoach stops to admire the view of sailboats and a passenger liner docked in Avalon harbor on Catalina Island. The island, one of the few places in Southern California that looks much the same as when Spanish explorers came ashore, boasted a stagecoach line that opened in 1903 and carried travelers to the island's 1,450-feet summit. Richard Henry Dana wrote about Avalon in his novel *Two Years Before the Mast.*

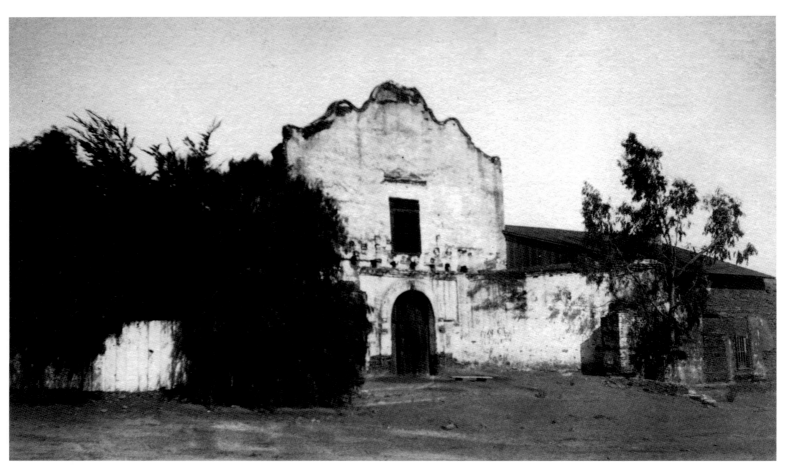

Known as the Mother of the Missions, San Diego de Alcala was the first California mission, built by Father Junipero Serra. Originally situated on a hilltop overlooking the bay, the mission was moved six miles inland due to poor soil and water conditions. In 1775, hundreds of locals attacked the second site, seen here around 1909, killing Father Luis Jayme. Father Jayme became the first Christian martyr in California.

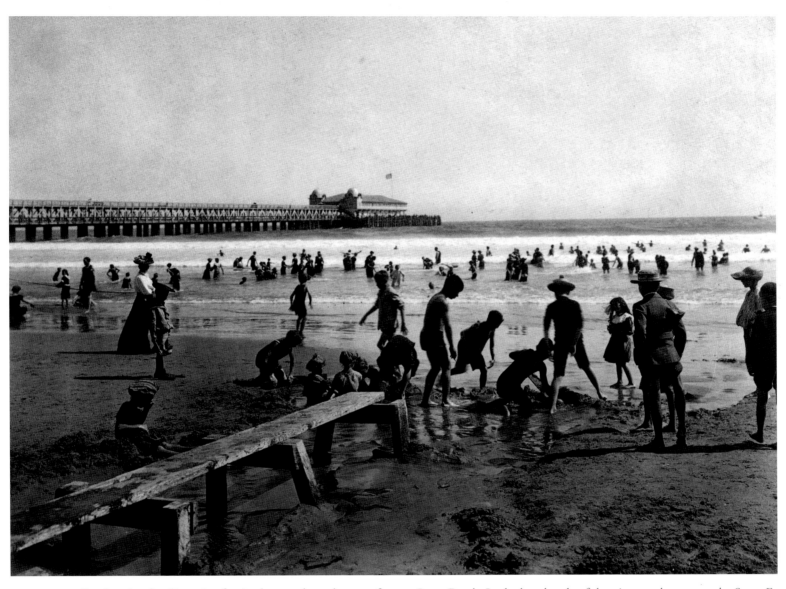

Beach-going families enjoy fun in the sun along the waterfront at Long Beach. In the last decade of the nineteenth century, the Santa Fe and Southern Pacific Railroad routes brought droves of visitors to this seaside resort. Long Beach became so popular that between 1902 and 1910, about the time this photograph was taken, it was the fastest-growing city in America.

Although Palomar Mountain eventually became home to one of the world's largest telescopes, its beginnings were closely connected with the opening of the Butterfield Stagecoach Line. Although the line brought in settlers—enough to support three schools during the 1890s—the area's population steadily dwindled through the years. Seen here is the ruins of one of Palomar's two post offices, which also housed a branch of the library.

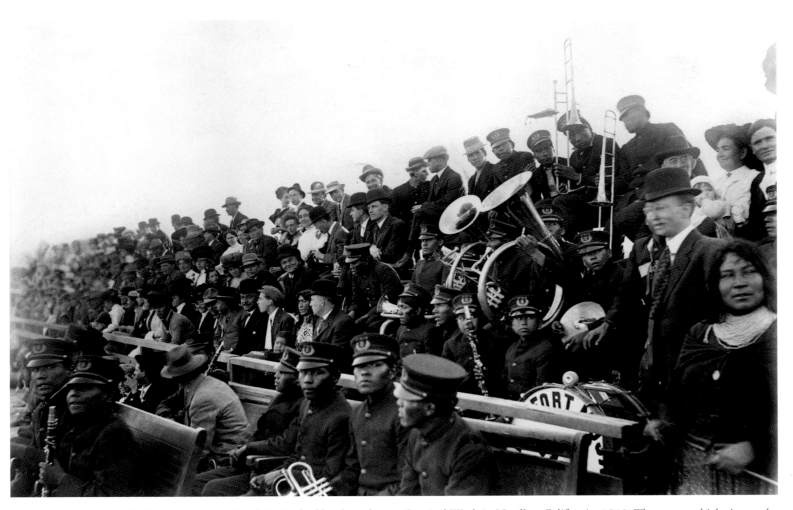

An all–Native American band sits in the bleachers during Carnival Week in Needles, California, 1910. The town, which sits on the California-Arizona border, takes its name from a group of pointed rocks on the Arizona side of the Colorado River. These band members may belong to the Fort Mohave Indian band, formed in 1906.

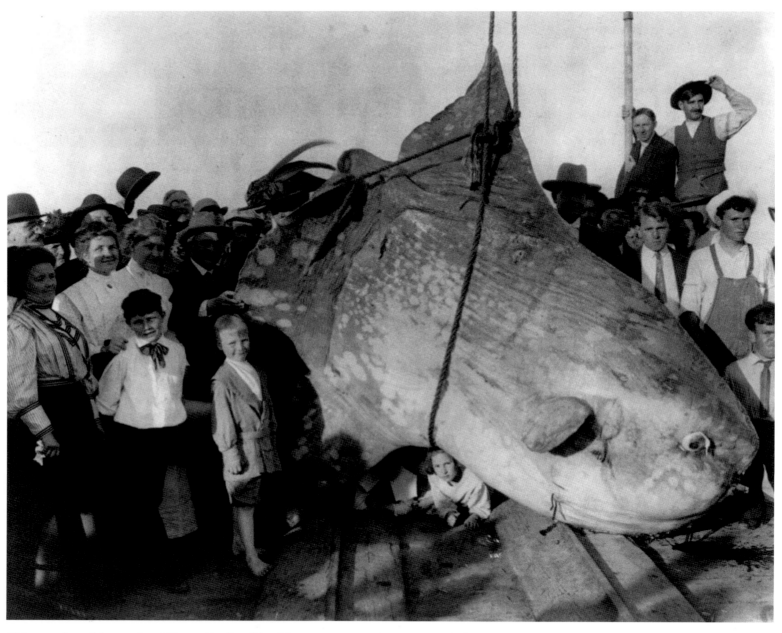

This record sunfish, caught off Santa Catalina Island in 1910, was too heavy to weigh, but estimates place it between 2,500 and 3,500 pounds. Anglers had long enjoyed fishing the waters here, stating that for those who love the "strenuous kind of fishing" there is no better place than Catalina Island.

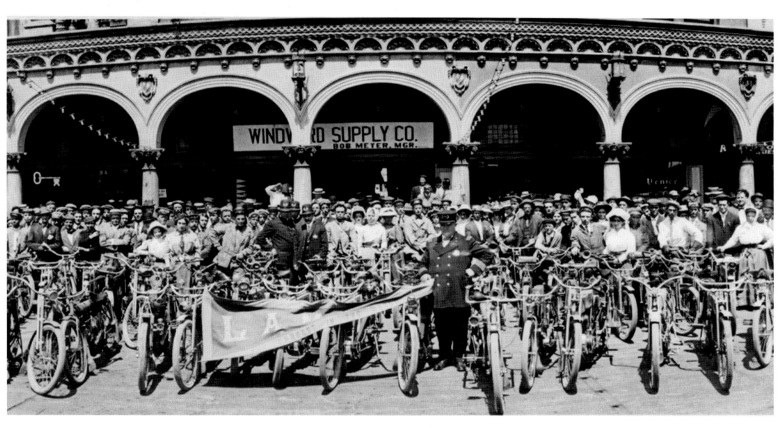

By 1910, Venice's amusement pier had plenty to offer visitors to this seaside town. The beachfront pier sported a dance hall, restaurant, hot saltwater pool, an aquarium, and an arcade. Although most tourists arrived via the Pacific Electric Railway from Los Angeles and Santa Monica, it's apparent this group of motorcyclists had no need for public transportation.

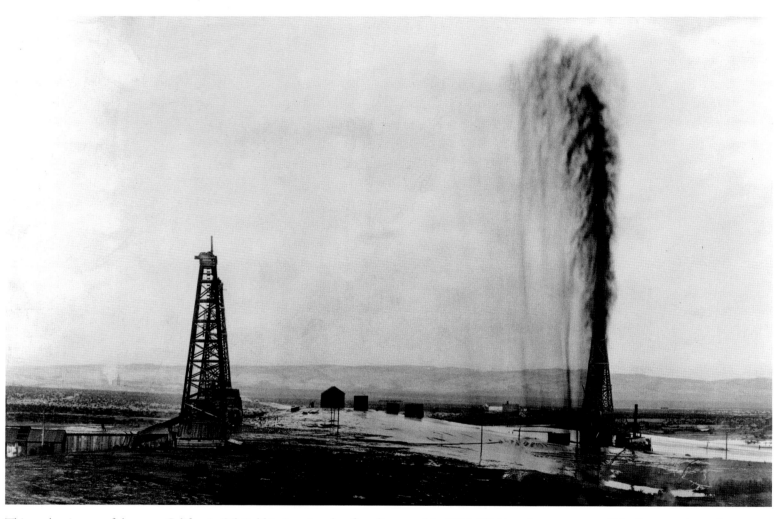

This gusher is part of the great California Oil Field in Los Angeles, first discovered in 1892. Within a few years, over 200 oil companies and 2,500 wells were within city limits. Los Angeles went on to become one of the major oil-producing areas of the world.

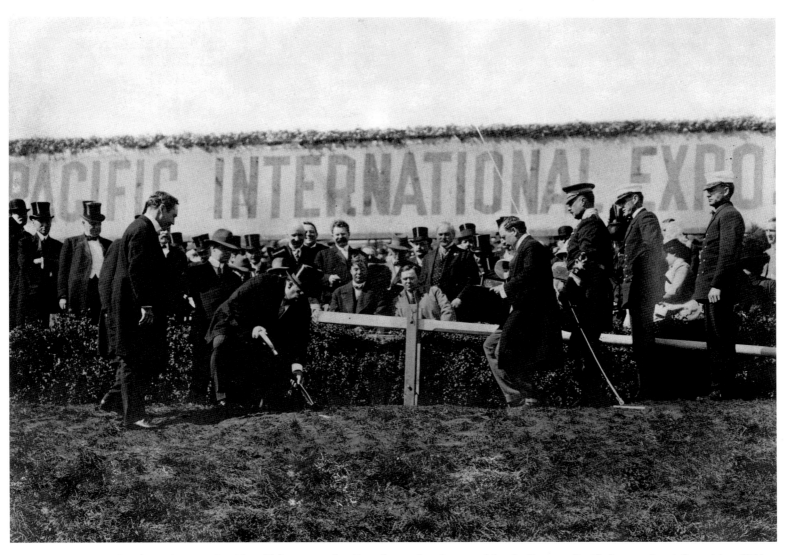

On October 14, 1911, President Taft came to San Francisco to break ground for the Panama-Pacific International Exposition. Taking nearly three years to complete, the 1915 fair gave a huge economic boost in the years following the 1906 earthquake and fire. Visiting the exposition, poet Edwin Markham wrote, "I have seen beauty that will give the world new standards of art, and a joy in loveliness never before reached."

First formed in 1850, the Sheriff's Department of Los Angeles County brought law and order to a city that had more murders annually, in proportion to its population, than any other community in California. Throughout its colorful history, the department dealt with lynch mobs, banditos, the murder of its sheriff, and a massacre of Chinese involved in a tong war. In 1912, about the time of this photograph, the department hired its first female deputy.

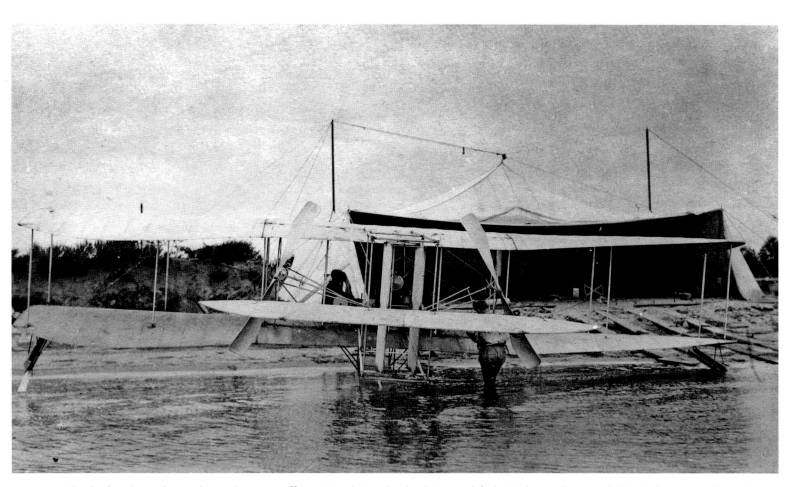

This biplane being lowered into the water off San Diego's North Island is a modified Wright Brothers Model B. Early aviator Glenn Curtiss operated a flying school on North Island, leasing the land until World War I. When World War II began, North Island was the major continental base supporting forces in the Pacific. In pre-aviation years, North Island was a favorite hunting and camping destination.

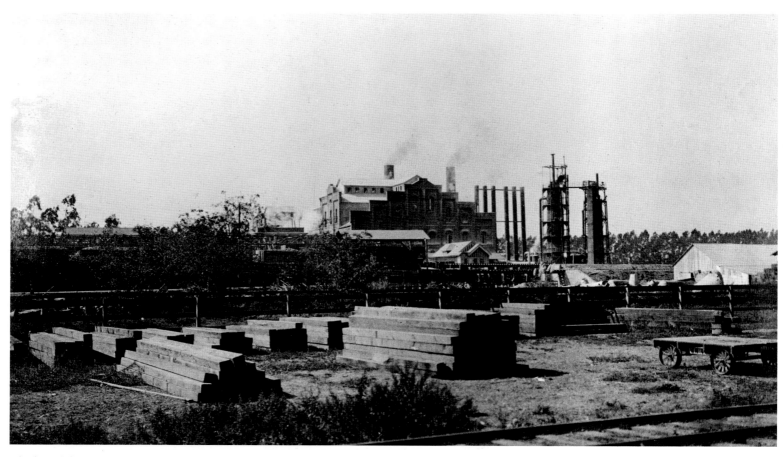

The lime kiln towers shown in this image of an Oxnard factory are most likely those of the American Beet Sugar Company, considered the "model sugar factory of America." On the factory grounds were housing units for engineers and supervisors as well as a two-story lodging house with dining room built for the workers. North of the factory were 36 adobe houses for the Mexican field workers.

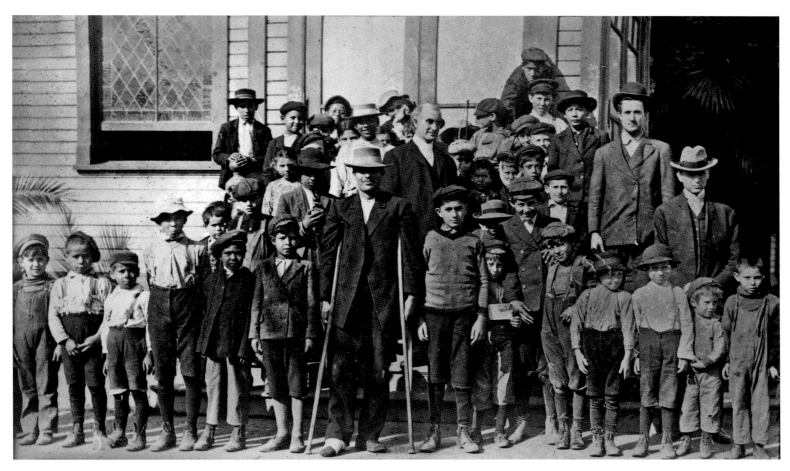

Samuel Merrill, a businessman and philanthropist, helped found the Los Angeles Industrial Home Society for homeless boys between the ages of eight and thirteen. Merrill, a transported New York native, first came to California in 1856 in a family move precipitated by his brother's poor health. He founded both the Oakland and Los Angeles YMCAs. The boys' home he helped build was later renamed the McKinley Boys' Home to honor the assassinated president.

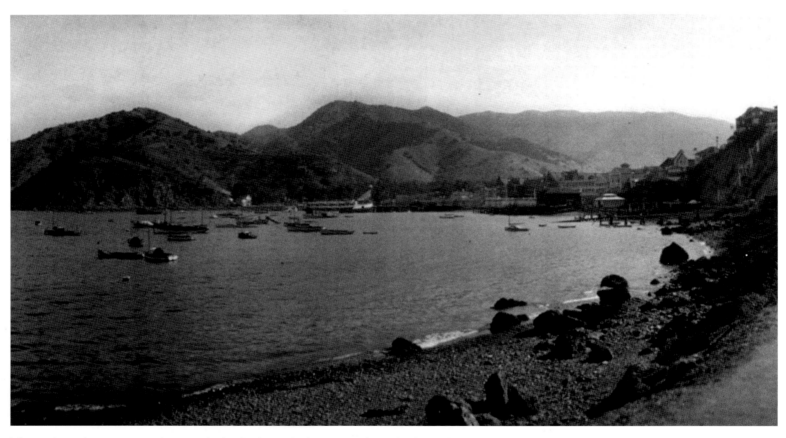

This wide-angle panoramic photograph clearly shows the bay at Catalina Island and the dirt road leading into the town of Avalon. Beginning in 1911, when this photograph was taken, Catalina served as the backdrop to more than 300 movies, including *Rain, Treasure Island, Mutiny on the Bounty,* and *Captains Courageous.*

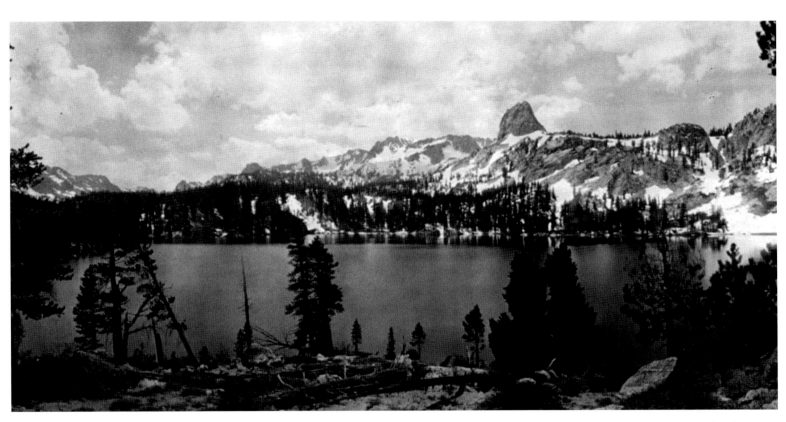

Lake George is one of the Mammoth Lakes, located in the Sierra Nevada at an elevation of over 9,000 feet. The Mammoth Lakes basin is a glacial cirque carved by the movement of glacial ice. Several small streams and alpine meadows provide spectacular displays of wildflowers during early summer. Mammoth Lakes was a quiet summertime getaway for families wishing to hunt, fish, horseback ride, or camp.

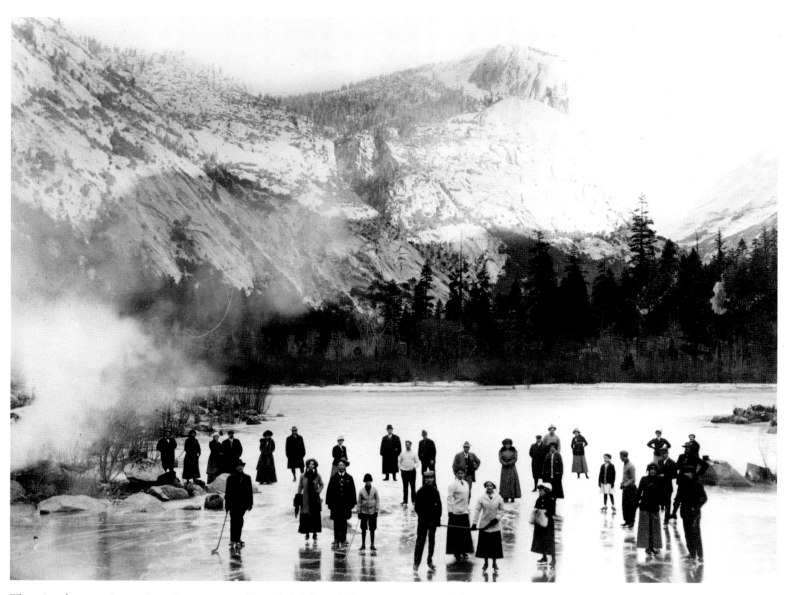

These ice skaters enjoy a wintertime romp on Yosemite's Mirror Lake in 1911. Around the turn of the century, Mirror Lake was one of the stops on the great tour of Yosemite at a time when the West was still seen as a rugged frontier. The lake is at its fullest during the snow melt and can cover up to eight acres.

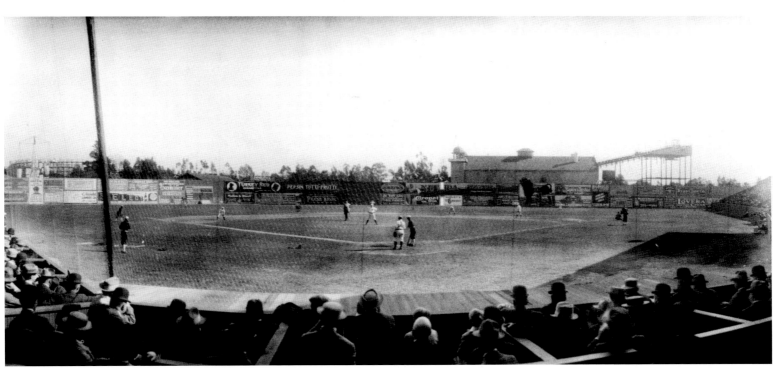

Baseball fans watched the action at Washington Park in Los Angeles, home to the L.A. Angels from 1912 until 1925. The Angels were part of the Pacific Coast League (PCL) and considered the best team in the league. Ellsworth Hoy, a deaf-mute Angels player, was credited with umpires signaling balls and strikes with their hands. Washington Park could hold a crowd of 15,000 "kranks," the period term for fans.

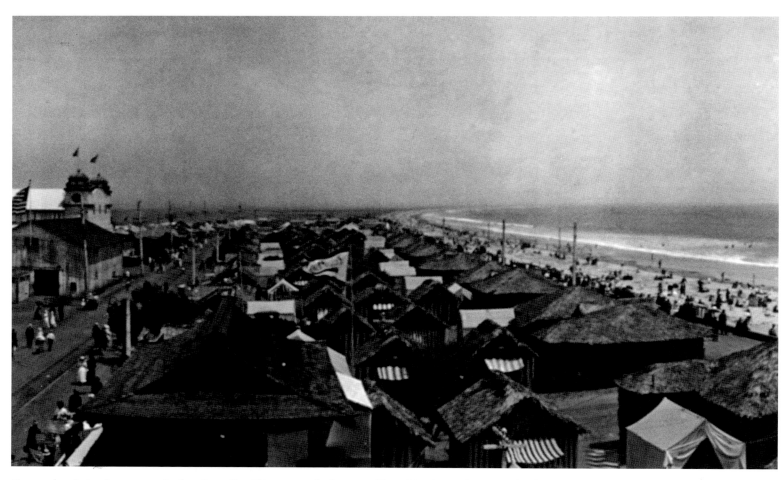

Coronado, sitting just across the bay from San Diego, was the home to Tent City, located just south of the Hotel del Coronado. A popular summer vacation spot, Tent City was created for families whose budgets didn't include lodging at the luxurious "Hotel del." Tent City had its own newspaper, band concerts, church services, and sporting events. Electricity from the hotel provided power for lamps hung in each tent.

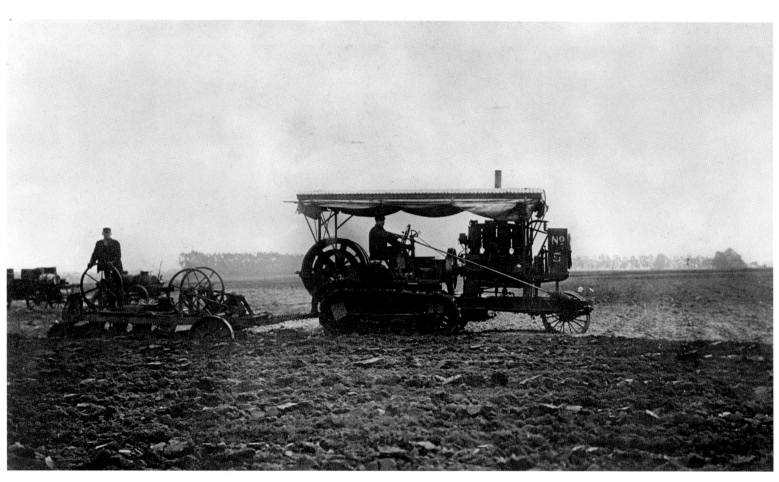

Over the years, Oxnard's agricultural products have included sugar beets, cucumbers, strawberries, and lima beans. The area's climate is particularly conducive to an abundant strawberry crop, and today, Oxnard is California's largest strawberry producer. The city is named for the Oxnard family, who developed the first sugar beet factory. The plowing in this photograph may have been part of the American Beet Sugar Company's operation.

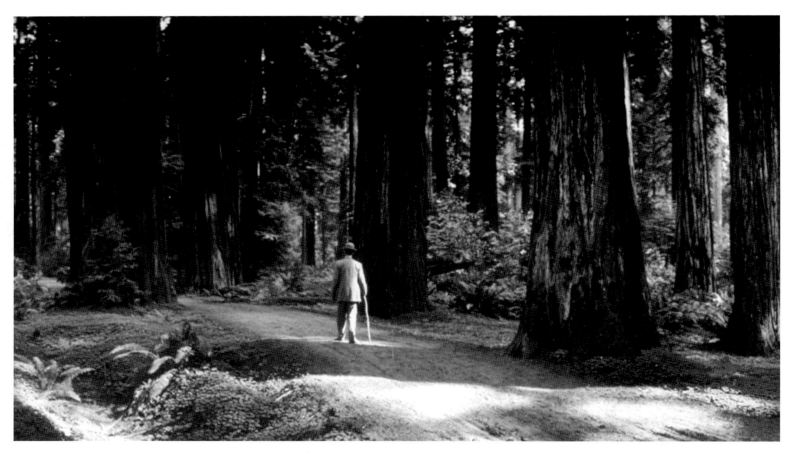

In 1919, the Secretary of the California Redwood Association wrote an article touting the many reasons redwoods are the perfect choice for construction: "The Redwoods are wonderful trees—their living power is without peer among perishable plant and animal life . . . they are gaining favor in the East since their two outstanding virtues—fire and rot resistance—have become well-established."

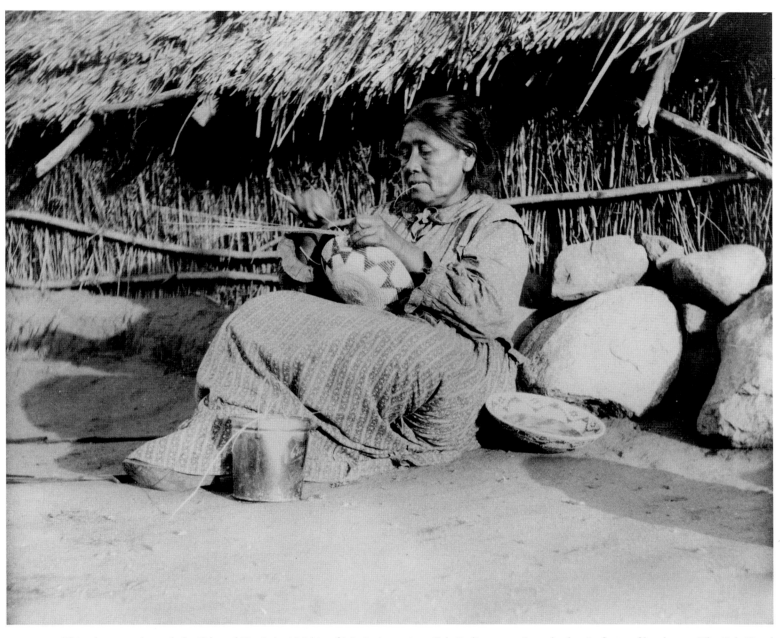

This photograph made by Edward Davis in 1914 is of Maria Antonia, a Pala Indian, weaving a basket in front of her home. The Pala Band is comprised of the Cupeño and Luiseño Indians who live near Palomar Mountain. Historically, the Cupeño occupied the land around the San Luis Rey River but in 1903 were forced onto a 10,000-acre reservation with the Luiseño. The Cupeños call the forced move their "Trail of Tears."

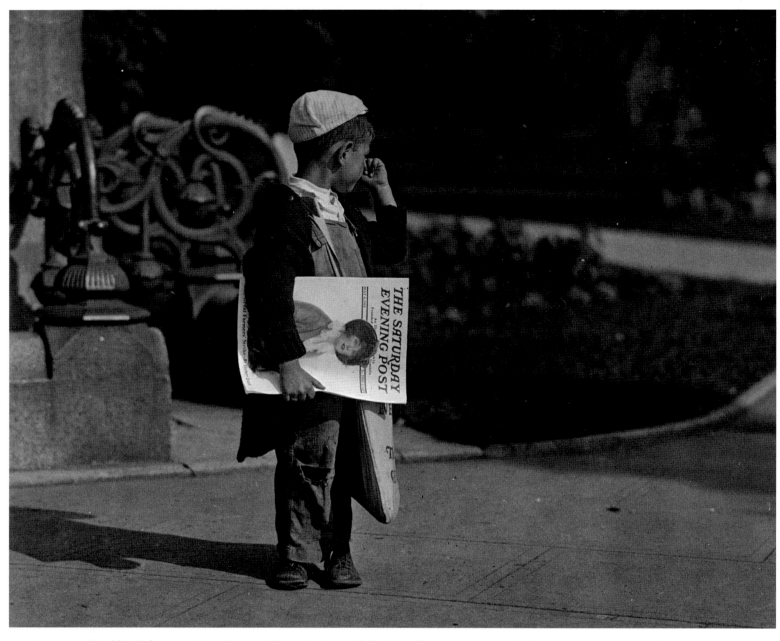

Freddie Kafer was a 5- or 6-year-old newsie who sold the *Saturday Evening Post* and other newspapers at the Sacramento State Capitol entrance. Newsies like Freddie were the main distributors of newspapers from the mid–nineteenth to the early twentieth century. Newsies hawked their wares from the street corners or by walking through neighborhoods. The boys were among the poorest of the poor and often slept on the street.

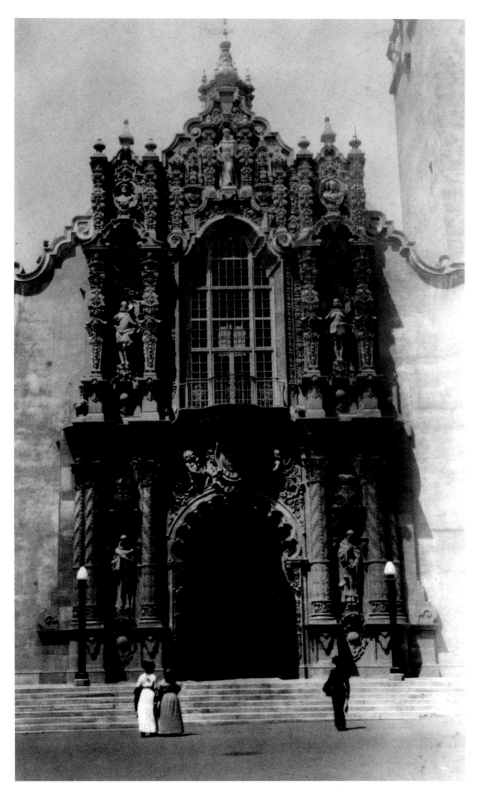

San Diego had its year of glory in 1915, when the world came to visit the Panama-California Exposition, created to celebrate the opening of the Panama Canal. Built in Balboa Park, the exposition buildings were constructed in a Spanish colonial style, as can be seen on this façade of the California Building. The front sculptures include Father Junipero Serra, Juan Rodriguez Cabrillo, George Vancouver, and Gaspar de Portola, the first Spanish governor of California.

Like San Diego's 1915 Exposition, San Francisco's Panama-Pacific International Exposition celebrated the completion of the Panama Canal. For San Franciscans, it was also a special opportunity to show the world that the city had recovered from the 1906 earthquake. Exhibits, such as the one in this photograph, were widely visited, but none was as special as that of the Liberty Bell, whose trip to California marked the last time she was moved out of Pennsylvania.

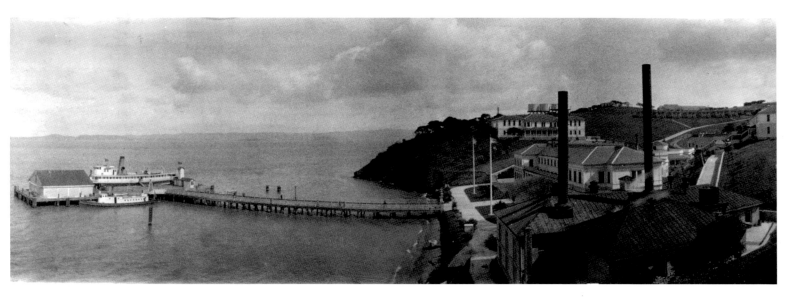

Angel Island, located in San Francisco Bay, became the home of the Immigration Station known as the Ellis Island of the West. In its time, the station processed one million Asian immigrants. When the island became part of the United States in 1848 following the Mexican-American War, the former owner, Antonio Osio, fought a losing legal battle to retain title. President Fillmore declared the island a military reserve, home to an infantry garrison.

NOTES ON THE PHOTOGRAPHS

These notes, listed by page number, attempt to include all aspects known of the photographs. Each of the photographs is identified by the page number, photograph's title or description, photographer and collection, archive, and call or box number when applicable. Although every attempt was made to collect all data, in some cases complete data may be unavailable due to the age and condition of some of the photographs and records.